iPhoto '11

The Macintosh iLife Guide to using iPhoto with Mac OS X Lion and iCloud

D1501172

Jim Heid

with Dennis R. Cohen and Michael E. Cohen

Peachpit
Press

iPhoto '11

The Macintosh iLife Guide to using iPhoto with OS X Lion and iCloud

Jim Heid, with Dennis Cohen and Michael Cohen

Peachpit Press
1249 Eighth Street
Berkeley, CA 94710
510/524-2178
510/524-2221 (fax)

Find us on the Web at: www.peachpit.com
To report errors, please send a note to errata@peachpit.com

Peachpit Press is a division of Pearson Education.

Editor: Barbara Assadi
Production editor: Myrna Vladic
Proofreader: Scout Festa
Compositor: David Van Ness
Cover design: Mimi Heft
Interior design: Jonathan Woolson, thinkplaydesign

Portions originally appeared in *Macworld* magazine, © Mac Publishing, LLC.
Apple product photography courtesy Apple Inc.

ISBN-13: 978-0-321-81951-2
ISBN-10: 0-321-81951-9

9 8 7 6 5 4 3 2 1

Printed and bound in the United States of America.

For Toby,
for my mom and
the rest of my family,
and in loving memory
of George Heid, my dad.
He would have loved this stuff.

George Heid (right), recording direct to disc
on a moving train, in the early 1950s.

About the Author

Jim Heid describes himself as a poster child for iLife: he has been taking photos, making movies, and playing music since he was a kid.

He began writing about personal computers in 1980. As Senior Technical Editor of one of the first computer magazines, *Kilobaud Microcomputing,* he began working with Mac prototypes in 1983. He began writing for *Macworld* magazine in 1984 and is now a Senior Contributor. He has also written for *PC World, Internet World,* and *Newsweek* magazines, and he was a technology columnist for the *Los Angeles Times.*

Jim is a popular speaker at user groups, conferences, and other events. He has taught at the Kodak Center for Creative Imaging in Camden, Maine; at the University of Hawaii; and at dozens of technology conferences in between. He's also an obsessed amateur photographer whose photos have been featured in the *San Francisco Chronicle.*

Jim works for lynda.com, an online education site, where he's responsible for developing video training courses that cover photography, Photoshop—and yes, iPhoto.

Acknowledgments

This book wouldn't exist if it weren't for Barbara Assadi and Arne Hurty, and I thank you both. Barbara has expertly edited this book and every one of its previous incarnations, and Arne created a design that has stood the test of time.

David Van Ness crafted the layouts in this book with precision and a fine eye for detail.

My thanks also go to Dennis and Michael Cohen for their editorial assistance, and to Cliff, Myrna, and everyone at Peachpit Press.

Thanks also to Mitch and everyone at MCN; to Chuck Wilcher; to Judy, Terry, Mimi, Pierre, Laura, Rennie, Hope, and Cynthia; to the entire, wonderful Heid and Malina families; and to all the critters at the Hook & Eye Farm: Sophie, Bob, Belle, Cowboy, Jane, Doc, and everyone with feathers.

Finally, my love and my thanks to Toby, my partner in crimes of all kinds—including, at long last, life. I love you!

—Jim Heid

Table of Contents

Read Me First

How the Book Works

Do you read computer books from cover to cover? I don't either. I read sections that interest me, and then I use the book as a reference when I'm stuck and need to look something up.

This book is designed to make this "just the facts" style of learning as easy as possible. The entire book is a series of two-page spreads, each a self-contained reference that covers one topic.

Keep it handy as you use iPhoto. When you are stuck—or just have a few free minutes and want to increase your iPhoto mastery—fan the pages, glancing at the tabs on the right-hand page, until you find what you need. Or use the index or the table of contents to look up specific topics.

Whether you read this book from cover to cover or use it as a reference, I hope you find it a useful companion to your iPhoto and photographic endeavors.

Most spreads begin with an introduction that sets the stage with an overview of the topic.

Here's the main course of each spread, where you'll find instructions, background information, and tips.

The section and spread names appear on the edges of the pages to allow you to quickly flip to specific topics.

Read the Book, Watch the Movies

You can't beat the printed page for delivering depth and detail, but some people learn best by watching. If you're in this second group, Apple's got you covered.

In iPhoto help. When you're working in iPhoto, you can use its built-in help to get instructions. Many help topics have short movies that you can watch to get the big picture of how to accomplish a task.

Click the link…

…and watch the movie.

On Apple's site. Interested in more of an overview of what iPhoto '11 is all about? Head directly to www.apple.com/ilife/video-showcase. There you can watch movies about the key features in iPhoto '11 and the rest of its siblings in the iLife family.

Join Me Online

I share photos that I take as well as tidbits relating to photography and other digital media topics in several online venues.

Flickr. For photo sharing, you'll find me on Flickr at www.flickr.com/jimheid.

Instagram. I also love sharing iPhone photos on Instagram, where you'll find me as @jimheid.

Facebook. Like almost a billion other highly productive individuals, I spend time on Facebook, too. Visit and subscribe to my feed at www.facebook.com/jimheid.

Twitter. Why yes, in fact, I do tweet now and again. Follow me at www.twitter.com/jimheid.

Welcome to iPhoto

Photographs can commemorate, inspire, amuse, persuade, and entertain. They're time machines that recall people and places. They're vehicles that carry messages into the future. They're ingrained in infancy and become intensely personal parts of our lives.

And now that photos have gone digital, they're everywhere. Between the cameras in our phones and the larger cameras that we tether to our wrists or wear around our necks, we have more ways to record slices of life than ever before. The phone in my pocket contains more photos than my dad shot in his lifetime.

How do we deal with this deluge of images? How do we keep track of them so we can find them years from now? How can we make them look better? How do we share them so that others can enjoy them?

iPhoto has answers—good answers— to each of these questions. iPhoto handles what I call the "tripod of digital imaging": organizing, enhancing, and sharing. This book explores each of these three legs in detail. Here's an overview of what we'll explore together.

Welcome to iPhoto.

Import and Organize

iPhoto makes it easy to import photos from your camera or an iPhone, iPod touch, or iPad.

Some or all. Choose to import every shot, or be selective and just bring in the best of them. Your photos live in your *photo library.*

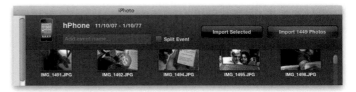

Automatic organization. iPhoto stores photos in virtual shoe-boxes called *events,* creating them for you automatically as you import photos.

Bring out your inner librarian. Are you one of those hyper-organized people whose socks are sorted by color? You'll love the organizational features iPhoto provides—everything from *keywords* that describe your photos to facial recognition features that collect shots containing the people in your life. Use at least some of these organizational aids, and you'll make your photos much easier to find.

Enhance and Improve

Just about any photo can benefit from some enhancement, and that's where iPhoto's edit view comes in.

Enhance with a click. You can often improve exposure and color balance with a single click.

Improve composition. Crop your photo to focus attention on your subject or just to improve its framing. And straighten those crooked shots so the ocean doesn't look slanted.

Retouch and refine. Use the edit view's tools to retouch blemishes and scratches, improve exposure and color balance, add sharpness, and much more.

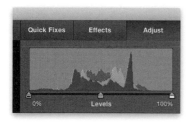

Share On-Screen, Online, and In Print

Don't let your best shots just sit there. Use iPhoto to share them—with loved ones, with clients, with the world.

Popcorn not included. Create slide shows using one of a dozen design themes, then display them on the Mac's screen (or on your TV), burn them to DVD discs, or use them in iMovie projects.

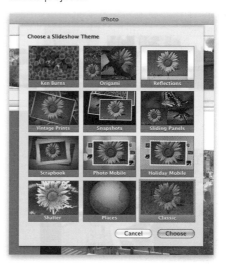

Online time. Email photos to friends and family. And post them on Facebook and Flickr for all the world—or just some of it—to see.

Meet your publisher. Print photos on your own printer, or order them from Apple. Better still, create photo books, calendars, and greeting cards.

The Rest of Your iLife

iPhoto is part of a family of programs that Apple calls iLife. The rest of the family includes iMovie for video editing, iDVD for creating DVDs, and GarageBand for recording music and podcasts.

iLife is included with every new Mac. You can also buy the individual programs (except for iDVD) from the App Store.

And then there's iTunes and its side-kicks, the iPod, iPad, and iPhone. While this i-ware isn't part of iLife, they work together beautifully. Use music from your iTunes library in your iPhoto slide shows and other iLife projects, and view photos, play GarageBand tunes, and watch iMovie flicks on an iPod, iPad, or iPhone. Connect your portable theater to a big-screen set—or add an Apple TV—and live iLife through your home entertainment system. Go from consuming media to pro-ducing your own, with your Mac at the center of it all.

iPhoto

· Import photos from cameras and elsewhere
· Organize photos into albums— or let iPhoto organize them based on events, faces, and places
· Crop, enhance, and print photos
· Order prints, calendars, cards, and books
· Create slide shows, and share photos online

iMovie

· Import and organize video from camcorders
· Edit video and create titles
· Add music soundtracks from iTunes
· Enhance video and add special effects
· Add photos and videos from iPhoto
· Share video through DVDs or the Web
· Export video for viewing on iPod, iPhone, iPad, or Apple TV

GarageBand

- Learn to play piano and guitar
- Create songs by assembling loops
- Connect a keyboard to play and record software instruments
- Record vocals, acoustic instruments, and electric guitars
- Create podcasts and add soundtracks to movies
- Transfer your productions to iTunes and use them in your iPhoto and iMovie creations

iTunes

- Shop for music, videos, and audiobooks at the iTunes Store
- Convert music CDs into digital music files
- Organize songs into playlists, and burn CDs
- Transfer music, photos, and videos to mobile devices
- Listen to Internet radio, podcasts, and audiobooks

iPhone, iPad, and iPod touch

- Shoot photos and movies, then import them into iPhoto
- Use iCloud's Photo Stream feature to sync your recent shots with your Mac
- Transfer photos and videos you create for mobile viewing

iDVD

- Create slide shows from your iPhoto library
- Add music soundtracks from iTunes
- Present video created in iMovie
- Distribute files in DVD-ROM format

iPhoto '11

iPhoto at a Glance

Millions of photographs lead lives of loneliness, trapped in unorganized boxes where they're never seen. Their digital brethren often share the same fate, exiled to cluttered folders on a hard drive and rarely opened.

With iPhoto, you can free your photos—and organize, print, and share them, too. iPhoto simplifies the entire process. You begin by *importing* images from a digital camera or another source. Then take advantage of iPhoto's ability to organize photos according to the events, the places, and even the faces you've photographed.

Along the way, you might also use iPhoto's editing features to make your photos look better. And you might use iPhoto's organization and searching features to help you file and locate images.

When you've finished organizing and editing photos, share them. Order prints or make your own. Design gorgeous photo books, arranging photos on each page and adding captions. Design calendars and greeting cards. Create slide shows, complete with music from iTunes, and then watch them on the Mac's screen, burn them to DVDs, or transfer them to an iPod, iPhone, or iPad.

Prefer to share over the Internet? Email photos to friends and family, and share them on Facebook and Flickr.

Welcome to the Photo Liberation Society.

Beyond the Shoebox

You can't enjoy photos if you can't find them. Use iPhoto's tools to organize and find your shots.

Organize

By faces. iPhoto can learn to recognize the people in your life (page 24).

By places. View your photos on a map (page 30).

And more. Add descriptions (page 22), create albums (page 42), and assign keywords for fast searching (page 38).

Find

Use the Search field to locate photos.

By text. Search for photo names and descriptions (page 40).

By date. Locate photos by when you took them (page 41).

And more. Search for keywords and ratings you've added (page 40), and create smart albums that search on multiple criteria (pages 46–49).

Fill the screen. Get the big picture when you browse, edit, or search your pictures—just click Full Screen. Use it to give yourself more room when you create books, calendars, and slideshows, too.

Your eventful life: iPhoto stores each set of photos you import as an *event*. You can create new events, combine events, and much more (page 20).

Skim and browse: To preview the photos in an event, skim the mouse pointer over the event (page 18). There isn't a faster way to browse.

People and places: iPhoto also helps you organize photos by faces (page 24) and locations (page 30).

To see the most recent photos you imported, click Last Import.

You can share photos with other Macs on your network (page 102).

Use albums to organize related photos—before creating a book or slide show, for example (pages 42–45).

Share photos online (pages 90–101).

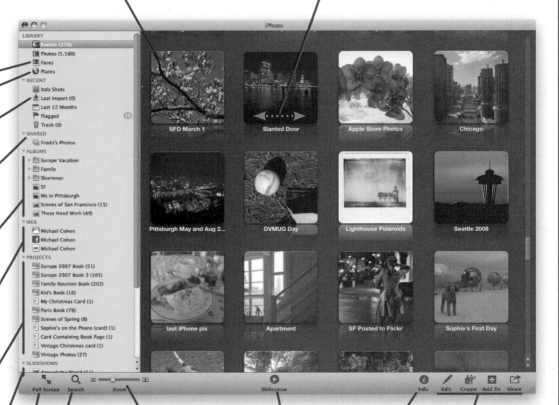

The Projects area holds books, greeting cards, and calendars (pages 112–131).

Create and display slide shows (pages 78–89).

Search for photos, albums, events, and more (previous page).

View iPhoto in Full Screen view (previous page).

To change the size of photo thumbnails, drag the slider. The slider works in other areas of iPhoto, too—for example, to zoom in on book pages.

Play an instant slide show (pages 12 and 78).

Get information about an item, change its name, assign a photo to a place, and add a description or keywords.

Use these buttons to edit photos, create new albums and projects, add photos to albums or projects, and share photos via email or on the Web.

The Essentials of Digital Imaging

Like any specialized field, digital imaging has its own jargon and technical concepts to understand. You can accomplish a lot in iPhoto without having to know these things, but a solid foundation in imaging essentials will help you get more out of iPhoto, your digital camera, and other imaging hardware.

There are two key points to take away from this little lesson. First, although iPhoto works beautifully with digital cameras, it can also accept images that you've scanned or received from a photofinisher. You can even save your favorite images from Web sites that you visit and from emails that you receive (page 15).

Second, the concept of resolution will arise again and again in your digital imaging endeavors. You'll want big, high-resolution images for good-quality prints, and small, low-resolution images for convenient emailing to friends and family. As described on page 90, you can use iPhoto to create low-resolution versions of your images.

Where Digital Images Come From

iPhoto can work with digital images from a variety of sources.

Digital Camera

Digital cameras are more capable than ever. One key factor that differentiates cameras is *resolution*: how many *pixels* of information they store in each image. Even inexpensive digital cameras now provide resolutions of 12 megapixels and up—more than enough to make large prints.

Most digital cameras connect to the Mac's USB port. Images are usually stored on removable-media cards; you can also transfer images into iPhoto by connecting a *media reader* to the Mac and inserting the memory card into the reader (page 16).

Scanner

With a scanner, you can create digital images from photographs and other hard-copy originals.

Scanners also connect via USB, although some high-end models connect via FireWire. Film scanners are a bit pricier, but can scan negatives and slides and deliver great image quality (page 138). Save your scanned images in JPEG format, and then add them to iPhoto by dragging their icons into the iPhoto window (page 14).

For tips on getting high-quality scans, visit www.scantips.com.

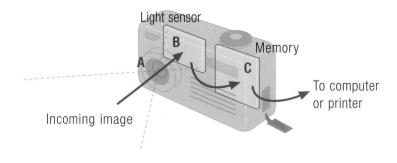

Light sensor

B

A

Memory

C

Incoming image

To computer or printer

In a digital camera, the image is focused by the lens (**A**) onto a sensor (**B**), where tiny, light-sensitive diodes called *photosites* convert photons into electrons. Those electrical values are converted into digital data and stored by a memory card or other medium (**C**), from which they can be transferred to a computer or printer.

Compact Disc

So *you're* the person who's still shooting film? Good news: for an extra charge, most photofinishers will burn your images on a compact disc in Kodak Picture CD format. You get not only prints and negatives, but also a CD that you can use with the Mac.

To learn more about Picture CD, google the phrase *picture cd*.

Internet

Many photofinishers also provide extra-cost Internet delivery options. After processing and scanning your film, they send you an email containing a Web address where you can view and download images. After downloading images, you can drag their icons into iPhoto's window.

A Short Glossary of Imaging Terms

artifacts Visible flaws in an image, often as a result of excessive *compression* or when you try to create a large print from a low-resolution image.

CompactFlash A removable-memory storage medium commonly used by digital cameras. A CompactFlash card measures 43 by 36 by 3.3 mm. The thicker *Type 2* cards are 5.5 mm wide.

compression The process of making image files use less storage space, usually by removing information that our eyes don't detect anyway. The most common form of image compression is *JPEG*.

EXIF Pronounced *ex-if*, a standard file format used by virtually all of today's digital cameras. EXIF files use JPEG

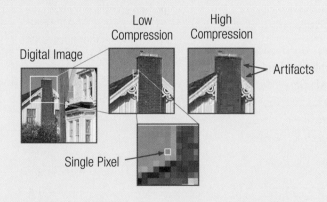

Digital Image

Low Compression

High Compression

Artifacts

Single Pixel

compression but also contain details about each image: the date and time it was taken, its resolution, the type of camera used, the exposure settings, and more. iPhoto retrieves and stores EXIF information when you import images. EXIF stands for *Exchangeable Image File*.

JPEG Pronounced *jay-peg*, the most common format for storing digital camera images. JPEG is a *lossy* compression

format: it shrinks files by discarding information that we can't perceive anyway. There are varying degrees of JPEG compression; many imaging programs enable you to specify how heavily JPEG images are compressed. Note that a heavily compressed JPEG image can contain *artifacts*. JPEG stands for *Joint Photographic Experts Group*.

megapixel One million pixels.

pixel Short for *picture element*, the smallest building block of an image. The number of pixels that a camera or scanner captures determines the *resolution* of the image.

raw An image containing the data captured by the camera's light sensor, with no additional in-camera image processing applied (see page 72).

resolution **1.** The size of an image, expressed in pixels. For example, an image whose resolution is 640 by 480 contains 480 vertical rows of pixels, each containing 640 pixels from left to right. **2.** A measure of the capabilities of a digital camera or scanner.

SmartMedia A commonly used design for removable-memory storage cards.

Importing Photos from a Camera

The first step in assembling a digital photo library is to import photos into iPhoto. There are several ways to import photos, but the most common method is to connect your camera to your Mac and transfer the photos using a USB cable. iPhoto can directly import photos from the vast majority of digital cameras.

iPhoto gives you plenty of control over the importing process. You can import every shot in the camera, or you can be selective and import only some. iPhoto stores your photos in the iPhoto Library, located inside your Pictures folder (see page 15).

iPhoto can also import the movie clips that most cameras are capable of taking. If you shot some movie clips along with your photos, iPhoto imports them, too.

You take photos of the events in your life: vacations, parties, fender benders on the freeway. When you import a set of photos, iPhoto stores them as an event. You can (and should) type a name and description of an event's photos before importing them. Think of it as the digital equivalent of writing notes on an envelope of prints.

You can manage events—split one event into many, merge multiple events into one, and more—using techniques described on page 20. But that can wait—let's get those shots into your Mac, shall we?

Step 1. Connect your camera to one of your Mac's USB ports (the port on the keyboard is particularly convenient if you have a wired keyboard) and turn the camera on. When iPhoto recognizes your camera, it displays the Import pane.

Tip: If your camera has a battery-saving sleep mode, adjust it so that the camera won't drift into slumber while your photos are still importing.

Step 2. In the event name box, type a name that best describes this set of photos. You can also type a brief description if you like.

iPhoto will often display your camera's make and model here.

A thumbnail version of each photo in the camera appears here.

Step 3. Click Import. (To import only some of the shots, see the opposite page.)

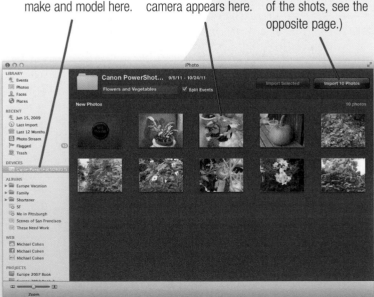

Tips for Importing Photos

Importing Only Some Shots

As you look over the thumbnails in the Import pane, you see some shots that you just know you aren't going to want. So why waste time importing them to begin with? You can be selective and import only those shots you want.

Step 1. To select the photos you want to import, press and hold the ⌘ key while clicking each photo. (For more ways to select photos, see page 43.)

Step 2. To import the photos you've selected, click Import Selected.

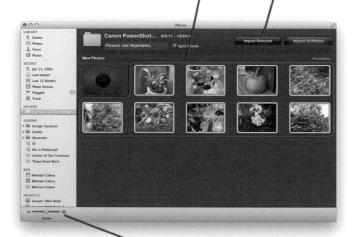

Remember to use the slider to make the thumbnails bigger or smaller as needed. Making them bigger can help you decide between two similar shots, while making them smaller can simplify selecting a large number of thumbnails.

To Delete or Not?

When iPhoto finishes importing, it displays a message asking if you'd like to keep or delete the original photos from the camera.

I recommend clicking Keep Originals. It's best to erase your memory card using your camera's controls. Specifically, use your camera's "format" command, not its "delete all" function.

What's the difference? Formatting the card not only deletes photos, it creates a brand-new directory—that digital table of contents that's so critical to any storage device. When you simply "delete all," the camera wipes the shots, but doesn't create a fresh directory. This increases the odds that little glitches of fate could cause directory corruption that leads to lost photos.

So click Keep Originals, then use your camera's menu controls to reformat the card.

Eject the Camera

Some cameras display an icon on your Finder desktop. If your camera does, be sure to "eject" the icon before disconnecting the camera: click the Eject button next to the camera's name in the iPhoto Devices list. (If you don't see the Eject button, you don't have to perform this step.)

Using Your Mac's Built-In SD Card Slot

Current iMacs and many MacBook Pro models contain a slot for an SD-format memory card. If your camera uses this popular type of memory card, you can import photos by inserting the card in your Mac's card slot.

The steps are identical to those described in "Using a Media Reader," on page 14.

Importing Photos with iCloud's Photo Stream

With Apple's new iCloud service, introduced in the fall of 2011, getting photos from a camera into iPhoto has become an almost trivial matter—that is, if the camera is an iPhone, iPad, or iPod touch. Forget about cables and memory cards to connect your devices to iPhoto: with iCloud's Photo Stream feature, it's all up in the air. And that's a *good* thing.

Your Photo Stream stores up to 1000 of your most recent photos. Snap a photo at the park, and it goes to your Photo Stream, and then flows back down from the cloud and into your iPhoto library.

There's a bit more to it than that, but as the following pages describe, your Photo Stream is the easiest, most automatic way to combine iPhoto and your iOS mobile devices.

Getting to Know the iCloud

iCloud is Apple's replacement for its MobileMe service (see "Whither MobileMe Galleries?" on the next page), and it provides both backup storage for iOS devices and data exchange between iOS devices and personal computers. iCloud is free, and you get 5 GB of backup storage, plus storage for as many as 1000 photos at any given time on Apple's servers. (You can upgrade to more storage for a price.) The photos stored by iCloud exist in the part of the iCloud service called the *Photo Stream.*

Signing Up for iCloud

To sign up for iCloud, you need a Mac running Mac OS X 10.7.2 "Lion" (or later) and an Apple ID—and if you don't have the latter, or even know what an Apple ID is, you can find out about it, and create one, right from the iCloud System Preferences pane in Lion.

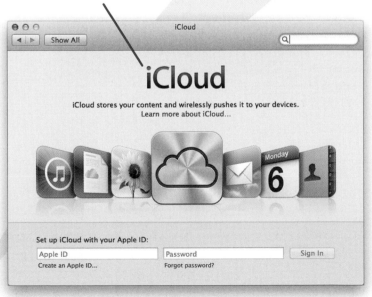

Once you sign up for iCloud, turn on the Photo Stream feature in the iCloud System Preferences pane.

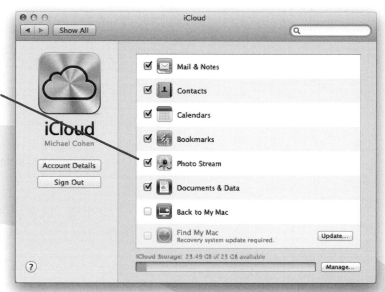

Setting Up Your iOS Device

To use iCloud and its Photo Stream with an iOS device, the device must be running iOS 5 or later. Not to worry: if you get a new iOS device these days, its initial setup process walks you through setting up an iCloud account; if you upgrade an existing iOS device to iOS 5, you'll be prompted to set up an iCloud account as well. With iOS 5 and Lion, in fact, it's almost impossible to avoid the "sign up for iCloud" prompts.

On your iOS device, turn on Photo Stream in the iCloud portion of the Settings app. There are no special options or features you have to worry about: activating Photo Stream is just a simple switch that you set to "On."

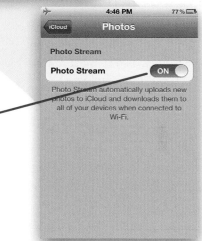

Whither MobileMe Galleries?

Apple has announced that MobileMe galleries will be shut down as of June 30, 2012. If you have used these galleries in the past, you will have to find a new place to post your online photo galleries (iPhoto currently includes Flickr and Facebook sharing—see pages 94 through 101). Photo Stream, unlike Mobile Me galleries, is not designed for public display of your photos. However, you can still use MobileMe before the shut-down date, which explains why you'll see pictures in this book that show MobileMe galleries. Consider these vestiges part of MobileMe's farewell tour.

How Photo Stream Works

How Photo Stream Works on an iOS Device

On an iOS device with a camera, such as the iPhone 4S with its sophisticated 8 megapixel shooter, you don't need to do anything to use Photo Stream: every time you take a picture, iOS 5 puts that picture into the Photo Stream. That's it. Simple.

Of course, there are limits to this simplicity: your pictures aren't actually uploaded to Apple's iCloud servers until your device is on a Wi-Fi network that's connected to the Internet.

And the Photo Stream only holds 1000 pictures at most at one time,

and only pictures taken within the last 30 days. So if you take more than 1000 pictures in a month, the 1001st picture replaces the first picture in the stream even if that picture is only a couple of weeks old. And regardless of how many pictures you take, the Photo Stream drops pictures more than 30 days old.

Don't panic, though: any pictures you take on your device are still stored in your Camera Roll, so, if necessary, you can always import them into iPhoto the old-fashioned way by connecting your device to your Mac and importing them just like you would with any other camera (see page 6).

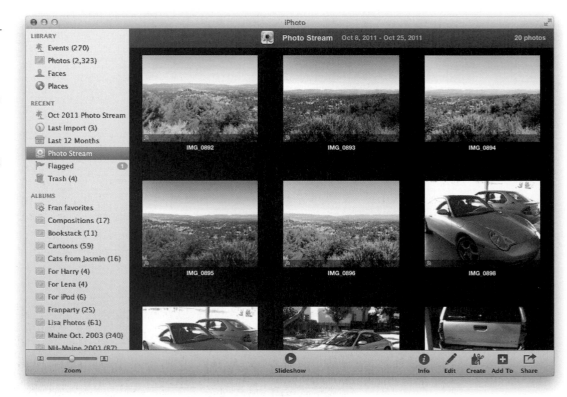

How Photo Stream Works in iPhoto

In the latest version of iPhoto, a Photo Stream item appears under the Recent heading in the sidebar. That's what you click to see the photos that iPhoto automatically downloads from the iCloud Photo Stream.

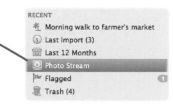

Enabling photo stream. However, you won't see anything until you turn Photo Stream on in iPhoto's preferences: choose iPhoto > Preferences and then click Photo Stream in the preference window's toolbar. Then click Enable Photo Stream.

iWhen you do, Photo activates the two options below the Enable Photo Stream option.

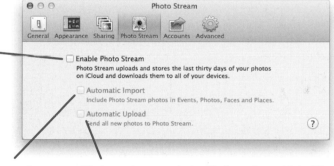

iPhoto creates a new event each month and imports new photos from the stream into that event (see page 18). This way, your iPhoto library always contains your mobile photos—and neatly organized by month, no less.

iPhoto copies any photos that you import into iPhoto from another source to your Photo Stream, so they'll be available on your iOS devices or other Macs that use iCloud. This way, if you drag some photos into iPhoto or download them from Facebook or Flickr, iPhoto will throw them into your Photo Stream so you can view them on your mobile device, too.

After the Import

What happens after iPhoto imports a set of photos? That's up to you. Admire your shots. Start filing and organizing them. Email a few favorites to a friend.

If you're like me, you'll want to check out your shots right away. A couple of clicks gives you a full-screen slide show, complete with music—perfect when you have a circle of eager friends and family watching over your shoulder. Or be selective: display thumbnails of your new photos, then take a close-up look at the best of the bunch.

Some housekeeping may await, too. Delete the shots you don't want. Rotate vertically oriented shots, if necessary. As you tidy up, you'll probably start getting ideas for sharing the photos. Email, prints, books, calendars, cards, DVDs, Facebook, Flickr, YouTube: if you like to share images, this is a great time to be alive.

And along the way, you'll want to celebrate your inner librarian. Organize your photo library with events, titles, captions, keywords, and albums. Trust me: you'll accumulate thousands of photos in no time. A few simple steps will make them easier to find.

But filing can wait. We have some fresh photos to explore.

Viewing Your Shots

Start by clicking the Last Import item in the Library area. This is the fastest way to access the most recent set of shots.

Selective viewing. Adjust the size of the photo thumbnails to your liking: jump down to the lower-left corner and use the Zoom slider.

To magnify a photo so that it fills the iPhoto window, double-click its thumbnail, or select the photo and press the spacebar. **Tip:** Maximize your viewing area: choose Window > Zoom or click the green zoom button in the upper-left corner.

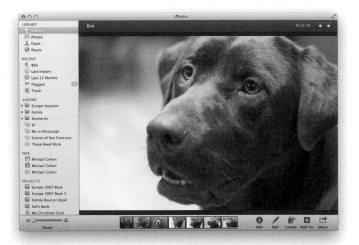

To return to thumbnails, double-click the magnified photo or press the spacebar.

Full-screen variation. To fill the entire screen with a photo, click . To return to the thumbnails, press Esc. (For more about full-screen view, see page 68.)

Tip: To move to the next or previous photo in either magnified view, press your keyboard's right- or left-arrow key. To move to any photo in the set, click its thumbnail in the thumbnail strip below the magnified photo.

Instant slide show. To screen your photos with more style, display a slide show. Click the Slideshow button, then click the Play button in the settings pane that appears next. To learn all about slide shows, see pages 78–89.

Notes and Tips

Rotate Verticals

Some cameras automatically rotate photos taken in vertical orientation. If yours doesn't, the job is yours. Select the photo or photos and then choose

Photos > Rotate Clockwise or Photos > Rotate Counterclockwise.

Delete the Dregs

See a photo that you know you don't want to keep? Trash it. To delete a photo, select it (click it once), then press the Delete key. You can also delete a photo by dragging it to the Trash on the left side of the iPhoto window.

- When you put a photo in the Trash, iPhoto doesn't actually erase the photo from your hard drive; that doesn't happen until you choose Empty iPhoto Trash from the iPhoto menu. If you change your mind

about deleting a photo, click the Trash item in the library list, select the photo you want to keep, and choose Photos > Restore to Photo Library (keyboard shortcut: ⌘-Delete.)

Playing Movies

If your last import included a movie clip, you can play it by double-clicking its thumbnail. iPhoto displays the movie in the iPhoto window along with a control panel that you can use to play, pause, and skip around the movie.

Customizing iPhoto's Appearance

The Preferences dialog box is the gateway to many iPhoto settings, which we'll explore as we go along. But you might want to begin by exploring the options in the Appearance pane—they let you tweak how iPhoto looks.

Choose iPhoto > Preferences, then click Appearance.

Want to see your thumbnail photos against a dark gray background? Drag the Background slider to the left.

With the Photo options, you can turn off the shadow effect

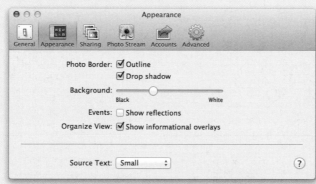

that iPhoto puts behind each photo, and display a thin border around each photo.

With the Events option, you can show or hide the reflection effect that iPhoto puts beneath

each Event thumbnail in Events view (see page 18).

If you'd prefer larger text in the Library area of the iPhoto window, choose Large from the Source Text pop-up menu.

Window customizing. You can adjust the width of the Library area of the iPhoto window. Position the mouse pointer over the vertical line that separates the Library area from the rest of the window. It changes into a double-headed arrow: ⊹. Drag left and right to adjust the width. A thinner Library area gives you more room for photo thumbnails, as well as a larger canvas for magnified views.

More Ways to Import Photos

Most people import photos directly from a camera using the technique I described on the previous pages. But you have more than one way to get photos into iPhoto.

A media reader is a great way to import photos from a camera's memory card. In fact, if you have a relatively recent iMac or MacBook, your Mac may already have an SD card slot built-in. In that case, if your camera uses an SD or SDXC memory card (many do), you can insert the card into it to transfer photos. (Apple explains the card slot in the support article at support.apple.com/kb/HT3553.)

If your Mac doesn't have such a slot, plug the reader into your Mac, then insert the memory card into the reader. Because you aren't using your camera to transfer photos, its battery charge will last longer.

If you need to get a reader, be sure to get one that supports the type of memory cards your camera uses. Or get a multi-format reader that supports several types of memory cards.

You can also import images by dragging their icons into the iPhoto window. If you've scanned a batch of images, you can use this technique to bring them into iPhoto. You can also use this technique to save photos that people email to you or that you find on Web sites.

Using a Media Reader

Here's the photo-importing technique I use most often.

Step 1. If you have an external media reader, connect it to your Mac.

Step 2. Be sure your camera's power is off, then remove the memory card from the camera and insert it into the reader. iPhoto recognizes the card and displays the Import pane shown on page 6.

Step 3. Type a name and description for the photos you're about to import, then import all or some of the photos, as described on the previous pages.

Step 4. After iPhoto has imported the photos, click the Eject button next to the memory card's name in the Devices list. Finally, remove the memory card from the reader, return the card to your camera, and then erase the card.

Importing from the Finder

To import an entire folder full of images, drag the folder to the Photos item or into the photo area.

iPhoto gives the new event the same name as the folder from which its images came. You can rename the event using the techniques described on page 18.

To import only some images, select their icons and then drag them to the Photos item or into the iPhoto window.

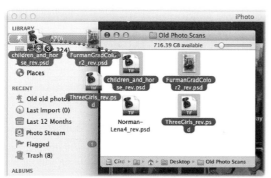

Note: When you import images that are already stored on your hard drive, iPhoto makes duplicate copies of them in your iPhoto library. You can change this using the Preferences command; see "File It Your Way" on page 17.

Importing from Email and Web Pages

A friend has emailed some photos to you, and you want to add them to your iPhoto library. If you're using Mail, the email program included with Mac OS X, simply drag the photos from the email message into the iPhoto window. If the email message contains several photos, Shift-click each one to select them all before dragging. As an alternative to dragging, you can also choose Add to iPhoto from the little Save pop-up menu that appears near the top right of an email message that contains attachments.

If you use Microsoft Entourage or Outlook or some other email program, your job is a bit more difficult. First, save the photos on your Mac's desktop. Next, drag them into the iPhoto window, as shown at left. Finally, delete the photos from your desktop.

To save a photo that's on a Web page, just drag the photo from your Web browser into the iPhoto window. In Apple's Safari browser, you can also Control-click a photo and choose Add Image to iPhoto Library from the shortcut menu.

Importing from Picture CDs

iPhoto can also import images saved on a Kodak Picture CD.

To get photos from a Kodak Picture CD, choose Import to Library from iPhoto's File menu, locate the Picture CD, and then locate and double-click the folder named Pictures. Finally, click the Import button. Or, use the Finder to open the Pictures folder on the CD and then drag images into iPhoto's window.

Photo CD. Kodak previously used an older format called Photo CD that you aren't likely to see too often. You can import the images from these discs by putting the disc in your optical drive and then choosing File > Import to Library; in the window that appears, select the Photo CD and click Import.

Where iPhoto Stores Your Photos

When you import photos, iPhoto stores them in the iPhoto Library, located inside the Pictures folder. (If you like, you can store your iPhoto Library elsewhere, such as on an external hard drive. For details, see page 137.)

Get in the habit of frequently backing up your iPhoto Library to avoid losing your images to a hardware or software problem. You can use iPhoto's disc-burning features to back up photos (page 134), or you can copy your iPhoto Library to a different hard drive. For advice on backing up your photos, see page 137.

For more details on the iPhoto Library, see page 140.

Importing Tips

iPhoto gives you plenty of control over the importing process. Do you want iPhoto to automatically split up the photos into numerous events? If so, what time interval do you want to use?

If you're adding photos by dragging them from folders on your hard drive, where do you want iPhoto to store the photos?

If questions like these burn in your brain, your fire extinguisher has just arrived. Otherwise, feel free to skip on. You can always return here when the embers begin to glow.

Skipping Shots You've Already Imported

You wisely took my advice and told iPhoto to not delete photos from your camera after an import (see page 7). But you forgot to erase the card before shooting another two-dozen shots.

No problem. When you connect your camera and switch to iPhoto's Import pane, iPhoto separates those photos you've already imported from those you haven't and won't import those unless you specifically select them.

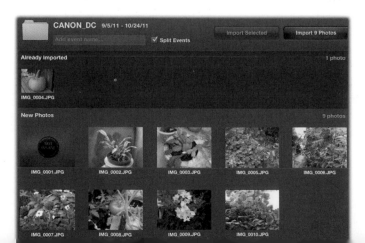

Dealing with Duplicates

Even if you try to import a photo that already exists in your library, iPhoto asks if you really want to import the duplicate.

To have iPhoto apply your choice to all duplicates it finds during this import session, click Apply to all duplicates.

To cancel the import session, click Cancel.

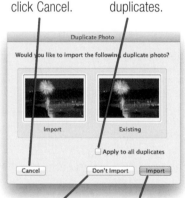

To not import the duplicate, click Don't Import.

To import the duplicate displayed, click Import.

Adjusting Event Settings

As I mentioned on page 6, iPhoto stores imported shots as events. When you import photos from a camera, iPhoto automatically splits them into events (unless you uncheck the Split Events box in the Import pane).

Normally, iPhoto considers one day's worth of photos to represent an event. For example, if you import some shots taken over a weekend, you'll have two events: Saturday's photos and Sunday's.

Using the Preferences command, you can change the interval of time iPhoto uses when splitting photos into events. Choose iPhoto > Preferences, then click General. The Autosplit Events pop-up offers you three additional choices.

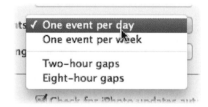

One event per week. iPhoto creates a new event for each seven-day period. Take a two-week vacation, import all your shots, and you'll have two events.

If you don't care to divide your time into small chunks, this is a reasonable option—although if you take as many

shots as I do, you may end up with events containing a cumbersomely large number of photos.

Two-hour gaps. iPhoto creates a new event every two hours. Say you do a day's worth of shooting: a sunrise hike at 6:00 a.m., a brunch with friends at 10:00 a.m., and a party at night. Import the shots, and iPhoto will create three events.

When you shoot a lot of shots throughout a day, this option can help corral them into manageable (and related) chunks. Surviving the busy day is your problem.

Eight-hour gaps. iPhoto creates a new event every eight hours. In the busy-day example above, you'd end up with two events: the first containing the hike and brunch photos, and the second containing the party pix.

Eventful advice. Before you import a set of photos, think about what kind of time intervals the photos represent, then consider tweaking the interval preference to match.

Or don't bother. You're never locked into the way iPhoto divvies up your life. You can move photos between events in whatever way you like. Pages 20 and 21 have all the details.

Events and Imports from the Finder

When you import photos from the Finder—by dragging their icons into iPhoto, as described on page 14—iPhoto does not split the photos into events. That makes sense when you think about it: if you're importing a dozen scanned images of photos that are decades old, how would iPhoto know how to divvy them up? But you can easily split them yourself, in a number of ways. Once again, see pages 20 and 21 for the details.

File It Your Way

Since the dawn of time—well, since the dawn of version 1.0—iPhoto has always stored images in the iPhoto Library. Generally, that's exactly what you want: when you copy photos from a camera or memory card, you want them stashed safely in your iPhoto Library.

But under some circumstances, iPhoto's "do things my way" approach to organization can work against you. When you add photos that are already stored on your hard drive—for example, images that you've scanned and saved—iPhoto makes additional copies in the iPhoto Library.

After adding photos to your Library that are already on your hard drive, you might want to delete the originals. That isn't

exactly a sweat-breaking chore, but it does take time. And you might prefer to stick with your existing filing system.

You have the option not to copy image files to the iPhoto Library. If you have a large library of meticulously filed scanned images on your hard drive, you can take advantage of this option. You won't have duplicate photos to delete, and you won't have to change the filing system you've developed for your scanned images.

To activate this option, choose iPhoto > Preferences, click the Advanced button, and then uncheck the box labeled Copy Items to the iPhoto Library.

From now on, when you add items from your hard drive to your iPhoto library, iPhoto simply creates aliases for each item. (In Mac OS parlance, an alias is a small file that simply points to an existing file.) If you edit an image, iPhoto stores the edited version in your iPhoto Library.

And by the way, unchecking this option does not change how iPhoto stores photos that you're importing from a camera or media reader. Photos that you import from a location other than a hard drive are always stored in your iPhoto Library.

Browsing Your Photo Library

Unlike any shoebox, iPhoto gives you several ways to browse and explore your photo library. Use Events view to get an at-a-glance look at your library. Forget which photos are in an event? Move your mouse pointer across the event thumbnail, and its photos flash before your eyes.

Events view is the most convenient way to work with your photo library, and chances are it's the view you'll use most of the time. But there's another way to see your shots. Click the Photos item in the Library list, and iPhoto displays your events in a different format—one that you may find useful for some browsing and photo-management tasks.

When you scroll in the Photos view, iPhoto pins a bar at the top of the viewing pane that shows the date and title of the event you're currently viewing.

Knowing the basics of photo browsing is important—the faster you can get around in your photo library, the greater the chances that you'll explore and enjoy your photos. And once you're familiar with those basics, you may want to investigate the ways iPhoto lets you organize and explore your photos by faces and places.

Here's an overview of the ways iPhoto lets you browse.

Basic Event Techniques

Here are the basic techniques you'll use when working with events.

Skimming thumbnails. Pass your mouse pointer over the event thumbnail without clicking.

Changing an event's name. Click the event's name, then type a new name and press Return.

Accessing an event's photos. Double-click the event thumbnail. Or select the event (click it once) and press the Return key. To return to Events view, click the All Events button (All Events) above the thumbnails.

Tips: Want to browse using just the keyboard? First, be sure the mouse pointer isn't over an event. Then, use the arrow keys to select an event. Press Return to see its thumbnails.

When you're viewing an event's photos, you can jump to the previous or next event by clicking the arrows in the upper-right corner of the iPhoto window.

Setting the key photo. Each event is represented by one photo, called the key photo or the poster photo. You can change the key photo to one that best represents the event. Skim across the event, and when you see the photo that you want to be the new key photo, press the spacebar. You can also Control-click the photo and choose Make Key Photo from the shortcut menu.

Displaying More Than One Event

Sometimes, you need to view the photos of more than one event at once. Maybe you're organizing some recent imports and you want to work on multiple events at the same time—to move some photos from one event to another, for example.

To open more than one event, select each event (click an event to select it and then Shift-click other events to select them as well), then double-click one of the selected events. iPhoto opens each selected event.

To return to Events view, click All Events or press the Esc key.

Another Way to Look: Photos View

The Events view is so efficient and versatile that you'll probably spend most of your time there. But there's another option: Photos view. To use it, click the Photos item in the Library area.

The Photos view can be handy for moving photos between events and for combining and splitting events, though as the following pages describe, you can do all of these tasks in Events view, too.

To open an event, click its triangle. **Tip:** To expand every event in your library, press the Option key while clicking any closed event's triangle. Conversely, to close every event, press Option while clicking any open event's triangle.

To rename an event in this view, click the title, then type the new name.

Tips for Working with Events

Anxious to start having fun with your photos? Go ahead and skip to page 24, where you can learn about iPhoto's faces and places features; or to page 42, where you can learn about creating photo albums and much more.

Eventually, you'll want to learn about the power tools that iPhoto provides for managing photos and events. These maneuvers can help you organize your iPhoto Library and make it easier to corral photos prior to sharing them.

Hiding Photos

A lot of photos fall into that middle ground between bad and beautiful: not awful enough to trash, not good enough to look at all the time. iPhoto lets you hide those mediocre shots to tidy up an event, but bring them back whenever you like.

Hiding photos is also a good strategy when you've taken several nearly identical shots—some portraits, each with a different smile. Pick the best, hide the rest.

To hide a photo, select it and choose Photos > Hide Photo (or press Command-L). The photo vanishes, and adjacent photos snuggle in to fill the void.

Bringing them back. When you're viewing an event, iPhoto lets you know if any of its photos are hidden.

To see hidden photos, choose View > Hidden Photos. A photo marked as hidden has an X on its corner.

Splitting and Merging

You can split one event into two. Say you have an event containing a hundred shots from an afternoon bike ride and an evening dinner. You may prefer to split the event into two separate, more manageable ones.

To split an event, open it to display its thumbnails. Then, select the photos you want to split off (the dinner shots, for example), and choose Events > Split Event. Finally, name the new event.

Merging events. You can also combine two or more events into one. Maybe you fired off some shots at a party, imported them so everyone could see, then took some more. You want all the party shots to be in one event. Easy: drag one event to the other.

You can also merge more than two events: Shift-click or Command-click each event, then drag them to another event. Or select all the events, then choose Events > Create Event.

Moving Photos Between Events

Sometimes, your life as an event planner requires you to move individual photos between events. Maybe you want to fine-tune the way iPhoto autosplit an event. Or maybe a travel companion emailed you some shots that she took, and you want to add a few of them to your vacation event.

There are moving plans aplenty.

Dragging. Open the events in detail view: select them and double-click one of them (page 19). Now drag thumbnails from one event to another. To give yourself

more dragging room, zoom the iPhoto window (Window > Zoom) and make the thumbnails smaller (drag the Zoom slider).

Cut and paste. Select the photos you want to move, and choose Edit > Cut. Select the event where you want them, then choose Edit > Paste. When dragging seems like too much work—too many photos, too many events—this is an efficient alternative.

Flagging. This can be the most powerful way to move photos, and it's described at right.

A New Event

You can create a new, empty event and then add photos to it. Be sure no events or photos are selected, then choose Events > Create Event.

Flagging Photos

Flagging is like attaching a sticky note to a photo. Trying to decide which shots to add to a book? Flag the best candidates, and you can return to them in a flash.

To flag a photo, select it and choose Photos > Flag Photo or press Command-period. A flag badge appears on the photo's thumbnail.

You can flag multiple photos at once—select them first, then choose Photos > Flag Photo—and you can flag as many shots as you like. To quickly see the shots you've flagged, click the Flagged item in the Recent area of the Library list.

You've flagged some shots. Then what?

Move them to an existing event. After flagging the shots, return to Events view. Select the event where you want to move the photos, then choose Events > Add Flagged Photos to Selected Event. If you need to move some shots that are scattered throughout your library, this is the best way to do it.

Move them to a new event. To move flagged photos into a new event of their own, choose Events > Create Event From Flagged Photos. Keep in mind, though, that iPhoto will move those photos from their original events.

Work with them. Select the Flagged item in the Library area. The flagged shots lurk there, ready to be edited, shared—whatever you like.

Lower the flags. Done working with some flagged photos? Here's the easiest way to unflag them all: click the little number next to the Flagged item in the Library area.

Adding Titles and Captions

iPhoto forces some organization on you by storing each set of imported images as a separate event. Even if you never use iPhoto's other organizational features, you're still ahead of the old shoebox photo-filing system: you will always be able to view your photos in chronological order.

But don't stop there. Take the time to assign *titles* and *descriptions* to your favorite shots. By performing these and other housekeeping tasks, you can make photos easier to find and keep your library well organized.

Titles are names or brief descriptions that you assign to photos and events: Party Photos, Mary at the Beach, and so on. iPhoto can use these titles as captions for its Web photo albums and books. Using the View menu, you can have iPhoto display titles below each thumbnail image. You can also search for photos by typing title or description text in the Search box (page 40).

There's one more benefit to assigning titles to photos: when you're working in other iLife programs (and in many other programs, including Apple's iWork family), you can search for a photo by typing part of its title in the photo media browser's Search box.

Of course, you don't have to type titles and descriptions for every photo in your library. But for the ones you plan to share in some way—or that you'll want to search for later—it's time well spent.

Using the Information Pane

When you want to give photos titles and descriptions, turn to the Information pane. To display the Information pane, click the 🛈 button.

Step 1. Select the photo to which you want to assign a title and/or description.

Step 2. Click in the Title or Description area of the Information pane, then type the title or description.

Keep your titles fairly short.

Think of a description as the text you'd normally write on the back of a photo.

Editing Photo Information Directly

The Information pane is a great place to view and change all kinds of details: a photo's title, its description, and more.

But there's another way to edit photo information, and it's often more convenient than opening the Information pane. Simply click the title beneath a photo's thumbnail, and start typing.

(If you don't see titles beneath your photo thumbnails, choose View > Titles.)

Tip: Type a title, and press ⌘-] to jump directly to the title field of the next photo or ⌘-[to move to the previous photo's title field.

Tips

Check your spelling. Want to check the spelling of your titles and descriptions? Select the text you want to proofread, then choose Edit > Spelling > Check Spelling. Or select the text you want to proofread and press ⌘-;.

Many at once. To change information for many photos at once, select them and choose Photos > Batch Change. If you're like me and are often too lazy to assign titles and descriptions to individual photos, this can be a good compromise: assign a phrase to a set of related photos, and you can search for that phrase later.

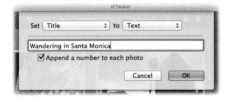

Note: You can also type photo titles and descriptions when specifying location information for a photo (page 30). And you can also assign keywords and ratings by working directly beneath photo thumbnails (page 38).

Changing the Date

Time is important. The date stored along with a photo determines how iPhoto sorts the photo. Accurate dates also simplify searching and organizing your library.

All digital cameras store date and time information along with the image (see the sidebar on page 141). But what if your camera's clock is off? Maybe you forgot to adjust its time zone when you flew to Hawaii.

Or maybe you've scanned some old family photos and you want their dates to reflect when they were *taken*, not scanned. That Aunt Mary photo is from 1960, not 2012.

Time travel is easy in iPhoto. You can edit the date of an event, a selection of images, or just one photo: select the items you want to change and choose Photos > Adjust Date and Time.

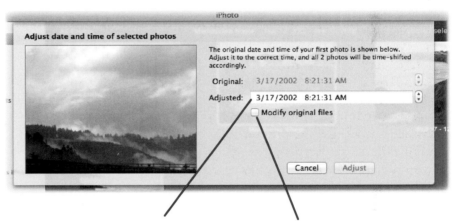

In the Adjusted field, click the first value (such as the month or year) that you want to change, and type it. You can press Tab while working in the Adjusted field to move from one value to the next and Shift-Tab to move to the previous value.

If you check this box, iPhoto records the modified date in the image file itself. (Otherwise, iPhoto simply notes the changed time in its internal database, leaving the original image unchanged.) You might choose this option if you plan to export the image for use in another image-management program, such as Apple's Aperture.

Faces at a Glance

Chances are you take a lot of photos of the people in your life. With the Faces feature you can explore your photo library by face: "Show me all the photos of Suzanne," or "Show me every photo containing both Suzanne and Bethany."

Start by "introducing" iPhoto to someone: select a photo of Suzanne and type her name. iPhoto displays more photos that may contain her. Confirm the ones that include Suzanne, reject the ones that don't. The more photos you confirm, the better iPhoto gets at recognizing Suzanne. When you import new photos of her, iPhoto recognizes them. It's futuristic facial-recognition technology—applied to the people you love.

Once you've built up a collection of faces, you can bring iPhoto's other talents to bear. View a slide show. Make a book. Or just browse your favorite mugs. And unless you tell it to, iPhoto never forgets a face.

Naming a Face

When iPhoto scans your photos for faces, it's simply identifying photos that it thinks contains eyes, noses, and mouths. It's up to you to tell iPhoto who those folks are—a process called *naming a face.*

Step 1. Select a photo containing a face you want to name.

You can select a photo's thumbnail, or double-click the photo to display a larger version.

Step 2. Click the Info button.

Step 3. Hover over an unnamed face, or click the number of unnamed faces under Faces in the Information pane.

The photo appears with a box enclosing each face.

Step 4. Click the *unnamed* text, type the person's name, and then press the Return key. If the photo contains additional unnamed faces, repeat this step to name each face.

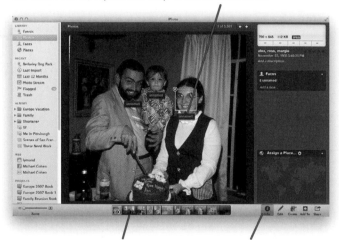

To move to different photos and name the faces they contain, click the thumbnail at the bottom of the window.

Are you all done naming? Click Info to close the Information pane.

Notes and Tips

Name suggestions. As you type a name, iPhoto may display suggestions based on similarly spelled names that you've already provided.

To take one of these suggestions, click it. Or just ignore the suggestion and continue typing a name.

Forget a face. Say you have a group shot containing some faces you don't want to track. To have iPhoto forget a face, as it were, point to the face and then click the X that appears in the box.

More of the Same

You probably have more than one photo of someone you've named. Now it's time to let iPhoto know that. iPhoto helps by suggesting photos that may contain that named person. The more photos you positively identify, the better iPhoto gets at recognizing someone's face.

Step 1. If you've just finished naming a face, click the right-pointing arrow next to the person's name. If you're viewing the corkboard (see below), double-click a tile.

iPhoto displays photos that may contain that person.

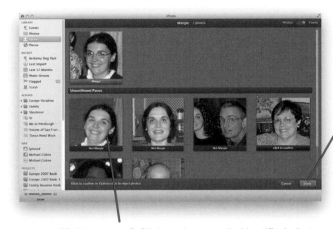

Step 2. Click the Confirm Additional Faces button, then confirm photos as shown here.

Right person? Click each correctly identified photo. **Tip:** To quickly confirm numerous photos, drag a selection box around them.

Wrong person? If iPhoto misidentified a person, click the photo twice (or press Option while clicking the photo). The text *Not [name]* appears below the photo.

Step 3. When you're finished, click Done.

Even more of the same. After you click Done, iPhoto may display additional photos that it suspects contain that person— proof that iPhoto gets better at recognizing people as you confirm photos of them. Repeat the steps to confirm or reject photos.

Tip: If iPhoto misidentified a number of photos, press Option while dragging across the photos to quickly reject them.

Introducing the Corkboard

iPhoto displays your collection of faces on the *corkboard*. To see the corkboard, click the Faces item in the Library list. Each person appears on his or her own *tile*.

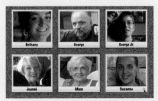

You can work with the face tiles using many of the same techniques that you use when working with events

(page 20). To make the tiles larger or smaller, drag the size slider. To see someone's face flash before your eyes, skim the mouse pointer across his or her tile. (It's fun!) To set a key photo for a tile, skim across the

tile until you see the photo you want, then press the spacebar. To rename a tile, click its name, then start typing.

For more tips, see the following pages.

Working with Faces

Adding a Missing Face

Sometimes, iPhoto isn't able to recognize that a face is a face. This can happen if a face is in profile, if someone's head was tilted significantly, or if the photo was taken in poor or unusually colored light. (To appreciate why iPhoto can miss faces in these circumstances, see page 28.)

The solution: add the face by hand.

Step 1. Click Info.

Step 2. Click Add a Face under Faces in the Information pane.

Here, my sister Jeanné's jaunty head tilt has stumped iPhoto.

Step 4 (optional). Customize the size of the box by dragging its corners.

The box's size isn't critical—it simply determines how that occurrence of the face appears on the corkboard. In general, a "tighter" crop is better.

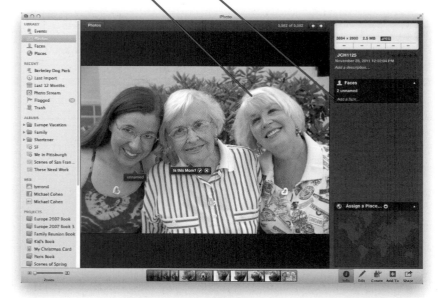

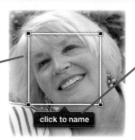

A box appears in the center of the photo.

Step 3. Drag the box so that it encloses the face.

Step 5. Click Click to Name.

Step 6. Type that person's name and press Return.

Notes and Tips

For your convenience only. Adding a missing face won't help iPhoto recognize that person's face in the future. Put another way, iPhoto never considers a manually added face as the "seed" for further recognition. Adding a missing face is simply a way to ensure that a particular photo is included in someone's corkboard tile.

Back-of-the-head shots. You have a romantic shot of a couple walking away from the camera on a country road. In the interest of thorough filing, you want that shot in their respective corkboard tiles— but iPhoto obviously can't recognize the back of someone's head. The solution: add their "faces" manually. That way, this photo will appear in their corkboard tiles.

Group challenges. In group photos, faces tend to be on the small side, and that can cause iPhoto to miss a face, particularly with fairly low-resolution photos. iPhoto just doesn't have enough pixel data to perform facial analysis. Again, the solution is to manually add faces that iPhoto missed.

Working in Face View

When you double-click a person's corkboard tile to view photos of him or her, a set of thumbnails appears—much as it does when you double-click an event. And as with the event view, a row of buttons lets you do things with those thumbnails—edit, hide, and flag photos; display a slide show; create print projects; and share photos online. These buttons are a convenient way to immediately start showcasing a favorite person.

But face view contains some unique elements, too—things you don't see when viewing event thumbnails.

More matches. If you've imported new photos—or if you never did finish confirming every suspected match—you may see more thumbnails below the *Unconfirmed Faces* dividing line described on page 25. (You may have to scroll the iPhoto window to see them.)

Tip: If you'd like to confirm or reject those suspected matches now, you can click the Confirm Additional Faces button.

The Confirm Additional Faces button. As you already know, you can click this button to confirm or reject photos. If you've accidentally confirmed a photo of the wrong person, click Confirm Additional Faces, then click the photo wrongly named so that its label reads *Not Suzanne* (for example).

Face view switch. With the Photo-Faces switch, you can alternate between viewing the full thumbnail or just the person's face. When the switch is set to Photos, the full thumbnail appears. Here's a shot containing my sister:

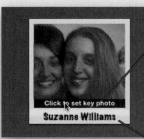

When you set the switch to Faces, each thumbnail shows only the face of the person whose photos you're viewing. Here's the identical shot in face-detail view:

Tip: Face-detail view is a great way to rediscover photos. That cute facial expression someone was wearing in a group shot may have gotten lost in the crowd. By focusing your attention on just that one person, face-detail view lets you see your photos in a new way.

Working with Corkboard Tiles

When you select someone's tile on the corkboard and click the Info button, the Information pane appears.

To view the Information panes for other people, press the arrow keys.

To set the key photo for this person, skim across

the Information pane thumbnails until the photo you want appears, then click the

Click to Set Key Photo button. Or, skim across the corkboard tile and, when the photo you want is visible, Control-click on the tile and choose Set Key Photo from the shortcut menu.

To rename this person, click the name and type. (You can also rename tiles directly on the corkboard; see page 25.)

Optional: You can type the person's full name and email address in the Information pane.

Important: If you plan to share photos of this person on Facebook, be sure to type the full name and email address under which that person is registered on Facebook. For details, see page 97.

Tips for Faces

How Face Recognition Works

You obviously don't have to understand how iPhoto recognizes faces in order to use the Faces feature. Still, you might be curious. What's more, understanding how iPhoto recognizes faces can help explain why it sometimes fails to do so, as described on the previous pages.

C. Tilt! If your subject's head is tilted more than approximately 30 degrees in either direction, iPhoto may miss that face.

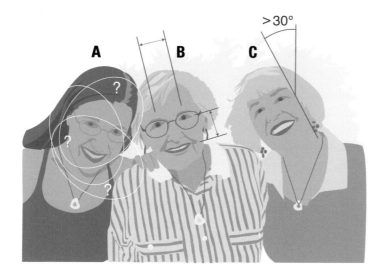

A. Is that a face? iPhoto searches for patterns of light and dark that are common in a face. This is why iPhoto may miss a face that's in profile or poorly lit. iPhoto also checks to see if the area's color is within the range of common skin tones. Photograph someone under a blue neon light, and iPhoto is likely to miss that face.

B. Is it a named face? Once iPhoto determines that it has found a face, it compares the face to other faces you've already named. This process involves assessing characteristics such as the distance between the eyes, the distance between the eyes and mouth, and more.

Improving Recognition

Variety matters. As I've mentioned, the more photos of a specific face that you confirm, the better able iPhoto is to identify additional photos containing that face.

But quantity isn't the only factor; variety is critical, too. Confirming one photo can sometimes unlock the door to iPhoto suddenly recognizing many more photos of that person. This is most likely to happen when that photo depicts the person in a slightly different way—with his or her head tilted or in partial profile, for example.

The value of rejection. When you tell iPhoto that a photo *isn't* of a specific person, you don't help iPhoto identify future photos of that person. Still, rejection has its place: by confirming who *isn't* in a photo, you prevent the misidentified photo from showing up in future naming sessions for that person.

The cream rises. Just as Google puts the most relevant search results at the top of the list, iPhoto puts the most likely facial matches at the top of its confirmation view. Photos that match more loosely appear farther down.

Gene recognition. iPhoto sometimes mistakes family members for one another. (It often confuses my mom and my aunt—something I once did when I was a toddler.) It's no wonder: family members often look alike, and as the illustration at left shows, part of iPhoto's facial recognition technology involves measuring features that make one face different from another.

There's no tip here, except maybe a tip of the hat to the beauty of genetics. And a reminder that the more photos you confirm, the better iPhoto gets at telling everyone apart.

Another Way to Confirm

As you work with faces, you may occasionally see an inquiry like this one:

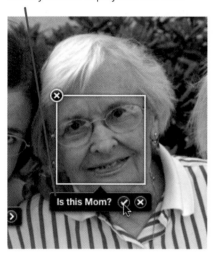

iPhoto displays this query when you're looking at a photo containing a face that iPhoto thinks it recognizes, but that you haven't yet confirmed.

To confirm iPhoto's suspicions, click the check mark. If iPhoto misidentified the person, click the X.

This process is simply a convenient alternative to switching into the Confirm Additional Faces mode and confirming or rejecting the photo there. It's iPhoto's way of saying, "Hey, as long as you're here, maybe you want to confirm this person's identity."

Forgetting a Face

The time may come when you want to remove someone's tile from your corkboard. (And that, I assure you, is the most interesting euphemism for "break up" that you'll read in this book.) It's easy: select the person's tile, then press ⌘-Delete. iPhoto asks if you really want to delete that person from your list of faces. To confirm the deed, click Delete Face.

Besides a parting of the ways, there are other reasons why you might delete a face. Maybe you accidentally confirmed a bunch of misidentified photos, and you want to start over. And incidentally, you can delete multiple face tiles in one fell swoop: Shift-click each one or enclose them in a selection rectangle, then press ⌘-Delete.

Note: Deleting a face does *not* delete the photos of that person from your iPhoto library.

No Pets, Please

It was a common question when face recognition first debuted in iPhoto: does the Faces feature recognize pets? The answer is no. And armed with the background into how facial recognition works, you can understand why: a cat's color is not usually going to be a skin tone, nor will your poodle's facial geometry match that of a human face—even if your friends claim you two look alike.

iPhoto may occasionally recognize an animal's face, but consider those incidents happy accidents. And keep in mind that if you want to create a corkboard tile for your critters, you can always manually add their faces, as described on page 26.

Faces and Smart Albums

The smart albums feature lets you quickly search for and view photos that meet very specific criteria. And it works beautifully with faces; for details, see page 48.

Beyond the Corkboard

As I describe later in this chapter, iPhoto's facial smarts extend beyond the Faces feature. When positioning photos in slide shows, iPhoto looks for faces and tries to position a photo so that faces aren't cut off. Similarly, in iPhoto's edit view, the red-eye removal feature as well as some color controls are smart enough to detect faces.

The bottom line: whether you're organizing, enhancing, or sharing photos, iPhoto knows a face when it sees one.

Places at a Glance

You and your camera, you go places. When you return home, you tell iPhoto where you've been.

That's the idea behind iPhoto's Places feature, which lets you associate geographical locations with your photos—and then explore your library using maps and more.

Some digital cameras include or accept optional Global Positioning System (GPS) receivers that record your location as you shoot, a process called *geotagging*. Apple's iPhone 3G, 3GS, 4, and 4S can also go along for the ride, thanks to their built-in GPS and camera, as can the iPad 2 and iPod touch (4th generation or later).

A camera with GPS is a fine traveling companion, but is by no means essential. You can use iPhoto to geotag your shots— doing so takes just a few clicks, and you can be more precise than GPS allows.

What does geotagging get you? For starters, the ability to explore your library by place. View a Google map directly within iPhoto, with little pushpins indicating where you've snapped the shutter. Browse and search for photos based on their location. Add beautiful travel maps to your iPhoto book projects.

You don't have to geotag photos, but doing so does give you another way to explore and organize your library. And for those shots where locations are particularly memorable and relevant—a vacation, a honeymoon, an amusement park outing, a family barbecue in the backyard— geotagging adds something important to your photos: a sense of place.

Getting Around

When your library contains geotagged photos, you can explore them in a few different ways.

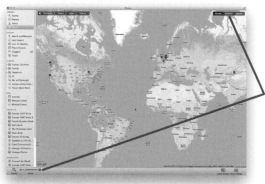

Read the map. Use a built-in Google map to see where you've been (page 35). Zoom in, pan around, even switch to a satellite view.

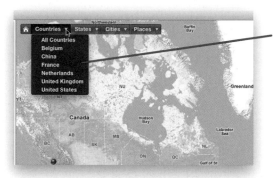

Browse. Use the location browser to explore. iPhoto even understands how places relate to each other—showing, for example, cities within states within countries (page 34).

Search. Type a place name and immediately view shots taken there (page 40). You can also create smart albums that collect photos taken in specific locations (page 49).

Assigning a Location to an Event

You can add a location to an entire event or to individual photos. The following pages contain full driving directions and some sightseeing tips. Here's the fastest way to add the same location to all the photos in an event.

Step 1. Select the event, then click the Info button at the bottom-right of the iPhoto window.

The Information pane opens with the selected event thumbnail displayed at the top.

Step 2. Type a location in the *Assign a Place* field.

iPhoto is aware of thousands of places (see the sidebar, below). As you type a location, a list of places appears. You can click one to choose it, or just keep typing.

You can customize a place or add an entirely new one (page 32).

Step 3. Press the Return key.

The Information pane displays a map of the location.

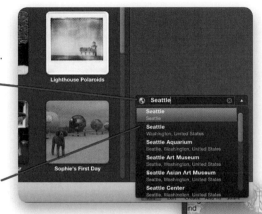

Notes and Tips

All or one? If you took all an event's photos in one place, it's fine to assign one location to all the photos in the event. But you can also assign a location to individual photos. The steps are almost identical to those at left. Select the photo, click the Info button, then specify the location.

Several at a time. To specify the same location for a few photos, select the photos (see page 43 for selection tips), then click the Info button for any one of them. In the Information pane, click the *Assign a Place* text field, then specify the location.

Beyond Cities: Points of Interest

iPhoto's built-in database of locations includes not only cities and towns, but also popular points of interest: the Grand Canyon, the Space Needle in Seattle, Wrigley Field in Chicago, the Eiffel Tower in Paris, even the Pyramid of Cheops in Egypt or, as here, the San Francisco Ferry Building.

If you took photos at a famous landmark, try typing the landmark's name when specifying

the location. iPhoto may know about it.

If iPhoto doesn't know about that landmark, add it as described on the following pages. Because iPhoto "understands" geography

and the hierarchical relationship between places, the photo will still be searchable by city and other criteria. For example, iPhoto knows that Wrigley Field is in Chicago, in Illinois, in the United States.

Tip: When using points of interest as locations, keep in mind that you're telling iPhoto where the photo was taken, not what the photo contains. If you took a photo of the Space Needle from

your Seattle hotel room window, don't specify Space Needle as that photo's location. Conversely, if you took a close-up of your kids while at the Space Needle, specify Space Needle—even if the Needle doesn't appear in the photo at all.

Remember: when it comes to places, it's all about where you were when you snapped the shutter—not about what appears in the photo.

Adding a New Place

iPhoto knows about a lot of places, but it doesn't know about *every* place. New Hampshire's beautiful Mount Monadnock isn't in its database. Nor is PNC Park, home of the Pittsburgh Pirates. Nor is your back yard.

Now, you could simply place that mountain photo in Jaffrey, New Hampshire. Or that Pirates photo in Pittsburgh. Or those back-yard barbecue shots in Your Town, USA.

But you can also be specific and add the place to iPhoto's database. Adding a place takes just a few steps, and if you enjoy playing with Google maps as much as I do, you'll find it fun. But most important, you'll place your photos with precision.

Step 1. Select an event or one or more photos, then click the Info button to display the Information pane.

Step 2. Click within the Assign a Place field, and then type the name of a place that's near the place you want to add. For example, New Hampshire's Mount Monadnock is partly located in the town of Jaffrey.

A small map appears, with a *marker pin* centered on the place name.

Searching Tips

You can search for towns (*Albion*), street addresses (*52 Grove St., Peterborough, NH*), landmarks (*Mount Monadnock*), ZIP codes (*94133*). You can also search for business names: *North Beach Pizza*. And you can mix and match: *701 Washington Rd., 15228* or *Joe's Diner, St. Louis*. You can also search for latitude and longitude (make certain you enter the latitude first).

Because iPhoto uses Google maps, the best place to learn about searching options is Google. Go to www.google.com/maps, then click the Help link.

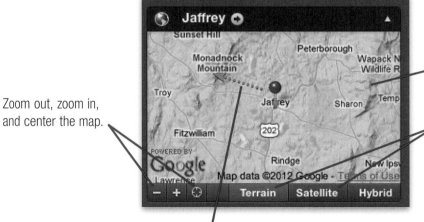

Zoom out, zoom in, and center the map.

To pan the map, drag within it.

To switch between terrain and/or satellite views, click the buttons.

Step 3. Drag the pin to the specific location that you want.

Tips for Adding Places

Fine-tuning a location. When iPhoto locates a place, the location's pin may not be where you were when you snapped the shutter. Say you spent an afternoon on the beach at San Francisco's Crissy Field. You want to geotag some photos you took in the shadow of the Golden Gate Bridge, but the pin that iPhoto dropped is located at the Crissy Field main entrance—not where you were standing.

The solution: drag the pin to the correct spot.

Google places Crissy Field here, at its main entrance. To fine-tune the location, drag the pin to the desired spot.

Renaming a location. When you create a custom location using the instructions on the opposite page, the location retains the name of the original place that you searched—for example, Jaffrey, New Hampshire instead of Mount Monadock.

Here's how to fix that so that the iPhoto place name more accurately reflects the real-world place name.

Step 1. In the Information pane, click the marker pin that you dragged to the exact location.

The pin turns yellow and a text box appears above it.

Step 2. Type the name that you want, and then click the check mark or press Return.

The map now reflects the name of the place.

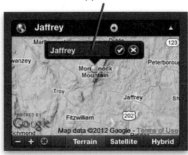

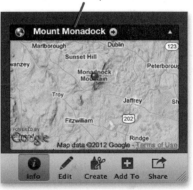

Reviewing this crazy place. Creating a custom place is really a two-phase job. The first phase is described on the opposite page: search for a place that's nearby, then drag the marker pin to the specific place that you want. The second phase is to give that new place a more meaningful name.

And incidentally, because iPhoto understands how places relate to each other, you can still search for the photo using related criteria. In the example on these pages, iPhoto knows that Mount Monadnock is in Jaffrey, NH, in the United States.

For a few ideas of ways to use personalized places, see "A Cookbook of Custom Places" on page 37.

Never forgets a place. Once you create a new place, it joins the list of thousands of places iPhoto already knows about. That means you can assign that place to new photos and events: select one or more photos, then start typing the place name (page 31).

Exploring and Browsing Places

The real payoff to specifying locations for your photos comes later—when you want to browse and search for photos. By clicking the Places item in the Library list, you can explore your world in a couple of ways. Use the *map view* to display a Google map that contains marker pins showing where you've taken photos. Zoom in to see a street-by-street view, or zoom out for the big picture. Want to see the photos that you took at a particular place? Click its pin.

You can also browse your geotagged photos by category. Step back for the big picture: "Show me all the photos I've taken in California." Or drill down to a specific area: "Let's see the photos I've taken in San Francisco's North Beach neighborhood."

Browsing is an excellent way to appreciate iPhoto's "smarts" when it comes to geography. The pop-up menus at the top-left of the map show how places relate to each other: for example, the North Beach neighborhood is in San Francisco, which is in California, which is in the United States.

As I described on page 30, you can also search for places using the Search box. And as I'll show on page 48, you can also use smart albums to search for places in some powerful ways.

Here's a close-up look at the map and browsing.

Exploring by Browsing

Browsing is a great way to quickly browse the places you've been.

Step 1. In the Library list, click Places, then use the pop-up menus to refine your geographic selection.

Countries Cities and towns

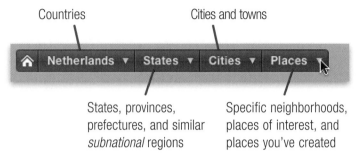

States, provinces, prefectures, and similar *subnational* regions

Specific neighborhoods, places of interest, and places you've created

Step 2. Choose the items in the pop-up menus to focus in on specific locations.

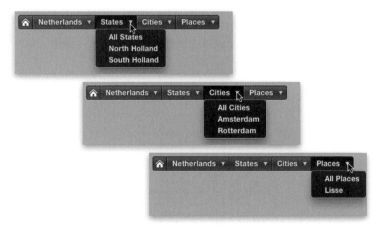

iPhoto displays only those photos taken at the location whose name you clicked.

Notes and Tips

Changing pop-ups. The locations in the pop-up menus change to reflect the country, region, or state you've selected in the pop-up menus to their left. In the example above, selecting Netherlands in the Country pop-up menu causes iPhoto to display only regions in that country where you've taken photos.

Exploring with the Map

Here's how to explore photos using iPhoto's built-in Google map.

Step 1. In the Library list, click Places.

Step 2. Use the controls to navigate the map, switch between terrain and/or satellite views, and view photos.

When you're zoomed out, iPhoto may use just one marker pin to represent locations that are close to each other. To see individual places, zoom in.

Switch between terrain, satellite, or hybrid view.

Point to a marker pin, and iPhoto displays the location or locations that it represents. To see photos taken there, click the arrow next to the place name.

To zoom in and out, drag the Zoom slider. **Shortcuts:** To zoom in on an area, double-click it. To zoom out, press Control and double-click.

Do you view a particular area frequently? Zoom in to display that area, then click Smart Album (see page 49).

View the photos for the places visible in the current map zoom setting. For example, if you're zoomed in on Northern California, clicking Show Photos displays thumbnails of all photos taken there.

Places in the Information Pane

The Information pane—that appears when you select an event and click Info—provides a few location-related niceties.

The map in the pane shows marker pins for each geotagged photo in that event. But here's a detail you may not have noticed: skim over the event's thumbnails at the top of the Information pane, and the marker pin for the currently visible thumbnail highlights in green. It's fun to watch the pins light up as you skim through the thumbnails.

Above the map in the Information pane is an arrow next to the place name. Click this arrow, and iPhoto switches to map view, with the map zoomed to match its counterpart in the Information pane. It's a handy way to jump to map view for further exploration.

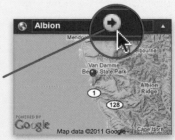

Tips for Places

Managing Your Places

Sometimes you need to clean up your place. And sometimes you need to clean up your Places. Maybe you want to change the name of a place—for example, iPhoto inaccurately calls San Francisco's AT&T Park *At Park*. Or maybe you'd like to refine a place's exact location. Or maybe you need to delete a place you no longer want.

To manage your places, choose Window > Manage My Places. Doing so displays the Manage My Places window, which lists the places you've added.

Want to create a new place? Follow the instructions on page 33 to create a new location. Then, choose Window > Manage My Places and reposition the pin (and, if you wish, the vicinity for the location you just created).

To rename a place, click its name, then type.

To delete a place, click the little minus sign.
Note: Deleting a place doesn't delete photos you took there; it simply removes the geotagging from those photos.

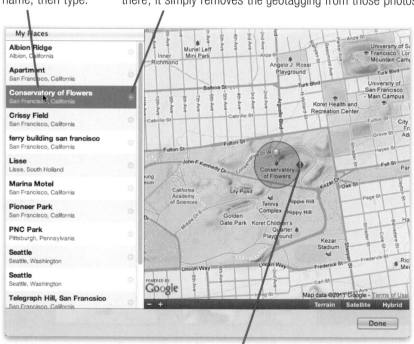

By dragging the blue arrows, you can change a place's *vicinity.* If you take a photo anywhere within the shaded area, iPhoto considers the photo to have been taken at that location.

Map Options: Terrain or Satellite?

When you're viewing a Google map in iPhoto—whether in the Manage My Places dialog or in map view—you can choose between terrain view, satellite view, or a hybrid of both.

Many times, the choice is one of personal preference. Choose terrain if you like viewing maps that look like folding road maps (kids: ask your parents). For an added coolness factor, go satellite.

But there are some circumstances that recommend one view over the other.

Terrain: for addresses. When you want to add or refine a place with a street address, a terrain map is often easier to read.

Satellite: for close-ups. You can zoom in for a much closer look by using satellite view. That's particularly handy when you want to precisely position a marker pin or its region. Here, I've very precisely defined the location: the right-field bleachers at AT&T Park in San Francisco. In terrain view, you can't zoom in to this degree.

Web Sharing: Privacy Matters

When you export a photo from iPhoto—to share it on a personal Web site or your Flickr account, for example—iPhoto does *not* include the location information with the photo. That's to protect your privacy: you might not want just anyone to know exactly where your kids play, for example.

But if you do want to include location information, it's easy: choose iPhoto > Preferences, click Advanced, then check the box labeled *Include location information for published photos.*

Note: To have your geotagged photos show up on your Flickr map, you have another step to perform; see page 100.

A Cookbook of Custom Places

As I've already mentioned, by selecting a pin and then refining its location and vicinity, you can create your own custom places. Here are a few ideas.

Custom Place Ideas	
Place	**Technique**
A camp site	Google-search to find the campground or park. Specify a location and drag the pin to the camp site's location, then adjust the size of its vicinity to encompass the camp site.
Your neighborhood	Google-search to find your address. Specify a location, then drag the pin and resize its vicinity to encompass the area you consider to be "your neighborhood."
Your back yard	Same as above, but resize the pin's vicinity to encompass your back yard.
A favorite restaurant	Google-search the restaurant name or address. Specify a location and drag it to the exact address, then make the vicinity very small.
Your seats in the bleachers	Google-search the ballpark, then specify a location. Switch to satellite view, then zoom in on the map. Position the pin where you were sitting, then make its vicinity small.

The GPS Angle

If your camera has a GPS receiver or you're using a current iPhone, iPod touch, or iPad, you've already arrived: every photo you take contains location information. iPhoto reads this data when you import photos, adding those photos to your map.

At this writing, a few consumer-oriented digital cameras have built-in GPS receivers. Many single-lens reflex (SLR) digital cameras accept optional GPS receivers. Shown here: the oddly named Promote GPS,

which works with many Nikon and Fuji digital SLRs and costs about $150.

If your camera can't accept a GPS add-on, there's ATP's Photo Finder. It takes a clever approach to geotagging. Synchronize your digital camera's built-in clock with the Photo Finder's clock, then go shooting. When you get home,

insert your camera's memory card into the Photo Finder, and it adds locations to each shot.

Should you bother? Before investing in GPS camera gear, try geotagging in iPhoto. It's easy and actually allows for more precision than GPS, which can be inaccurate (and generally doesn't work at all indoors).

Assigning Keywords and Ratings

Chances are that many of your photos fall into specific categories: baby photos, scenic shots, and so on. By creating and assigning *keywords*, you can make related images easier to find.

Keywords are labels useful for categorizing and locating all the photos of a given kind: vacation shots, baby pictures, mug shots, you name it.

iPhoto has several predefined keywords that cover common categories. But you can replace the existing ones to cover the kinds of photos you take, and you can add as many new keywords as you like.

You can assign multiple keywords to a single image. For example, if you have a Beach keyword, a Dog keyword, and a Summer keyword, you might assign all three to a photo of your dog taken at the beach in July.

Keywords are one way to categorize your photos; ratings are another. You can assign a rating of from one to five stars to a photo—rank your favorites for quick searching, or mark the stinkers for future deletion.

As with many iPhoto housekeeping tasks, assigning keywords and ratings is entirely optional. But if you take the time, you can use iPhoto's search and Smart Albums features to quickly locate and collect photos that meet specific criteria.

Creating and Editing Keywords

Step 1. Choose Window > Manage My Keywords (⌘-K).

Step 2. Click the Edit Keywords button.

Step 3. Edit keywords as shown below, then click OK.

Use the checkmark keyword (or not) however you like—to mark some photos for future use, for example.

Creating a new keyword. Click the plus sign, then type the keyword and press Return.

Deleting a keyword. Don't want to use a certain keyword anymore? Select it, then click the minus sign.
Note: The keyword is removed from any photos to which you'd assigned it.

Editing a keyword. Select the keyword, click Rename, then type the new name. Or simply double-click directly on the keyword.

Use certain keywords often? Give them one-key shortcuts (see the opposite page). To create or edit a shortcut, select the keyword and click Shortcut, or simply double-click that keyword's shortcut area.

Tips

Displaying keywords. To have iPhoto display keywords in the Information pane, choose View > Keywords.

Creating a keyword directly. When viewing keywords in the Information pane, you can create a new keyword by simply typing it in the Keywords area. Click anywhere within the Keywords area, then type a keyword and press Return.

Assigning Keywords

You have a few ways to assign keywords.

The Keywords window. Choose Window > Manage My Keywords. Select the photo(s), then click one or more keywords.

The keyboard. If you assigned a keyboard shortcut to the keyword, reap your reward now. With the Manage My Keywords window open, select the photo(s), and tap the shortcut key.

If you have to assign various keywords to a set of photos, combine shortcut keys with the arrow keys. Select a photo, tap a key, tap an arrow key to move to a new photo, tap a key.

In the Keywords box in the Information pane. See the tip on the opposite page.

Keyword Tips

Removing a keyword. To remove a keyword from a photo, select the photo and click the keyword in the Keywords window, or tap the keyword's keyboard shortcut, if you created one. If you're viewing keywords in the Information pane (View > Keywords), you can also simply select the keyword and press the Delete key.

Keywords window tips. Here are a few tips for the Keywords window.

Keywords for which you've created keyboard shortcuts appear in this area, along with their shortcuts.

Just working with keyboard-shortcut keywords? Hide the rest of your keywords.

Want to add a shortcut to an existing keyword? No need to click Edit Keywords: simply drag the keyword into the Quick Group area. Similarly, to remove a shortcut from a keyword, drag the keyword down to the Keywords area.

Art Critic: Rating Your Photos

You can assign a rating of from one to five stars to a photo, and there are a few ways to do it.

The Photos menu. Choose a rating from the My Rating submenu.

The keyboard. Press ⌘ along with 0 (zero) through 5. This shortcut pairs up nicely with the arrow keys: rate a photo, press an arrow key to move to the next photo, and repeat.

The shortcut menu. Control-click a photo and choose a rating from the shortcut.

In one fell swoop. Want to give a bunch of photos the same rating? Select them, then use one of the previous techniques.

With the Information pane. Select a photo and then click the stars in the Information pane.

Ratings Tips

To see ratings beneath your photo thumbnails, choose View > Rating (Shift-⌘-R). When ratings are visible, you can change them by clicking the stars and dots.

Finally, here's one more incentive to rate your favorite shots: when creating a book or calendar using the Autoflow feature, iPhoto gives higher priority to photos with higher ratings.

Morning Walk
★★★★

The Encounter
★★★★★

Searching for Photos

Browsing is fun, but not when you're looking for something specific. When you're on the hunt, you want help: directions from your car's navigation system, a directory in a shopping mall, or a search feature in your digital photography program.

iPhoto lets you search in several ways. For quick searches, jump down to the Search box and start typing. As you type, iPhoto narrows down the photos it displays—much as iTunes does during song searches. The more time you spend giving titles and descriptions to your best shots (page 22), the better the search feature works.

In the Search box, the magnifying glass is a pop-up menu that lets you search in more specific ways. Look for photos taken on certain dates. Or photos with a four-star rating, or with certain keywords.

And when your searching needs are *very* specific—show me the four-star photos of the dog taken before noon at the beach with my

Nikon camera during the month of July in San Francisco—iPhoto can accommodate. Just create a smart album (page 46).

So go ahead and browse when you want to relive random memories. But when you're on a mission? Search.

Search Box Basics

No matter what kind of search you perform, keep this in mind: iPhoto searches whatever item you've selected in the Library list. If you want to search your entire library, be sure to click Events or Photos. To search the last year's worth of photos, click Last 12 Months. To search for a specific face or place, click Faces or Places, respectively. To search a specific album, click the album. You get it.

Step 1. Click the Search button or press ⌘-F.

Step 2. Type something. iPhoto searches photo filenames, event names, titles, descriptions, faces, places, and keywords.

Step 3. To clear a search (displaying everything again), click ⊗ in the Search box.

Variations

Searching by rating. From the Search box pop-up menu, choose Rating. Click the stars to specify a minimum number of stars a photo must have.

Note: Higher-rated photos also appear: if you click three stars, four- and five-star photos also appear. To find *just* three-star photos, for example, create a smart album.

Searching by keyword. From the Search box pop-up menu, choose Keyword, then click one or more keywords. (For tips on keyword searching, see the opposite page.)

→ **Searching by date.** From the Search box pop-up menu, choose Date, then specify a date or range of dates (see the opposite page).

Searching by Date

Even if you never give a photo a title, description, or keywords, you can always search by date, since your camera records the date and time when you take a photo.

And remember, you can use iPhoto to adjust the dates of your photos to make date searches as accurate as possible (page 23).

The Big Picture

When you display the Calendar panel, it shows the current year.

Display the previous or following year.

Switch between viewing by year or by a specific month.

Months in which you've taken photos appear in bold. To see photos from a specific month, click that month. To select more than one month, drag across months, Shift-click, or ⌘-click.

Narrow Your View

To explore a specific month, double-click its name.

Display the previous or following month.

Return to year view.

Days on which you've taken photos appear in bold. To see photos from a specific day, click the day. To see photos from a range of days, drag across the days. To see photos from discontinuous days (for example, every Saturday), ⌘-click the days.

Tip: If you point to a month or date without clicking, iPhoto tells you how many photos you took during that month or on that date, as shown here.

Advanced Keyword Searches

When you click multiple keywords, iPhoto puts an *and* between each one: "find all photos with the keywords Sophie *and* Beach."

Sometimes, *and* isn't what you want.

Excluding a keyword. To exclude a keyword, press Option while clicking it. Say you want to find all Sophie photos that *weren't* taken at the beach. Click the Beach keyword, then Option-click the Sophie keyword. Notice the Search box: it reads *not Beach and Sophie*.

Either/or. To search for photos with one keyword or another, press Shift while clicking keywords. For example, to find all photos of the baby *or* the dog, Shift-click the Baby and Dog keywords.

Combinations thereof. By combining the Shift-click and Option-click variations, you can conduct some fairly complex searches, though it can be confusing to figure out which key sequences to use. For very specific searches, smart albums are easier.

Creating Albums

Getting photos back from a lab is always exciting, but what's really fun is creating a photo album that turns a collection of photos into a story.

An iPhoto album contains a series of photographs sequenced in an order that helps tell a story or document an event. Creating an album is often the first step in sharing a set of photos. For example, before creating a slide show or book, you'll usually want to create an album containing the photos you want to use.

Creating albums in iPhoto is a simple matter of dragging thumbnail images. You can add and remove photos to and from albums at any time, and you can sequence the photos in whatever order you like. You can even include the same photo in many different albums.

The photos in an album might be from one event, or from a dozen different events. If you've used iTunes to create playlists, you're well on your way to understanding albums: just as an iTunes playlist lets you create your own music compilations, an iPhoto album lets you create your own image compilations.

You don't have to create albums for every set of photos you import. But when you want to combine photos from different events, particularly when you're planning to share the photos in some way, albums are the answer.

Step 1. Click the Create button near the lower-right corner of the iPhoto window, then choose Album.

You can also choose File > New Album or use the ⌘-N keyboard shortcut. In either case, iPhoto creates an untitled album at the bottom of the Library list's Albums collection with its name selected.

| untitled album |

Step 2. Type a new name for the album, then press Return.

Tip: To create an album and add photos to it in one step, select the photos *before* creating the new album (page 44).

Step 3. Add photos.

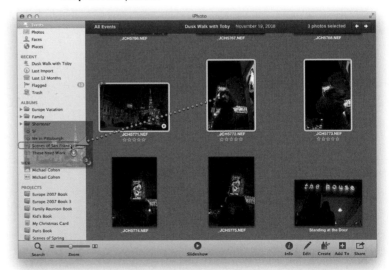

After you've created the album, begin dragging photos into it. You can drag photos one at a time, or select multiple photos and drag them in all at once.

As you drag, iPhoto indicates how many photos you've selected.

Organizing an Album

The order of the photos in an album is important: when you create slide shows, books, or Web photo galleries, iPhoto presents the photos in the order in which they appear in the album.

Once you've created an album, you may want to fine-tune the order of its photos.

To edit an album's name, double-click its name in the Library list or edit it in the Information pane.

To move an album to a different location in the Albums area, drag it up or down. As the following pages describe, you can also create folders to organize related albums.

To change the order of the photos, drag them. Here, the nighttime skyline photo is being moved so it will appear after the other nighttime shot.

Removing a photo. Don't want a photo in an album after all? Select it and press the Delete key. This removes the photo from the album, but not from your hard drive or photo library.

Tips for Selecting Photos

Selecting photos is a common activity in iPhoto: you select photos in order to delete them, add them to an album, move them around within an album, and more.

When working with multiple photos, remember the standard Mac selection shortcuts: to select a range of photos, click the first one and Shift-click the last one. To select multiple photos that aren't adjacent to each other, press ⌘ while clicking each photo.

As the screen below shows, you can also select a series of pictures by dragging a selection rectangle around them.

Tips for Working with Albums

Albums Are Optional

You don't *have* to create an album in order to share photos: you can create slide shows, books, calendars, and Web pages by simply selecting photos in your library and then using the appropriate button or command. And by hiding less-than-perfect photos (page 20), you can "edit" an event to contain only those photos you want to use in a project.

Still, when you're about to create a photo project of some kind, it's better to create an album first. Albums give you the ability to change the sequence of photos. You can resequence photos while creating slide shows, books, and the like, but creating these items is easier when you start with photos that are in roughly the final order that you plan to use.

Album Shortcuts

You can create an album and add images to it in one step. Select one or more images and then create the new album. You can also drag the selected images into a blank spot of the Library list.

When you use either technique, iPhoto gives the new album a generic name, such as *untitled album*. To rename the album, double-click its name and type a new name.

If you have photos on a storage device—your hard drive, an optical disc, or a digital camera's memory card—you can import them into iPhoto *and* create an album in one fell swoop.

Simply drag the photos from the Finder onto the Albums heading in the Library list. iPhoto imports the photos, storing them in their own untitled event. iPhoto also creates an untitled album and adds the photos to it.

Albums and flagging. iPhoto's flagging feature (page 21) teams up nicely with albums. Want to create an album of shots that are scattered throughout your library? Flag the shots, then select the Flagged item in your Library list. Next, choose Edit > Select All, then create the new album.

From Album to Event

You've created an album containing the best photos of a friend's wedding. The photos are from various events; indeed, some were emailed to you from other attendees.

You'd prefer that the photos were in an event of their own. Easy. Select the album, choose Edit > Select All, then choose Events > Create Event. iPhoto creates a new event, and moves the photos in the album into the event. Note, however, that the photos are removed from the events where they originated.

Photo Count

You can have iPhoto display the number of photos in each album next to each album's name. In the Preferences dialog, click General, then check the Show Item Counts box.

To Experiment, Duplicate

You have a photo that appears in multiple albums, but you want to edit its appearance in just one album, leaving the original version unchanged in other albums. Time for the Duplicate command: select the photo and choose Duplicate from the Photos menu (⌘-D). Now edit the duplicate.

Duplicating an album. There may be times when you'll want several versions of an album. For example, you might have one version with photos sequenced for a slide show and another version with photos organized for a book. Or you

might simply want to experiment with several different photo arrangements until you find the one you like best.

iPhoto makes this kind of experimentation easy. Simply duplicate an album by selecting the album and choosing Duplicate from the Photos menu. iPhoto makes a duplicate of the album, which you can rename and experiment with.

You can make as many duplicates of an album as you like. You can even duplicate a smart album—perhaps as a prelude to

experimenting with different search criteria. Don't worry about devouring disk space. Albums don't include your actual photos; they simply contain "pointers" to the photos in your library.

Albums and iLife

Another good reason to create albums surfaces in the iLife set of applications: iMovie, iDVD, GarageBand, and iWeb all display iPhoto albums in their photo media browsers.

Have a batch of photos you want to use in another iLife program? Rather than searching through your library using those programs' media browsers, first stash the photos in an album. Then, choose that album in the other iLife program.

iPhoto album support is also built into other programs, including Mail, Mac OS X's screen saver, and Apple's iWork programs.

Organize Your Library with Folders

As you create albums, slide shows, and books, your Library list may become cluttered. iPhoto helps a bit by providing separate areas for albums, slide shows, projects, and other items. But you can do your part, too. Take advantage of the ability to create folders in the Albums area of the Library list.

Folders in iPhoto have the same benefit that they have on your hard drive: they let you store related items. And as with the documents on your hard drive, the definition of "related items" is up to you.

Filing strategies. You can use folders in any way you like. You might want to set up a project-

based filing system: create a folder for a project, then stash albums, books, and slide shows in that folder.

Or you might prefer an object-oriented filing system: stash all your albums in one folder, all your slide shows in another, and all your books in yet another.

You might want to mix and match these approaches or come up with something completely different. What's important is that you create a filing scheme that helps you quickly locate items.

Creating a folder. To create a folder, choose File > New Folder. iPhoto names a new folder *untitled folder*, and selects its name. To rename the folder, just start typing.

Working with folders. To move an item into a folder, simply drag it to the folder until you see a highlighted border around the folder.

To close or open a folder, click the little triangle to the left of its name.

Like folders in the Mac's Finder, iPhoto folders are "spring loaded"—if you drag something to a closed folder and pause briefly, the folder opens.

Folders within folders. You can create folders inside of folders. You might use this scheme to store all the albums, books, and slide shows that relate to a specific event or theme.

To open a folder and all the nested folders within it, press Option while clicking the folder's triangle.

45

Creating Smart Albums

iPhoto can assemble albums for you based on criteria that you specify. Spell out what you want, and iPhoto does the work for you.

A few possibilities: Create an album containing every shot you took in the last week. Or of every photo you took in November 2002. Or of every November 2002 photo that has *Sophie* in its title. Or of every photo from 2008 that has *Paris* as a location, *croissant* in its title, *food* as a keyword, and a rating of at least four stars.

If you've taken the time to assign titles, comments, faces, places, and keywords to your photos, here's where that time investment pays off. You can still use smart albums if you haven't assigned this kind of information to photos; you just won't be able to search on as broad a range of criteria.

You can also create smart albums that have criteria based on information that your camera stores with each photo (see page 141). Create one smart album that corrals all the shots you took with your Sony camera, and another that collects all your Canon shots. Or create a smart album of all your photos shot at a high ISO speed (page 144), or at a fast shutter speed, or with a telephoto lens.

As described on page 48, smart albums also team up beautifully with the Places and Faces features.

Smart albums are a great way to quickly gather up related photos for printing, backing up, browsing, emailing—you name it.

Creating a Smart Album

Step 1. Choose File > New Smart Album (Option-⌘-N).

You can also create a new smart album by pressing the Option key, clicking the Create button in the lower-right corner of the iPhoto window, then choosing Smart Album from the menu that pops up.

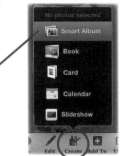

Step 2. Specify what to look for.

Type a name for the smart album.

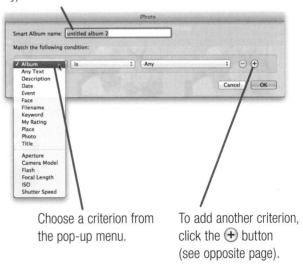

Choose a criterion from the pop-up menu.

To add another criterion, click the ⊕ button (see opposite page).

Step 3. Click OK or press Return or Enter.

In the Albums area, iPhoto indicates smart albums with a special icon: 🔛 .

Changing a Smart Album

To modify a smart album, select it in the Albums area and choose File > Edit Smart Album.

Be More Specific: Specifying Multiple Criteria

By adding additional criteria, you can be very specific about what you want to find.

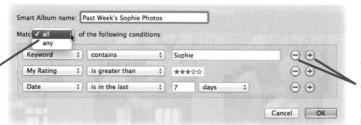

Normally, iPhoto locates photos that meet all the criteria you specify. To have iPhoto locate a photo that meets any of the criteria, choose any.

To delete a criterion, click the ⊖ button. To add a criterion, click the ⊕ button.

Tips for Smart Albums

They're alive. iPhoto is always watching. If you import photos that meet a smart album's criteria, iPhoto adds those photos to the album. iPhoto may also add to a smart album when you edit photo information. For example, if you change a photo's title to *Beach picnic*, iPhoto adds the photo to any smart album set up to search for *beach* in the title.

From smart to dumb. You can't turn a smart album into a static one (unlike iTunes, iPhoto doesn't provide a Live Updating check box). Here's a workaround. Click the smart album in the Albums list, then select all the photos in the

album. (Click one photo, then press ⌘-A.) Next, choose File > New > Album. This creates an album containing the photos currently in the smart album.

Deleting photos. To delete a photo from a smart album, select it and press ⌘-Option-Delete. Note that this also deletes the photo from your library and moves it to the iPhoto Trash.

Smart Album Suggestions

For a Compilation of	Specify These Criteria
All your movies	Photo is Movie
All your raw-format photos	Photo is Raw
All flagged or hidden photos	Photo is Flagged or Photo is Hidden
Recent favorites	Date is in the last 1 month (for example) and My Rating is greater than three stars
All your Winter photos	Date is in the range 12/21/2011 to 3/20/2012
All photos that aren't in any album	Album is not Any
Photos from a specific camera	Camera Model is *model*
Photos from the second-to-last event you imported	Event is not in the last 1 event and Event is in the last 2 events
Photos from the week before last	Date is not in the last 1 week and Date is in the last 2 weeks
Photos taken with a telephoto lens	Focal Length is greater than 150 (for example)

Smart Albums, Faces, and Places

Smart albums team up beautifully with the Faces and Places features. In fact, when you're using the Places feature, the iPhoto toolbar sports a dedicated Smart Album button (in Faces, you need to press the Option key when clicking the Create button to provide a smart album choice).

By creating a smart album for one or more faces, you can easily corral photos of specific people: Show me every photo of Mimi that I took at the beach last July. Show me every photo in which mom and I appear.

For Places, smart albums provide a few benefits. Gather photos taken at a certain location: Show me the photos I took in San Francisco last summer. Show me the San Francisco photos that have Sophie in them. Show me the nighttime Eiffel Tower photos that I took with my Nikon's tele-photo lens. Smart albums even give you a convenient way to save a specific view of the Places map.

As I mentioned on the previous pages, iPhoto updates the contents of a smart album as you add to your library (and when you cull photos you no longer want). So each time you add a photo containing a face you've named or containing a geo-tagged location, iPhoto adds that photo to any appropriate smart albums.

As always, the more criteria you specify in a smart album, the more searching power you have. But even with just a single criterion, a smart album gives you quick access to a favorite person or a favorite place. What's not to like about that?

Smart Albums and Faces

You can create a smart album that collects photos of a specific person in a couple of ways.

Step 1. On the Faces corkboard, select someone's tile.

Step 2. Click the Create button and press the Option key, then choose Smart Album from the pop-up menu.

Other ways. You can also create a smart album for a person by simply dragging that person's tile over to the Library area. And you can include a Face criterion when building a smart album. Set up the pop-ups in the smart albums dialog to read Face is *name of person*.

Notes and Tips

To create a smart album that gathers photos in which two people appear *together*, select both of their corkboard tiles (click one, then Shift-click the other), then Option-click the Create button and choose Smart Album from the pop-up menu.

Next, in the Albums list, select the smart album you just created and choose File > Edit Smart Album. In the smart album dialog, change the Match pop-up to read All.

To gather photos that contain more than two people, just Shift-click each person's face tile before creating the smart album.

Faces and Smart Albums	
For a Compilation of	Specify These Criteria
All Polk family members	Face ends with *Polk* (requires that you use first and last names in tiles)
All the women in your library	Face starts with *Ms.* (requires that you use honorifics in names)
Photos that don't contain Bill	Face does not contain *Bill*
All photos containing Toby and Josh, whether they're together in a photo or not	Face is *Toby* and Face is *Josh*, with the pop-up set to Any

Smart Albums and Places

A Smart Album for a Region

Maybe you'd like to create a smart album that collects photos created in a region, such as the San Francisco Bay Area or greater Paris. The technique at right won't do the job—if you specify *San Francisco*, iPhoto won't find photos taken in Sausalito.

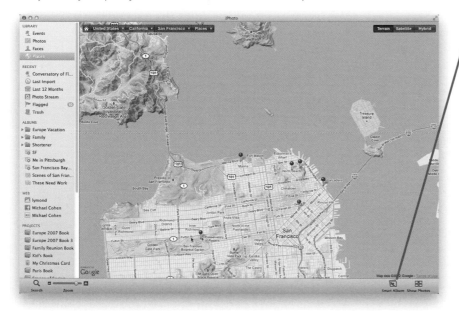

Here's where map view helps.

Step 1. Use the map in Places to zoom and pan so that the region whose photos you want are visible.

Step 2. Click the Smart Album button.

A Smart Album for a Specific Place

Here's how to quickly gather all the geo-tagged photos taken in a certain location.

Step 1. Create a new smart album (see page 46).

Step 2. Set up the pop-up menus to read Place is *location name*.

Be sure to type the location exactly as it appears in Places, lest iPhoto not find it.

Notes and Tips

When you create a smart album in this way, iPhoto gives it the name of the region it encompasses. In the above example, the album gets the name *California*. You can change its name—to *San Francisco Bay Area*, for example.

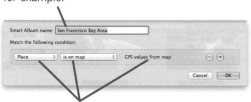

If you edit the smart album, you'll notice its criterion reads *Place is on map GPS values from map*.

Here are a few more place-related smart album ideas.

Places and Smart Albums	
For a Compilation of	**Specify These Criteria**
Photos that are not geotagged	Photo is not tagged with GPS
Photos taken in a few different places	Place is *place name* (repeat for each location and change Match pop-up to Any)
Photos that were not taken in a specific region	Place is not GPS values from map (create the smart album as above, then edit it and change *is on map* to *is not on map*)

Basic Photo Editing

Many photos can benefit from some tweaking. Maybe you'd like to crop out that huge telephone pole that distracts from your subject. Maybe the exposure is too light, too dark, or lacks contrast. Or maybe the camera's flash gave your subject's eyes the dreaded red-eye flaw.

iPhoto's edit view can fix these problems and others. And it does so in a clever way that doesn't replace your original image.

When you edit a photo, iPhoto keeps a list of the changes you made. If you reopen an edited image and make more changes, iPhoto applies your entire list of changes to the *original* version of the photo. It's called *non-destructive* editing, and the result is fewer passes through the evil JPEG-compression meat grinder— and better photo quality. (For more about iPhoto non-destructive editing, including an important caveat, see page 141.)

As you get accustomed to iPhoto editing, you might want to experiment with full-screen editing (page 68).

Editing Essentials

To work on a photo, open it in iPhoto's edit view.

Step 1. Select the photo you want to edit.

Step 2. Click the Edit button or press the Return key.

The photo opens in edit view, and new tools and buttons appear (opposite page).

Step 3. Now what? Here are some of the ways iPhoto can help an ailing photo.

Photo First-Aid	
Symptom	**Cure (and Page)**
Red-eye from flash	Red-Eye tool (page 52)
Poor contrast and "punch"	Enhance button (page 54); for more control, the Adjust pane (pages 58–61)
Subject is obscured in shadow or bright areas are washed out	Shadow and highlight recovery (page 62)
Crooked and/or badly framed	Straighten and/or Crop tools (page 53)
Scratches or blemishes	Retouch tool (page 55)
Color balance is incorrect	Adjust pane (page 65)
Photo is "grainy" from low light	Adjust pane (page 66)

Global Versus Local Editing

When you edit a photo, you change the photo everywhere you've used it—in slide shows, books, and calendars, for example. When you're printing a photo, there's another way to fine-tune an image. iPhoto's print view provides an Adjust pane whose controls are similar to the ones covered on the following pages. This means you can fine-tune the way a photo prints without changing its appearance elsewhere—very handy. I'll remind you of this local editing opportunity when we discuss printing.

Edit View at a Glance

Save any changes and open the previous or next photo for editing (keyboard shortcut: left or right arrow).

Apply a variety of effects (page 56).

Switch to full-screen view (page 68).

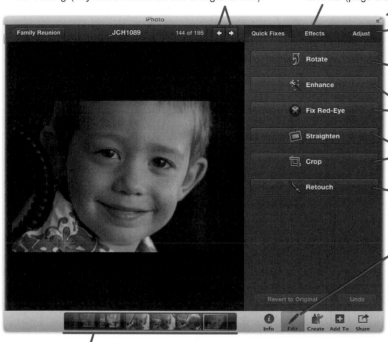

Finely control exposure, color balance, sharpness, and more (pages 58–67).

Rotate a photo in 90-degree increments (page 53).

Fix the pixels: use One-Click Enhance (page 54) and fix red-eye (page 52).

Improve the composition: straighten and crop a photo (page 53).

Remove scratches and other flaws (page 55).

Save any changes and leave edit view.

Zoom in and out (lower left of iPhoto window). **Tip:** When zoomed in, you can quickly scroll by pressing the spacebar and dragging within the photo.

A row of thumbnails shows adjacent photos. To edit a different photo, click its thumbnail. Place the pointer over the row to expand the thumbnails temporarily so you can see them more clearly.

Three Things to Remember When Editing

Before-and-after view. To see how your photo looked before you made any changes, hold down the Shift key. By pressing and releasing Shift, you can see a before-and-after view of all of your edits to the original.

Safety nets: undo and revert. Not happy with your very latest change? Choose Edit > Undo. Not happy with the changes you made since you opened the photo? Choose Photos > Revert to Original, and iPhoto discards your edits and restores the photo to its previous state.

Change your mind? To exit edit view without saving any changes, press the Esc key (if a tool, like the Straighten tool, is active, press Esc twice: the first Esc closes the tool, the second Esc discards the edits).

Fixing Composition Problems and Red-Eye

Some photos can benefit from...less. Maybe you weren't able to get close enough to your subject, and you'd like to get rid of some visual clutter. Or maybe a scenic vista is marred by a dumpster that you didn't notice when you took the shot. Or maybe you want to order a print, and you want your photo's proportions to match the size you want.

iPhoto's Crop tool is the answer for jobs like these. By cropping a photo, you can often improve its composition and better highlight its subject matter.

Similarly, some photos need a bit of straightening. It's easy to tilt the camera when you're shooting, making the whole world look just a little crooked.

To put your world on the level, use the Straighten tool. A drag of the mouse is all it takes.

Then there's red-eye. Biologically, it's caused by the bright light of an electronic flash reflecting off a subject's retinas and the blood vessels around them. Aesthetically, it makes people look like demons.

iPhoto can help here, too. The Red-Eye tool gives you a couple of ways to get the red out. Indeed, face recognition even comes into play: if iPhoto detects one or more faces in a photo, one click of the mouse is all it takes to remove red-eye—everywhere it occurs.

Removing Red-Eye

Step 1. Open the photo in edit view and then click the Quick Fixes tab.

Step 2. Drag the Zoom slider to zoom in on the subject's eyes.

Step 3. Click the Red-Eye button.

Step 4. If you see this check box, iPhoto has detected a face in the photo. Click the check box to have iPhoto automatically fix the red-eye.

If the *Auto-fix red-eye* check box is inactive, iPhoto didn't detect a face, and you'll need to remove the red-eye yourself.

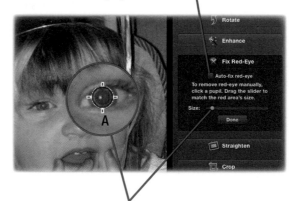

Drag the slider until the tool (A) is slightly larger than the red area of the eye. Then, click the red area of each eye.

Step 5. In the Fix Red-Eye pane, click Done.

Cropping a Photo

Step 1. Open the photo in edit view and then click the Quick Fixes tab.

Step 2. Click the Crop button.

Step 3. Adjust the size and position of the crop rectangle to enclose the portion of the image you want to keep, and then click Done.

When you move or resize the crop area, you see a grid that divides the crop area into thirds. You can often improve the composition of a photo by placing its main subject along this grid (see page 147).

To move the crop area, drag inside it.

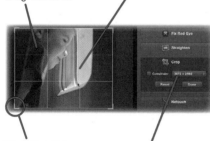

To resize the crop area, drag one of its corners or edges.

You can control the proportions of the crop area so that your photo fits a certain print size or display dimension (see "Constraining the crop," right).

Notes and Tips

Constraining the crop. You can make the crop area any size you like. But sometimes, you may want to control the proportions of the crop area—to ensure that your photo's proportions match a certain print size, for example.

Choose an option from the menu beside the Constrain box. Choosing an item automatically checks the box.

| 2560 × 1440 (Display) |
| 1600 × 1200 (Original) |
| 2 × 3 (iPhone) |
| 3 × 5 |
| 4 × 3 (DVD) |
| 4 × 3 (Book) |
| 4 × 6 (Postcard) |
| 5 × 7 (L, 2L) |
| ✓ 8 × 10 |
| 16 × 9 (HD) |
| 16 × 20 |
| 20 × 30 (Poster) |
| Square |
| Custom... |
| Constrain as landscape |
| Constrain as portrait |

For example, if you plan to order an eight- by ten-inch print of the photo, choose 8 x 10.

To switch between a horizontal and vertical crop area, choose Constrain as Landscape or Constrain as Portrait. To override the constrain setting, press Shift while resizing the crop area; this automatically unchecks the Constrain box.

Resetting the crop. To start over, click Reset; iPhoto restores the original crop rectangle.

Cropping and resolution. When you crop a photo, you throw away pixels, lowering the photo's resolution. If you print a heavily cropped photo, you may notice ugly digital artifacts. Always shoot at the highest resolution your camera provides; this gives you more flexibility to crop later (see page 144).

The local option. If you're printing a photo on your own printer, you might prefer to use iPhoto's print tools to crop—that way, you won't change the photo everywhere you've used it. See page 104.

Straightening a Photo

Step 1. Open the photo in edit view and then click the Quick Fixes tab.

Step 2. Click the Straighten button.

Step 3. Drag the Straighten slider left or right, using the on-screen grid as a guide, and then click Done.

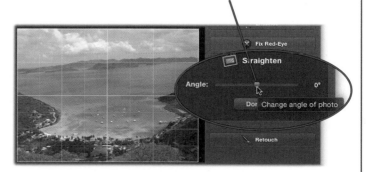

Enhancing and Retouching Photos

Old photos can appear faded, their color washed out by Father Time. They might also have scratches and creases brought on by decades of shoebox imprisonment.

New photos can often benefit from some enhancement, too. That shot you took in a dark room with the flash turned off—its color could use some punching up. That family photo you want to use as a holiday card—the clan might look better with fewer wrinkles and blemishes.

iPhoto's Enhance and Retouch tools are ideal for tasks like these. With the Enhance tool, you can improve a photo's colors and exposure, bring out details hidden in shadows, and rescue a photo you might otherwise delete. With the Retouch tool, you can remove minor scratches and blemishes, not to mention that chocolate smudge on your kid's face.

iPhoto's editing features make it easy to fix many common image problems, but iPhoto isn't a full-fledged digital darkroom. You can't, for example, remove power lines that snake across an otherwise scenic vista, nor can you darken only a portion of an image. For tasks like these, you'll want to use Adobe Photoshop or Photoshop Elements—both of which pair up beautifully with iPhoto (see page 76).

Using One-Click Enhance

Try the Enhance button with any photo that needs some help—such as this one, where a bright background caused the subject to be underexposed.

To apply one-click enhance, open a photo in edit view and click the Quick Fixes button, and then click the Enhance button.

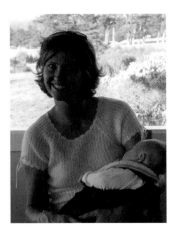 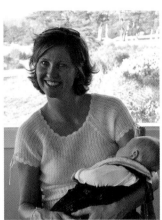

Before **After**

Tips

If the Enhance tool isn't doing the job—maybe you feel its results are too harsh—undo your enhancements and turn to the tools in the Adjust pane (see page 58).

And speaking of the Adjust pane, if you happen to open it right after you click the Enhance button, you'll see its sliders have moved from their default positions, indicating exactly what changes iPhoto has made to improve the image. This can be a good way to learn about image enhancement and improve your own skills with the Adjust pane.

Retouching a Photo

Step 1. Open the photo in edit view and then click Quick Fixes.

Step 2. Click the Retouch button.

Step 3. Click or drag across the flaw you want to remove, and then click Done.

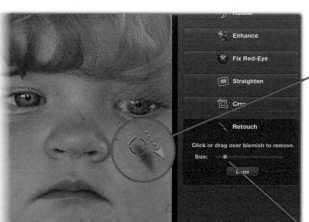

For larger scratches and flaws, try dragging in short strokes. This helps iPhoto blend your retouching into the surrounding area. For small blemishes, a single click is often all you need. Experiment and undo as needed.

You can enlarge or reduce the size of the retouch brush. A larger brush makes short work of large flaws, but you may find it picks up extraneous colors or patterns from surrounding areas. When that happens, undo your work, reduce the size of the brush, and try again.

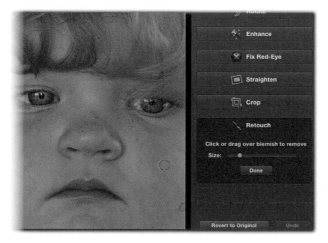

Notes and Tips

Zoom for precision. To retouch with more precision, use the Zoom slider to zoom in on the area of the image that you're working on. You can also zoom by pressing the 0 (zero), 1, or 2 keys.

Undo and revert. You can undo each mouse click or drag by clicking the Undo button at the bottom of the Quick Fixes pane.

To undo all of your retouching, click the Revert to Original button at the bottom of the Quick Fixes pane. Note that you'll also lose any other edits, such as cropping, that you performed since switching into edit view. Because of this, you might want to retouch first—that way, you won't lose work if you decide to revert. Or take a different approach: do your cropping and other adjustments, then exit edit view. Reopen the photo in edit view, and retouch.

Brush keyboard shortcuts. To make the retouch brush smaller, press the left-bracket ([) key. To make the brush larger, press the right-bracket key.

Applying Effects to Photos

With the Effects pane, you can alter a photo to give it a unique look. Evoke the colors of an old, faded tintype. Turn a color photo into a black-and-white one. Blur the edges of a scene to create a gauzy, romantic look. Juice up the colors in a photo or tone them down.

As the tips at right describe, you can apply more than one effect to a photo, and you can apply an effect more than once.

Keep in mind that applying an effect to a photo changes that photo everywhere it appears—in albums, books, slide shows, and so on. If you want to retain the existing version of a photo, be sure to duplicate it before applying an effect: select the photo and choose Duplicate from the Photos menu or use the ⌘-D keyboard shortcut.

And there's a local editing angle, too: you can apply black-and-white, sepia, or antique effects in slide shows and print projects.

Applying Effects

Step 1. Open a photo in edit view.

Step 2. Click the Effects button to display the Effects pane (opposite page).

Step 3. Click the desired effect(s).

Effective Tips

Combining effects. Some effects pair up particularly well. For a dream-like look, try combining Edge Blur with the B&W effect. For an old-fashioned look, pair the Sepia or Antique effects with the Vignette effect. To create an oval border around a photo, combine the Matte and Vignette effects.

Don't be afraid to try offbeat combinations, either. It might seem contradictory to follow the Boost Color effect with the Fade Color effect, but you can get some interesting results when you do.

If you effect yourself into a corner, just click the Revert to Original button at the bottom-left of the Effects pane to return to safety.

When once isn't enough. You can apply most effects up to nine times: simply click the desired effect's button over and over again. (The two exceptions are the B&W and Sepia effects; clicking their buttons repeatedly will only wear out your mouse or trackpad.)

iPhoto lets you know how many times you've applied an effect. To backtrack one time, click the left-pointing arrow.

Refining an effect. You can refine the appearance of an effect by using the controls in the Adjust pane (discussed on the following pages). In particular, you can improve the contrast and tonal range of a black-and-white conversion by adjusting the Saturation, Tint, and Temperature sliders. For details, see page 65.

A Gallery of Effects

No single photo is ideally suited to every effect, but that didn't stop me from working my dog into this example.

To remove the effects you've applied, click the None thumbnail in the lower-right of the Effects pane.

The effects at the top of the Effects pane are self-explanatory: Lighten makes the colors lighter, Darken makes the colors darker, Contrast increases contrast, Warmer moves the colors more toward orange, Cooler moves the colors more toward cyan, and Saturate increases the color intensity.

B&W. Convert to black and white.

Sepia. Add a warm brown cast.

Antique. Simulate the faded colors of an old photo.

Matte. Add a soft-edged white border.

Vignette. Add a soft black border.

Edge Blur. Blur the edges of a photo. **Tip:** Try clicking this one a few times and combining it with the B&W effect.

Tip: The Matte and Vignette effects work best when a photo's subject is in the center of the image. For these examples, I cropped the photo before applying the effect, and I clicked the effect's button several times.

Fade. Decrease a photo's color saturation (for more control, use the Adjust pane; page 64).

Boost. Increase a photo's color saturation (for more control, use the Adjust pane; page 64).

Advanced Editing and the Adjust Pane

Some photos need more help than others. That portrait captures the essence of your subject—but it's just a bit dark. That shot of a beautiful white gardenia would be prettier if the flower didn't have a jaundiced yellow color cast. And that shot of the dog playing in the park would be cuter if you could actually see the dog.

To fix problems like these, use the Adjust pane—its controls let you fine-tune exposure, tweak color balance, sharpen details, and more.

The basics of the Adjust pane are a cinch: after opening a photo for editing, summon the Adjust pane by clicking the Adjust tab at the right of the edit view window. Then, drag the appropriate sliders left or right until you get the desired results.

That last part—getting the desired results—isn't always a cinch. Adjusting exposure, color balance, and sharpness can be tricky, and knowing a few digital imaging concepts can help you reach your goals. You'll find a detailed look at these concepts in the following pages. Here's the big picture.

A Sampling of Adjustments

Adjust Exposure

Use the Exposure and Levels sliders to brighten or darken photos and improve contrast (page 60).

Fix Color Problems

Use the Saturation, Temperature, and Tint sliders to remove unwanted color casts, increase or decrease color vividness, and more (page 64).

Recover Shadow and Highlight Detail

Use the Shadow and Highlight sliders to bring detail out of dark shadows and overly bright areas (page 62).

The Adjust Pane at a Glance

The histogram is a bar graph that shows a photo's distribution of tonal values—blacks, whites, and everything in between. Knowing how to read the histogram can help you improve brightness and contrast (see the following page).

The Exposure slider adjusts overall brightness; use it and the Levels sliders to fix exposure and contrast problems (page 60).

The Contrast slider increases or decreases the contrast range.

The Saturation slider makes colors less vivid or more vivid (page 64).

Enhance the contrast and sharpness in ways that improve a photo's—you guessed it—definition (page 63).

The Highlights and Shadows sliders restore details hidden in dark shadows and bright areas (page 62).

Low-light or high-ISO shots often have digital noise that the De-noise slider can help to minimize (page 67).

The white-point tool corrects color casts by adjusting the color of white or gray areas (page 65).

The local angle. You'll find an Adjust pane elsewhere in iPhoto: there's one in the custom print view (page 106). This Adjust pane isn't identical to the one in edit view, but it's very similar—and it's a great place to adjust a photo without changing it everywhere you may have used it.

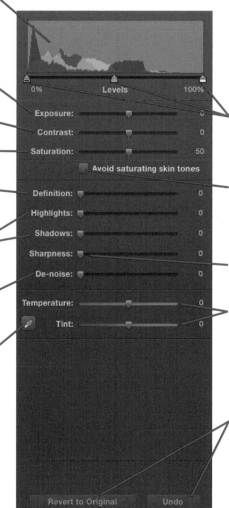

The Levels sliders are often the best tools for improving brightness and contrast (page 60).

Adjusting the color of a photo containing faces? This option helps keep skin color accurate (page 64).

The Sharpness slider increases clarity and crispness; sharpening before printing can improve your output (page 66).

The Temperature and Tint sliders adjust color balance; use them to fix unwanted color casts and create special effects (page 64).

Never mind! If you've adjusted yourself into a corner, click Revert to Original to restore all the sliders to their factory settings, or, if it's just the last adjustment that is a problem, click the Undo button.

Adjusting Exposure and Levels

The Adjust pane gives you control over many aspects of a photo's appearance, but chances are you'll use its exposure controls most often. For improving a photo's exposure and contrast, use the Levels sliders and the Exposure slider. By adjusting them—while keeping a close eye on the photo's histogram—you can often make dramatic improvements in a photo's appearance.

Which tools should you use? It depends on the photo. Some photos respond better to the Exposure slider, while others benefit from levels adjustments. Still other photos benefit from both approaches: do some initial tweaks with the Exposure slider, then fine-tune the levels.

When you drag these sliders, you tell iPhoto to stretch the photo's existing tonal values to cover a broader tonal range. Oversimplified, when you change the black point, you tell iPhoto, "See this grayish black? I want you to treat it as a darker black and adjust everything else accordingly."

The Levels sliders can often work wonders, but they can't work miracles. If a photo has an extremely narrow contrast range, you may see visible *banding*—jarring color shifts instead of smooth gradations—after adjusting levels. You're telling iPhoto to stretch a molehill into a mountain, and there may not be enough data to allow for smooth gradations in shading and color.

Reading a Histogram

A *histogram* is a bar graph that shows how much black, white, and mid-tone data a photograph has. Pure black is on the left, pure white is on the right, and the mid-tones are in between. iPhoto displays a color histogram that breaks this information down into an image's three primary-color channels: red, green, and blue.

Beneath the histogram is a set of sliders that let you change what iPhoto considers to be pure black, pure white, or mid-tone values.

A Sampling of Histograms

This properly exposed shot has a good distribution of dark, bright, and mid-tone areas.

This overexposed shot has very little data in the blacks; everything is bunched up toward the right side—the white side—of the histogram.

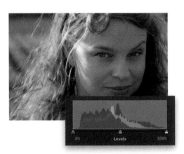

Nice cityscape, but it's underexposed; notice the absence of data at the right end of the histogram.

Using the Levels Sliders

Before

Cute kid, flat photo. The histogram tells the tale: there's little data in the brightest whites.

After

The photo's brightness and contrast are improved, and its histogram shows a broader tonal range.

To darken the photo, drag the *black-point* slider to the right.

To adjust the overall brightness of the photo, drag the mid-tone slider.

● To brighten the photo, drag the *white-point* slider to the left.

Drag until the sliders almost reach the point where the image data begins. These sloped areas are often called the *shoulders* of the histogram.

Using the Exposure Slider

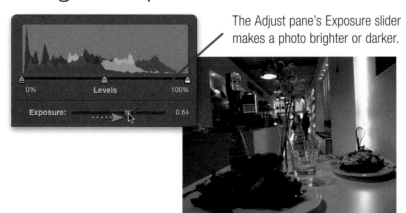

The Adjust pane's Exposure slider makes a photo brighter or darker.

I enhanced this underexposed photo by dragging the Exposure slider to the right. This action broadens the histogram.

Note: The Exposure slider works best with raw-format images. For JPEG-format images, the Levels sliders tend to provide more precision. For more details, see page 75.

Adjusting Definition, Shadows, and Highlights

Recovering Shadow and Highlight Details

Cameras don't perceive high-contrast scenes as well as our eyes do. As a result, high-contrast photos are often missing something. Shadows are dark and devoid of detail, or bright areas are washed out to nearly pure white.

Sometimes your camera's exposure meter works against you, too. A bright background may have caused the camera to use an exposure setting that obscures darker foreground details. Conversely, a dark foreground may have led to an exposure setting that blows out details in brighter areas.

The Shadows and Highlights sliders in the Adjust pane can help. (For tips on using both, see the sidebar on the opposite page.)

Out of the shadows. To bring out details hidden in dark areas, use the Shadows slider.

Before

After

Details in the highlights. Bright areas of a photo often contain obscured detail that you can bring out using the Highlights slider.

Before

After

Improving a Photo's Definition

The Definition adjustment is a great tool for adding punch to a photo. In fact, it's one of the best adjustments you can make to a photo.

To add definition, drag the Definition slider to the right.

Definition: ▉ ————————————— 0

Before

After

How It Works

Under the hood, the Definition slider makes localized contrast adjustments throughout the image to subtly improve detail. When you add definition, iPhoto increases the contrast in mid-tone areas of the image—those not-too-bright and not-too-dark areas that lurk in the middle area of the histogram. Adding definition has the effect of making mid-tone areas appear sharper and removing some of the "cloudiness" that digital images can have.

But who cares? The point to remember is this: applying the Definition adjustment to your best shots can often make them even better.

Shadow and Highlight Recovery Tips

Use sparingly. A little adjustment goes a long way. Drag the sliders too far, and you may up with an artificial-looking photo that has strange halos where bright and dark areas meet.

Shadows *and* highlights. Scenes with a lot of contrast can often benefit from *both* a shadow and highlight adjustment to bring details out of both. But again, use sparingly: overdo it, and you'll end up with a flat, artificial-looking photo.

Plays well with others. You can often get the best results by combining adjustments. To recover shadow details, try brightening the photo with the mid-tone or white-point Levels slider, then drag the Shadows slider.

You might even try brightening the photo until highlights appear too bright, then darken them a bit by using the Highlights slider.

And that's a good guideline for all your Adjust pane endeavors: the best results often come from combinations of several adjustments, not just one.

Changing a Photo's Colors

The Adjust pane provides ways to perform several types of color-related adjustments. With the Saturation slider, you can adjust the vividness of a photo's colors. Turn down the saturation to create a muted, pastel look or to compensate for a camera's overly enthusiastic built-in color settings. Or turn up the saturation to make a photo's colors more intense.

With the Temperature and Tint sliders, you can change a photo's color balance, fix a color cast introduced by artificial light or caused by fading film, or create a special effect to make a photo feel warmer or colder.

How can you tell if the colors you see on your screen will accurately translate to an inkjet or photographic print? Advanced Photoshop users rely on display-calibration hardware and other tools to calibrate their systems so that displayed colors match printed colors as closely as possible.

You can apply this strategy to iPhoto. Or you can take a simpler approach. First, calibrate your screen using the Displays system preference. Second, if you'll be creating your own inkjet prints, make test prints as you work on a photo, duplicating the photo as necessary to get different versions.

Finally, as with many aspects of the Adjust pane, there's a local angle to color adjustments. When you're printing a photo, you can use the Adjust pane in the custom-print view to change colors without changing the photo everywhere you've used it (page 106).

Adjusting Color Saturation

To make a photo's colors more vivid, drag the Saturation slider to the right. To make colors more muted, drag the slider to the left. If iPhoto detects a face, it activates a feature that prevents your adjustments from altering skin colors. You can also turn the feature on (or off) yourself.

Original

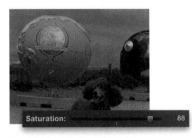

Increased Saturation

Decreased Saturation

Tips

Pale and pastel. To give a pastel-like quality to a photo's colors, decrease the saturation.

Going gray. If you drag the Saturation slider all the way to the left, you create a *grayscale* version of the photo. Generally, the B & W option under the Effects tab does a better job, but experiment and see which version you like best.

Note: If the skin-tones box is checked, you can't completely desaturate the photo. To create a grayscale image, uncheck the box.

Watch your gamut. If you significantly increase a photo's saturation, you probably won't be able to print a version that matches what you see on screen. Printers have a much narrower color range, or *gamut*, than does the Mac's screen.

Adjusting Color Balance

To adjust a photo's color balance, use the Temperature slider, the Tint slider, or both.

Temperature. The Temperature slider adjusts a photo's color temperature. To make a photo appear *cooler* (more bluish tones), drag the slider to the left. To make a photo appear warmer (more yellow/orange tones), drag the slider to the right.

Original

Cooler

Warmer

Tint. The Tint slider adjusts red/green color balance. If you drag the slider to the left, iPhoto adds red, making a photo appear less green. If you drag the slider to the right, you add green and lessen the amount of red. The Tint slider can help remove the greenish color cast that you may find in photos taken under fluorescent lighting.

Colorful Tips

Temperature Tips. Photos taken under incandescent light with your camera's flash turned off tend to have a yellowish cast to them. I like this warm look, but if you don't, try dragging the Temperature slider to the left to cool things off. If the corrected image looks dark, bump up the Exposure or mid-tone Levels slider.

You can often simulate different lighting conditions by shifting a photo's color temperature slightly. Warm up a photo to simulate late afternoon sun, or cool it down to simulate shade or twilight.

Old color photos often take on a reddish-yellow appearance as their color dyes fade. To fix this, drag the Temperature slider to the left a bit.

Gray Balancing. If you have an off-color photo containing an object that you know should be gray or white, click the eye-dropper tool (), then click the part of the photo that should be gray or white. iPhoto adjusts the Temperature and Tint sliders as best it can to make the object a neutral gray.

Better Black and White

iPhoto's B & W effect under the Effects tab does a good job of converting a color photo to black and white, but you can often improve on its efforts: after clicking B&W, adjust the Saturation, Temperature, and Tint sliders under the Adjust pane.

When you drag the color sliders after converting a photo to black and white, iPhoto blends the photo's red, green, and blue color channels in different ways. To make a black-and-white photo appear richer, bump up the saturation after clicking the B & W effect. While you're experimenting, drag the Temperature and Tint sliders to see how they alter the photo's tonal values. (For you film fogies, this is the digital equivalent of exposing black-and-white film through color filters.)

After Clicking B & W Effect

After Adjustments

Sharpening and Reducing Noise

All digital images—whether captured by a scanner or a camera—have an inherent softness. Some softness is introduced by inexpensive lenses, and some is introduced by imaging sensors and their fixed grid of pixels.

Digital cameras compensate for this inherent softness by applying some sharpening immediately after you take a photo. You can often adjust the amount of sharpness they apply; I like to turn down the sharpness settings on my cameras, preferring to sharpen later, if necessary. (If you shoot in raw mode, your camera applies little or no sharpening to the image; see page 72.)

Inkjet printers and offset printing presses (including the kind used to print iPhoto books, greeting cards, and calendars) also introduce some softness. The bottom line: several factors are working against your image to obscure fine details.

Some sharpening can add crispness to a photo, whether you plan to view it on-screen or print it on paper. But photos that will be printed are particularly good candidates for sharpening.

Sharpening is part of the "balanced diet" that you should consider applying to your best shots. Fine-tune the exposure using the Levels or Exposure sliders. Bring out details hidden in shadows and highlights. Apply the Definition adjustment to add some pop. Fine-tune the color saturation, if you like.

But keep the word *balanced* in mind: apply too much of any adjustment, and you'll get weird, unnatural-looking results.

Sharpening Basics

To sharpen a photo, drag the Adjust pane's Sharpness slider to the right.

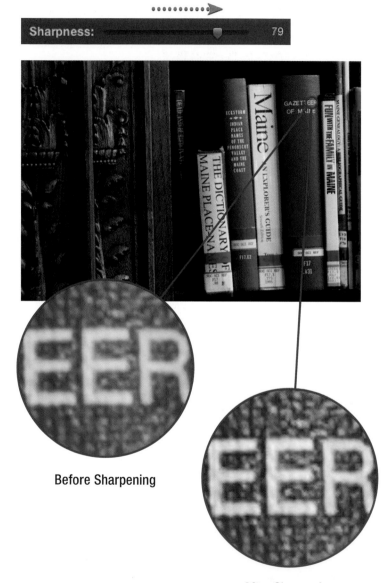

Before Sharpening

After Sharpening

Sharpening Tips

Should You Sharpen?

Just because digital images have an inherent softness doesn't mean that you should apply sharpening to every photo you take. First, consider the photo itself. A photo that lacks fine details—say, a close-up of a baby's face—won't gain much from sharpening, and may even be hurt by it. Conversely, a photo containing fine details—such as the one on the opposite page—may benefit greatly from sharpening.

Also consider how you'll be using the photo. A photo destined for a slide show or video project probably doesn't need sharpening. A photo that you plan to print—either yourself or by ordering prints or a book—is a better candidate for sharpening, especially if the photo contains fine details.

Printing? Sharpen heavily. Don't be afraid to heavily sharpen a photo that you're going to print. Even if the photo looks a bit too sharp onscreen, chances are it will print nicely.

Also consider the paper you're using. Premium glossy photo paper shows fine details best, so photos destined for it can benefit from sharpening. On the other hand, matte- and luster-finish photo papers have a fine texture that obscures detail a bit.

The local angle. Just want to sharpen a photo for printing on your inkjet printer? Don't forget the option of sharpening using the Adjust pane in the custom print view—see page 107.

View Right

iPhoto's edit view introduces some softness of its own when it scales a photo to whatever zoom setting you've made. To get the most accurate onscreen view possible, view your photo at 100 or 200 percent when making sharpness adjustments: press the 1 key to view at 100 percent, and the 2 key to view at 200 percent.

How It Works

Regardless of what you see on TV, no digital imaging program can turn a blurry photo into a sharp one. Instead, iPhoto detects boundaries of light and dark, and makes light edges a bit lighter and dark edges a bit darker. When it's done right—that is, not to excess—our eyes perceive this as increased sharpness.

Reducing Noise in Photos

Photos taken in low light—indoors, with the flash turned off, for example—often have a grainy appearance, especially if you've used your camera's menus to turn up the ISO setting (page 144).

With a digital camera, high ISO settings basically amplify the signal from the camera's sensor.

It's a bit like turning up the volume on a radio: it doesn't make the radio more sensitive to weak signals, but it does boost whatever signal is there.

But when you crank up the volume of a weak signal, the static gets louder, too. In a digital photo, this "static" is called *noise*, and it's especially noticeable in areas of little detail—a blue sky or a smooth-cheeked baby.

At moderate ISO settings, such as 200, noise tends to be subtle and may not even show up in prints. But at high ISO speeds, noise can be deafening, creating a speckled, snowy appearance like that of a weak TV signal.

To quiet down noisy shots, use the Adjust pane's De-noise slider. The farther you drag the slider, the stronger the noise reduction. Applied too heavily, noise reduction can give detailed areas a mottled, plastic look. Experiment with your noisy shots, remembering to zoom in for a closer look.

The Big Picture: Full-Screen Editing

When you're editing and enhancing a photo, it's often helpful to see the big picture—that is, to display your photo at as large a size as possible. When you go big, it's easier to perform color and exposure adjustments and to find flaws that need retouching.

Full-screen view gives you a picture window into your pictures. Just click the Full Screen (⧉) button or, better yet, use the ⌘-Control-F keyboard shortcut.

When you enter full-screen view, your Library list goes away and iPhoto's buttons and controls arrange themselves to make more room for your photos. Move the mouse pointer to the top of the screen, and the menu bar glides into view.

Full-screen view is great when you're editing photos, browsing them, or creating slide shows, books, and calendars. Full-screen view is less ideal when you need to drag photos into albums or other projects, since the Library list isn't visible in full-screen view.

Full-screen view teams up nicely with another iPhoto feature: the ability to compare two or more photos in order to find the best shot in a series. You can display two or more photos side-by-side and even edit them.

It's worth noting that you can also compare photos in iPhoto's standard edit view. But, because full-screen view maximizes your screen space, it's the best view for your photo-comparison sessions.

Switching to Full-Screen View

To edit a photo in full-screen view, select the photo, click the Edit button, and then click the Full Screen button (⧉).

If you've zoomed in on a photo, the Navigation pane appears. Drag the rectangle to quickly pan around the zoomed photo.

You can also move to the next or previous photo by clicking the arrow buttons or by using the arrow keys on your keyboard.

To display a different photo, click its thumbnail.

You can view and edit photo information in full-screen view; click the Info button to display the Information pane.

To exit full-screen view, click the Full Screen button again. **Note:** You can also exit full-screen view by pressing your keyboard's Esc key.

Comparing Photos

It's always smart to take more than one version of an important shot—to experiment with different exposure settings or to simply increase your chances of capturing that perfect smile.

After you've imported those multiple variations into iPhoto, compare the photos to find the best one. (And if you don't want to see the rest, consider hiding them; see page 20.)

To Compare Photos

○ **Comparing in edit view.** If you're already working in full-screen edit view (opposite page), hold down the Command (⌘) key and click the thumbnail of the photo you want to compare to the one you are editing. iPhoto loads it and displays both side-by-side.

To remove a photo from the comparison, click the photo and then click the ✖ at its top left corner.

When you click a different thumbnail, its photo replaces the selected photo (in this example, the one on the right). To compare more than two photos, ⌘-click on their thumbnails. (You can compare up to eight photos.)

From browsing to comparing. You can also set up a comparison *before* entering edit view. Select the photos first, then click the Edit button. For a review of ways to select photos, see page 43.

Introducing the Projects Bookshelf

Full-screen view isn't just for editing. You can view your events, places, faces, and albums, too.

Full-screen view is also the gateway to iPhoto's Project Bookshelf, which visually (and artfully) shows the books,

calendars, and cards you've created.

To display the Project Bookshelf, click the Projects button—it appears along the bottom of the screen when you're in full-screen view.

Note: If you don't see the Projects button and its neighbors, it's because you're currently viewing an event, album, or collection of faces or places. To navigate out of the collection you're viewing, click the left-pointing button near the top-left corner of the screen—for example: **◄ All Events** .

Editing Tips

How the Saturation Adjustment Works

iPhoto inherits several professional-quality adjustments from its powerhouse sibling, Aperture: shadow and highlight recovery, and the Definition adjustment.

The Saturation adjustment also borrows from Aperture. When the *Avoid saturating skin tones* option is active in the Adjust pane, iPhoto is actually using an Aperture adjustment called *Vibrancy*. No, the slider's name doesn't change to Vibrancy, but under the hood, iPhoto is applying the same basic approach to adjusting the photo's colors—a selective saturation adjustment that preserves the color of skin tones.

This won't affect how you use the adjustment, but it's a fun piece of iPhoto-geek trivia: when the box is checked, the adjustment is Vibrancy. When the box isn't checked, the adjustment is Saturation.

And speaking of that pesky check box, I mentioned that it's automatically activated when iPhoto detects a face in the photo. If iPhoto misses a face for any of the reasons discussed on page 28,

you'll need to click the check box yourself to switch to the skin-friendly Vibrancy adjustment.

And as mentioned on page 65, you can uncheck the box to create a grayscale version of a photo—or to horrifically over-saturate a friend's complexion.

Copying and Pasting Adjustments

Sometimes, you might have a series of photos that can benefit from the same adjustments—maybe they're all similarly dark, for example, or all have the same color cast. Or maybe they all come to life when given the same combination of Definition and Sharpness adjustments.

With the Copy Adjustments and Paste Adjustments commands, you can apply one photo's adjustments to other photos. After tweaking a photo to perfection, choose Edit > Copy Adjustments. Next, open a different photo in edit view, display the Adjust pane, and choose Edit > Paste Adjustments and watch the Adjust pane's sliders move as if by magic.

The Keys to Editing

You can activate various editing tools by pressing a single key on your keyboard (see the table below).

While you're pawing your keyboard, remember that you can open a photo for editing by selecting the photo and pressing the Return key—you don't have to click the Edit button. To save changes and return to thumbnail browsing, press Return. To save changes and edit an adjacent photo, press an arrow key. To discard changes and exit edit view, press Esc. To switch to full-screen view, press Control-⌘-F.

Keyboard Editing

For this tool	Press
Crop	C
Straighten	S
Red-Eye	R
Retouch	T
Adjust pane	A
Effects pane	E
White Balance tool	W

And don't forget, you can change the size of the retouch brush and manual red-eye–removal tool by pressing the left bracket ([) and right bracket (]) keys.

From Publisher to Editor

Most of the time, you probably enter edit view while browsing your library or an album. But you can also enter edit view while working on a book, calendar, or greeting card: just Control-click the photo and choose Edit Photo from the shortcut menu.

Photo Editing in Your Hand

Owners of devices that run iOS 5—iPod touch, iPhone, and iPad—have access to four tools in the Photos app that are similar to those on iPhoto '11's Quick Fixes tab: Rotate, Enhance, Red-Eye, and Crop.

Select any image in the Photos app—even one in your Photo Stream (see page 8)—and tap the Edit button on the Photos app's top toolbar. A bottom toolbar appears with

the four tools. Tap the tools you want and then go to town. You don't need any help to figure them out; they literally explain themselves. Furthermore, Undo is available for all of the tools, so you don't need to worry about messing anything up.

Obviously, you can do a lot more with iPhoto's Edit tools then the equivalent Photos app tools, but for quick photo fixes in the field, they are a welcome convenience.

71

Shooting in Raw Mode

If you're an advanced photographer, a control freak, or both, there's an image format that you should be using. The image format is called *raw*, and it's supported by many mid-range and all high-end cameras.

Here's why raw matters. When you shoot in JPEG format, your camera permanently alters the photo: tweaking color balance and saturation, adjusting sharpness, and compressing the image to use less space.

Today's cameras do these jobs well, but you pay a price: you lose some control. You can still adjust the color balance, exposure, and sharpness of a JPEG image, but within a relatively narrow range. Exceed those limits, and you risk visible flaws.

When you shoot in raw mode, your camera saves the exact data recorded by its light sensors. Instead of being locked into the camera's alterations, you get the original, unprocessed image data: the raw data. Transfer this raw image to the Mac, and you can use iPhoto or other imaging software to fine-tune the image to a degree that the JPEG format doesn't permit.

Shooting raw has drawbacks, and many photographers prefer the convenience and efficiency of JPEG. But for pixel perfectionists who want maximum control, raw is the best way to shoot.

Choosing Raw

To shoot in raw mode, venture into your camera's menus and controls—specifically, to those that let you adjust image quality. In some cameras, you'll find these options buried in menus. In others, you can change image quality using buttons on the top of the camera. Check your manual.

Make sure. It's a sad fact of life: each camera company has created its own raw format, and if you have a newly introduced camera, iPhoto may not recognize your camera's raw format images. Before shooting raw, verify that iPhoto supports your camera's raw format. You may find that you need to update to a newer Mac OS X version—Apple often adds support for new cameras when it releases a Mac OS update. For a current list of supported cameras, go to http://www.apple.com/aperture/specs/raw.html; although the page lists cameras compatible with Apple's Aperture software, any Aperture-compatible camera is also compatible with iPhoto '11.

Make room. Raw files are often several times larger than their JPEG equivalents. For example, an 8-megapixel JPEG might use 4 MB while its raw version uses 16 MB. Because you'll get fewer raw images on a memory card, you might want to buy a few extra cards.

Those big files will also take up more space on your hard drive—and on the hard drive that you're using (or should be using) to back up your iPhoto library.

Make time. With some cameras, raw images can take longer to save after you snap the shutter. If you're shooting a fast-changing scene, verify that your camera's raw mode is fast enough to keep up with your subject.

Those large raw files also take longer to transfer to the Mac. Even with the fast connections built into all current cameras and Macs, you'll wait a bit longer to see your shots.

The Basics of Working with Raw Photos

In some ways, working with raw photos in iPhoto is no different than working with JPEG photos. You can import raw photos into your library, edit them using all of the edit-view features I've described previously, and share them using all of iPhoto's sharing features.

Importing raw photos. Aside from making sure you have plenty of free disk space, you don't have to do anything special to import raw photos into iPhoto. If iPhoto supports your camera's raw format, it imports the raw photos and stores them in your photo library.

JPEG companions. When you import raw photos, iPhoto creates JPEG versions of them. You don't see thumbnails for these JPEG companions in your photo library, but they're there.

iPhoto creates these JPEG versions for use by programs that don't understand the raw format. For example, when you access your iPhoto library from a different program, such as iMovie or iDVD, that program uses these JPEG versions.

However, when you open a raw photo in edit view, iPhoto does indeed use the original raw-format image. For details on how iPhoto handles raw images during and after the editing process, see the following pages.

Raw plus JPEG. Some cameras save a JPEG version of a photo at the same time that you shoot a raw version. This is a handy convenience that gives you the best of both worlds: a compact JPEG and a *digital negative*—a phrase often used to describe raw-format images.

When you import photos from such a camera, iPhoto imports both the JPEG and the raw versions of each shot. It also *displays* both versions, and if you're planning to do some editing, you'll want to make sure you open the raw version— you want iPhoto to base your changes on the highest-quality version available.

To see which photo is the JPEG version and which is the raw version, open the Information pane and select one of the photos. iPhoto displays its format at the top of the Information pane.

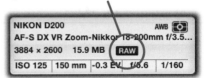

Max Headroom: The 16-Bit Advantage

I've already mentioned one big benefit of shooting in raw format: you aren't locked into the color, sharpness, and exposure settings made by your camera.

Another advantage deals with something called *latitude* or *headroom*: the ability to make dramatic adjustments without risking visible flaws. Simply put, a raw image is more malleable than a JPEG.

Raw photos have more latitude because they store more image data to begin with. JPEG images are 8-bit images; each of the three primary-color channels— red, green, and blue—are represented by 8 bits of data. That means that each channel can have up to 256 different tonal values, from 0 (black) through 255 (white). (Yes, things are getting a bit technical here, but such is life in the raw.)

Most cameras, however, are capable of capturing at least 12 bits of data for each color channel, for a possible 4096 different levels. When a camera creates a JPEG, it essentially throws away at least one-third of the data it originally captured.

Most of the time, that loss of data isn't a problem. But if you need to make significant changes to an image's exposure

and color balance, the more data you have to start with, the better. Where this extra latitude really pays off is with photos that were poorly exposed or taken under tricky lighting conditions.

Think of the extra data as money in the bank: when times get tough, you'll be glad it's there.

Working with Raw Images

How iPhoto Manages Raw Photos

iPhoto works hard to insulate you from the technicalities of working with raw photos. Here's a summary of how iPhoto works with raw captures.

iPhoto also creates a JPEG "stand-in" for printing and for use by other programs.

When you import a raw photo, iPhoto stores it in your photo library.

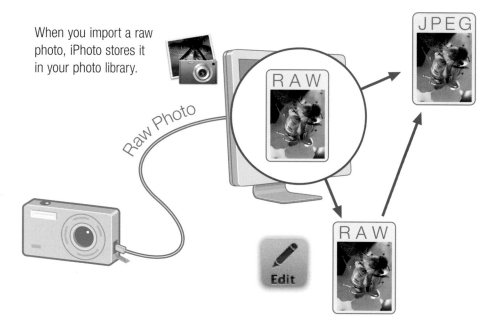

When you open a raw photo in edit view, iPhoto uses the original raw data that you imported.

When you leave edit view, iPhoto applies your edits to the raw data, then creates a JPEG photo that reflects the edits. The original raw file always remains unchanged, and you can access it in a couple of ways (see next page).

Editing an Already-Edited Raw Photo

If you edit a raw photo that you've already edited, iPhoto returns to the original raw version of the photo and applies all the changes you've made—today's as well as yesterday's. This non-destructive editing gives you far more flexibility than earlier iPhoto versions provided. You can edit an image as many times as you like without worrying about introducing quality loss each time.

The exception to the rule. Ah, but there's an exception. If you edited a raw photo using the older iPhoto '06, iPhoto '11 applies your latest edits to the edited JPEG that the older version of iPhoto created. Open that edited raw photo in edit view, and any new edits you make are applied to the JPEG version.

So what do you do if you've been using iPhoto for years and you want the full power of non-destructive editing? Select the edited version of the raw photo and choose Photos > Reprocess RAW. iPhoto discards the JPEG version (and any edits you made). Now you can bring the non-destructive editing power of iPhoto '11 to bear.

Exporting the Original Raw File

There's another way to get to your original raw data after making edits: export the original raw file from iPhoto.

First, select the JPEG version of the photo that iPhoto created after you edited the raw file. Next, choose Export from the File menu. Finally, in the Export Photos dialog, choose Original from the Kind pop-up menu. Save the file somewhere convenient, such as on your desktop.

When might you use this approach? Here's one scenario. You've edited a raw photo in iPhoto, but then you decide to try editing the original raw file in Adobe Photoshop Elements. You want to keep the version you edited in iPhoto, so instead of reverting the photo or duplicating the edited version, you export a raw version for use in Photoshop.

Raw Photos and Photoshop

As I describe on the following pages, iPhoto pairs up beautifully with the Adobe Photoshop family. This marriage is particularly happy where raw images are concerned: in my experience, Adobe's Camera Raw software does a better job than iPhoto when it comes to decoding and processing raw files. Camera Raw, even the version included with Photoshop Elements, provides more control than iPhoto's edit view—and control is what raw is all about.

I use iPhoto to import and store raw photos, but when I'm after maximum quality, I bring those photos into Photoshop. I fine-tune the photos in Photoshop, export them as JPEGs, then import those JPEGs back into iPhoto for sharing. It's more work, but the results are better.

To ensure that iPhoto supplies Photoshop with the original raw file and not the JPEG stand-in, choose Preferences from the iPhoto menu, click Advanced, and then check the box labeled *Use RAW when using external editor.* If you don't, iPhoto will hand Photoshop a JPEG when you go to edit the raw file—exactly what you *don't* want.

Saving as TIFF

Given that you're obsessed enough with image quality to be shooting in raw mode to begin with, you might lament the fact that iPhoto saves your edited images in the lossy, 8-bit JPEG format. You have a higher-quality alternative: tell iPhoto to use the TIFF format when saving edits to raw images.

To do so, choose Preferences from the iPhoto menu, click Advanced, and check the box labeled *Save edits as 16-bit TIFF files.* The resulting file will be much larger than a JPEG, but it will have that 16-bit headroom described on page 73, and it won't have any lossy compression.

Is it worth the extra storage space? Possibly, particularly for images whose brightness or levels you've altered dramatically. JPEG versions of these images might show that undesirable banding I mentioned on page 60. Consider doing some tests—let your eyes be your guide.

Using iPhoto with Photoshop

The editing features in iPhoto can handle many image-tuning tasks, but at the end of the day, Adobe Photoshop is a better-equipped digital darkroom. Photoshop and Photoshop Elements, its lighter-weight, less-expensive cousin, provide far more sophisticated retouching tools and more ways to improve a photo's lighting and exposure. And as I mention on the previous page, Photoshop can also be a better tool for working with raw-format images.

Photoshop (and Elements—everything on these pages applies to both) has slick features that have no counterparts in iPhoto. A library of exotic visual effects lets you simulate pastels, watercolors, brush strokes, and more. You can cut out the subject of a photo and superimpose it over a different background. You can stitch photos together into dramatic panoramas.

Using Photoshop for retouching doesn't mean abandoning iPhoto. The two programs work well together: you can use iPhoto to import, organize, and share photos, and Photoshop to enhance and retouch them.

Here's an introduction to some ways to turn iPhoto and Photoshop into collaborators.

From iPhoto to Photoshop

A photo in your iPhoto library needs some help. How do you open it in Photoshop? You have a few options.

Drag and drop. If you've already started Photoshop, its icon appears in your dock. To open a photo, simply click the photo in your iPhoto library and drag it to the Photoshop icon in the dock. When the icon highlights, release the mouse button, and Photoshop opens the photo directly from your iPhoto library. This drag-and-drop technique is handy if you use Photoshop only occasionally.

Important: Don't use this technique to try to open a raw file; you'll end up opening the JPEG stand-in in Photoshop instead. Use the techniques below to send raw images to Photoshop.

Direct connection. If you end up using Photoshop for all your image editing, you can set up iPhoto to directly hand off photos to Photoshop.

Choose Preferences from the iPhoto menu and click the Advanced button. From the Edit Photos pop-up menu, choose In Application. In the dialog that appears, navigate to your Applications folder, then locate and double-click the icon for your version of Photoshop.

From now on, when you go to edit a photo, iPhoto will hand that photo off to Photoshop.

Note: If you plan to send raw images from iPhoto to Photoshop, be sure to fine-tune iPhoto's preferences, as described on the previous page.

Middle ground. Maybe you use Photoshop frequently, but you also use iPhoto's edit view for cropping and other simple tasks—that's what I do. Head for the middle ground: specify Photoshop as your external image editor as described above, then return to the Preferences dialog and choose the In iPhoto option from the Edit Photos pop-up.

This restores iPhoto's factory setting: clicking the Edit button opens a photo in edit view. But iPhoto doesn't forget that you're also a Photoshop user. To open a photo in Photoshop, Control-click (or right-click) the photo and choose Edit in External Editor from the shortcut menu.

A Sampling of Elements Editing Ideas

Recovering Shadow and Highlight Details

iPhoto does shadow and highlight recovery (page 62); Photoshop does it better, providing finer control and better quality—especially if you shoot raw.

The Power of Layers

One of the best reasons to use Photoshop is a feature called *layers*. In Photoshop, an image can have multiple layers, and each layer can contain imagery or image-correction information. By using layers, you can make dramatic modifications to an image without ever altering the original data. This not only gives you more editing flexibility, it helps preserve image quality.

One particularly powerful use of layers involves selective lightening and darkening: changing the brightness of part of a photo without affecting other areas. It's a common technique in darkrooms, it's easy in Photoshop—and impossible in iPhoto.

Other very useful features of layers are that you can specify how the colors blend between them and that you can adjust the opacity (and thus transparency) of selections in the upper layer. One fairly subtle example of blending: a *multiply* blend darkens the two overlaid pixels, but a darker color blend chooses the darker pixel of the two.

There is more to layers than I can describe here. To learn about them, open Photoshop's online help and search for *layers* and *adjustment layers*.

Retouch the Flaws Away

iPhoto's Retouch tool does a good job of removing blemishes, dust specks, and other minor flaws. But it's no plastic surgeon.

In this photo, a pair of utility wires slice across a scenic vista. I used two retouching tools to improve the view.

Spot Healing Brush. Photoshop's Spot Healing Brush works much like iPhoto's Retouch tool, only better. Click the Spot Healing Brush tool in the tool palette,

then specify a brush size that's slightly larger than the flaw you want to remove. You can choose a brush size in the Tool Options toolbar, but it's more efficient to use the keyboard: press the right bracket key (]) for a larger brush, and the left bracket key ([) for a smaller one.

Next, simply click the flaw you want to remove. To remove a larger flaw, such as a scratch or utility wire, click and drag to paint over it.

Clone Stamp tool. The Spot Healing Brush works best when the area surrounding the flaw is similar to the area containing the flaw. For this example, the Spot Healing Brush did a great job of removing the wires from the areas surrounded by open sky or water, but it had trouble with areas that were surrounded by fine details, such as the offshore rocks and distant shoreline.

To fix those areas, I used Photoshop's Clone Stamp tool, which copies pixels from one area of an image to a different area.

After activating the Clone Stamp tool, point to an area adjacent to the flaw you want to fix. Then, hold down the Option key and click. Option-clicking tells Photoshop what area to use as a guide when healing the flaw, a process Photoshop gurus refer to as "defining the *source point*." After you've done that, paint across the flaw to copy pixels from the source point.

Slide Shows: iPhoto as Projector

With iPhoto's slide show features, you can display onscreen slide shows, complete with background music from your iTunes music library. Choose from several design *themes* that provide flashy transitions between photos. Tell iPhoto how long you want to see each photo, or have iPhoto time your slide show to match the length of the background music.

You can create two different types of slide shows: an *instant* slide show that provides quick results, and a *slide show project* that allows for much more control, including the ability to specify different durations for every photo. When you want to create a slide show and then export it—to view on your iPod, iPhone, or Apple TV, for example, or to burn with iDVD—you'll want to create a slide show project. (For more advice on the best path to take for your slide show needs, see page 87.)

Most of the time, you'll want to add photos to an album before viewing them as a slide show. That way, you can arrange the photos in a sequence that best tells your story. If you're in a hurry, though, just select some photos in your library and then display the slide show as described at right. Or fine-tune an event, hiding photos you don't want to show, then select the event thumbnail.

Somebody get the lights.

Playing an Instant Slide Show

Step 1. Select the photos you want to show.

To show an entire album or event, select it in the Library list. To see a slide show of a favorite face, select that person's tile on the corkboard. To show scenes from a favorite place, select the location in Places and click Show Photos on the toolbar.

Step 2. Click the Slideshow button.

The theme chooser appears.

Step 3. Choose a theme.

Optional: Customize your soundtrack and other settings (page 80).

Tip: To preview a theme, point to it. iPhoto displays a sample of the theme's design and transitions.

Step 4. Click the Play button.

Slide Show Themes at a Glance

Here's a brief rundown of the 12 slide show themes.

Classic. The most basic of the bunch. Photos are separated by a transition whose style you can choose.

Holiday Mobile. Photos appear dangling from strings, twisting and waving, against a soft, wintry sky spangled with pale stars.

Ken Burns. Like Classic, but with the addition of the automatic Ken Burns effect: iPhoto pans and zooms the photos.

Origami. Photos dynamically fold and unfold in various groupings.

Photo Mobile. Photos appear dangling from strings, twisting and waving, against a soft-blurred background.

Places. Photos appear on maps indicating where they were taken. Great for vacation photos. Requires Internet connection so that the required maps can download.

Reflections. Shows each photo on a white background with a fading reflection beneath it.

Scrapbook. Photos appear inside paper-like frames in a scrapbook with photos appearing with random transitions, sometimes sliding into view, sometimes fading, sometimes stacking one on another.

Shatter. Sports an edgy transition that separates the color components of a photo, then joins them when the next photo appears. Sweet eye candy.

Sliding Panels. Photos arranged in various rectangular arrays, usually in groups of two or three, that slide in and out of view.

Snapshots. Photos slide into view from the bottom of the screen, stacking atop each other as playback progresses. When a new photo appears, the photo beneath it becomes black and white—a nice touch.

Vintage Prints. Photos appear as white-framed snapshots, slightly faded, scattered and drifting over one another.

After the Lights Dim

Want to change a slide show during playback? Move the mouse, and a panel appears. Use it to display the themes browser, the music browser, or the settings panel.

(For details on customizing slide show settings and music, see the following pages.)

You can also pause and stop the slide show and move to the previous or next photo.

For additional navigation control, point near the bottom of the screen and a row of thumbnails

appears; drag across the row to skim through the slide show, or click a thumbnail to see its photo.

Customizing Instant Slide Shows

° ## Customizing Music Settings

Each slide show theme has its own canned song that plays unless you choose something else—which you can do by clicking Music.

Your iTunes library is a click away, as are your iTunes playlists, your GarageBand compositions, and some sample tunes.

For the sound of silence, uncheck the box.

To search, type a song, artist, or album name.

To preview a song, double-click it or select it and click the ● button.

You can create a song playlist without detouring into iTunes. Check the Custom Playlist box and then drag songs. To reorder, drag songs up and down. To remove a song, select it and press Delete.

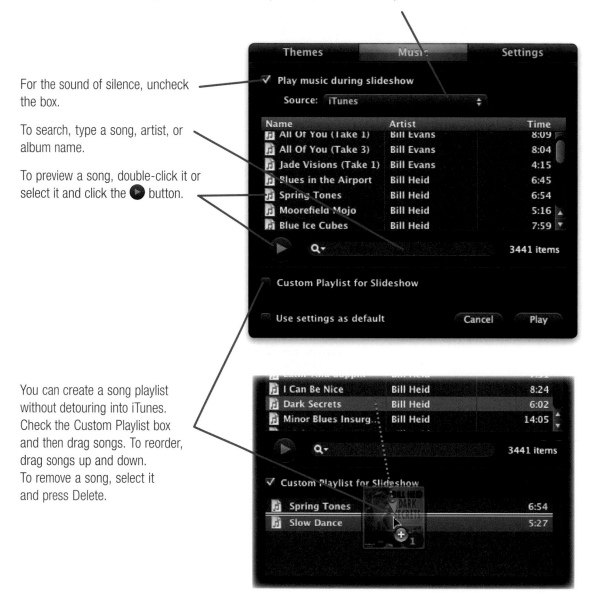

Customizing Slide Show Settings

Specify a duration, or have iPhoto adjust durations to match your soundtrack.

With some themes, you can choose a transition and adjust its speed and direction. To preview the transition, click the thumbnail.

A title slide can appear at the start of the slide show; its text is the name of the event, album, face, or place that you were viewing when you started.

Photos play in random order instead of the order they appear in the iPhoto window.

The slide show repeats until time comes to an end or until you press the Esc key, whichever comes first.

iPhoto zooms images when needed to ensure that the screen is always filled, with no black borders. Vertically oriented photos and photos you've cropped may display strangely.

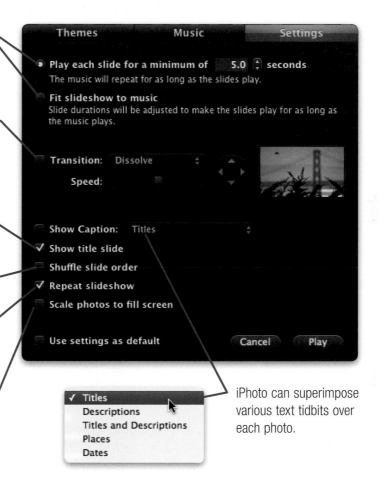

iPhoto can superimpose various text tidbits over each photo.

Creating a Slide Show Project

Instant slide shows provide instant gratification, but with limits. All photos appear for the same amount of time, with the same transition between them. You can't map out your own Ken Burns pan-and-zoom moves. Nor can you export the slide show for burning in iDVD or for viewing on an iPod, iPhone, or Apple TV.

By creating a *slide show project*, you can have all these things and more. Slide show projects appear in the Slideshows area of the Library list. Because they're saved as part of your iPhoto library, you can go back and add to slide show projects any time you want.

Your broader options start with the ability to have different durations for different shots. That view of the skyline? Five seconds. That montage of park scenes? Just a couple of seconds apiece.

The Classic and Ken Burns themes (described on page 79) give you more creative options, too. Mix and match transitions: put a cross dissolve between most vacations shots, for example, but a wipe transition when you change locations. And in both themes, you can tell Ken Burns exactly what to do, setting up moves that best highlight your subjects and tell your story.

When you're done, you can export your work to view on a big-screen TV, iPod, iPad, or iPhone—or to bring into iMovie for more editing and YouTube sharing. It all adds up to more creative control than instant slide shows give you.

Starting a Slide Show Project

Step 1. Select some photos; select an album, an event, or a faces tile on the corkboard; or navigate to a place in Places.

Step 2. Click the Create button in the lower-right corner of the iPhoto window.

Step 3. In the menu, click Slideshow. The new project appears in the sidebar with its name selected; you can type a new name if you want.

The slide show editor appears.

To jump to a specific photo, click its thumbnail. To change the order of photos, drag photos left or right. To remove a photo from the slide show, select it and press the Delete key. To select multiple photos for moving or deletion, Shift-click or ⌘-click them.

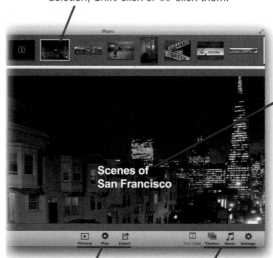

To change the text of the title slide, point to it and double-click, then type. You can also change fonts and sizes; see page 85.

Play or preview the slide show (opposite page), or export it (page 85).

Choose themes and music, and adjust slide show settings (opposite page).

Tip: Drag the Zoom slider (not shown here) to zoom in and show just part of a photo, or to set up the start or end of a Ken Burns move (see page 84).

Customizing a Slide Show Project

If you've tweaked an instant slide show, you'll find the controls in the slide show editor to be familiar—but more powerful.

Themes and music. The theme and music options are identical to those on pages 78–81.

Slide show settings. Many options in the Slideshow Settings pane also resemble their instant slide show counterparts. But several additional options give you more control.

The Transition options appear with the Classic or Ken Burns themes. Other themes have other options.

Choose the appropriate aspect ratio for the device on which you intend to view the slide show.

Customize settings for a photo (right).

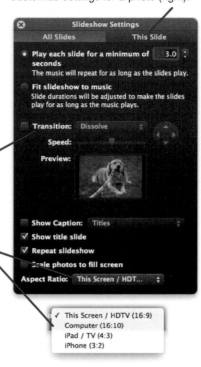

Adjusting individual photo settings. With the This Slide pane, depending on the theme, you can change the duration of whatever photo is displayed in the slide show editor. You can also add a black and white, sepia, or antique effect.

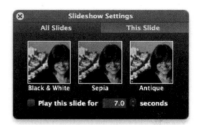

Note: Some themes allow for shorter photo durations than others and may offer other individual slide options.

For example, with the Classic or Ken Burns themes, you can also use the This Slide pane to set a transition for a specific photo and to turn the Ken Burns effect on or off. For more details, turn the page.

Previewing and Playing a Slide Show

As you create a slide show, you might want to preview your work to get a feel for its pacing. Previewing is also a good way to test some Ken Burns settings.

Previewing. To preview the slide show, click the Preview button. Playback begins with whatever photo appears in the editor. To jump to a different point in the slide show, click a thumbnail image in the photo browser.

Playing back. When you want to see your slide show in its full-screen glory, click the Play button. Your screen goes dark and playback begins.

As with instant slide shows, you can summon some controls during playback. Move the mouse, and the same pane shown on page 79 appears. Use it to pause or stop; skip to the previous or next slide; and change music, themes, and overall settings for the slide show.

Move the mouse pointer to the bottom of the screen, and a row of thumbnails appears. To jump to a photo, click its thumbnail. To scrub through the slide show, drag the small thumbnail preview left or right.

Preview versus playback. In general, when you're in the throes of slide show editing—fine-tuning Ken Burns moves, changing photo durations, adjusting transition timing—previewing is the most convenient way to check your work. And the preview feature lets you start the slide show from any point; by comparison, when you click Play, the slide show always plays from the very beginning.

Creative Options for Slide Show Projects

Using the Ken Burns Effect

The Ken Burns effect adds a dynamic sense of motion to a slide show by panning across photos and zooming in and out.

Two slide show themes allow for Ken Burns moves: Classic and (brace yourself!) Ken Burns. With the Classic theme, no photo has a Ken Burns move, but you can set one up for any photo using the instructions on this page.

With the Ken Burns theme, *every* photo has an automatic Ken Burns move: iPhoto pans and zooms using settings that it deems appropriate. You can customize those moves, and you can turn Ken Burns off for certain photos if you like.

Step 1. In the slide show editor, display the photo for which you want to create or customize a Ken Burns move.

Step 2. Click the Settings button to show the Slideshow Settings pane, then click its This Slide tab.

Step 3. Be sure the Ken Burns box is checked and set to the Start position, then position the photo as you want it to appear when it's first displayed.

Step 4. Click the End option in the Slideshow Settings pane, then specify the ending setting for the move.

Notes and Tips

Which theme? If you want a Ken Burns move on all or most of the photos in a slide show project, choose Ken Burns. iPhoto adds a move to each photo; you can customize the move or turn it off for those photos that you want to appear static. On the other hand, if you want to add the Ken Burns effect to only *some* photos, choose Classic, then add Ken to those photos that need to move.

No Ken do. To turn off a Ken Burns move for a photo, display that photo in the slide show editor, summon the Slideshow Settings pane, and then uncheck the Ken Burns box.

Zooming without moving. You want to show just part of a photo in a slide show, but you don't want to crop the photo, because that changes its appearance throughout your library. Solution: Make the photo's start and end positions the same.

Panning without zooming. Similarly, you might want to pan across a photo without changing the zoom setting. In this case, make the start and end zoom settings the same (or as close as you can get them).

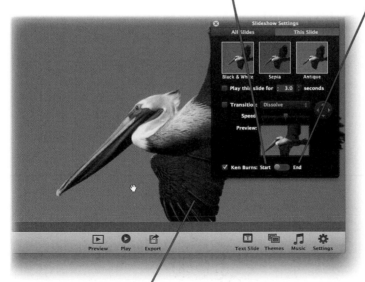

When zoomed in, specify which part of the photo you want to see by dragging within the photo.

To zoom in or out, drag the Zoom slider right or left.

Zooming in Other Themes

The remaining slide show themes don't provide for Ken Burns moves, but you can still zoom a photo to have just part of it appear—it's like cropping the photo without having to actually crop it in edit view.

To do it, display that photo in the slide show editor, drag the Zoom slider to zoom in, and then drag within the photo to position it as desired.

If you're working with a theme that displays multiple photos at once, be sure to select the photo you want to adjust before hitting that size slider. To select the photo, click it in the thumbnail photos browser.

Formatting Title Text

As mentioned previously, you can begin a slide show with a title slide: in the Slideshow Settings pane, check the Show Title Slide box.

For the title text, iPhoto uses the name of the slide show as it appears in the Library list. But you can change that: just click the text in the slide show editor, then type.

You can also insert subtitle text for other slides: select a slide in the thumbnail browser and then click the Text Slide button. Depending on the theme, the text appears either before the slide or superimposed on it. In all cases, a text slide thumbnail appears to the left of the thumbnail you selected.

You can change the font of the text, and even use multiple fonts in a title. Drag

across the text to select it, then choose Edit > Font > Show Fonts (or just press ⌘-T). Use the Fonts pane to change fonts and type size. To start a new line, press the Return key.

Tip: If you're unhappy with your formatting, jump back to Square One: for title slides, in the Slideshow Settings pane, uncheck the Show Title Slide box, then check it again; for subtitle slides, select the text slide, click the Text Slide button, then click it again. iPhoto restores the theme's original text formatting.

Exporting a Slide Show

You've refined your slide show project to perfection. Now what? Send it somewhere.

To iDVD. To burn a DVD containing the slide show, choose Share > iDVD. iPhoto prepares the slide show and ships it off to iDVD.

To iTunes. Want to view your slide show on an iPod, iPhone, iPad, or Apple TV? Send it to iTunes, then sync iTunes with your device.

In the slide show editor, click the Export button. In the Export dialog, click the check box for each size that you want to export. The blue dots indicate which Apple devices work best at those sizes.

To have the resulting movie added to your iTunes library, be sure to check the box labeled *Automatically send slideshow to iTunes.*

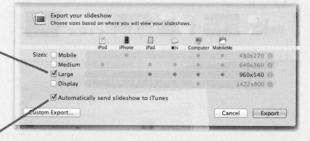

To iMovie. Maybe you'd like to add a voice-over narration to the slide show, or to include it in a larger movie project, or to upload it to YouTube. Export a

large version of the movie (click the Large box in the Export dialog box). In iMovie, choose File > Import > Movies, and then bring the movie in.

Slide Show Tips

Video in Slide Shows

If your iPhoto library contains video clips shot with a digital camera, you can use those clips in instant slide shows and slide show projects. iPhoto even lowers the volume of your background music when a movie clip plays so you can hear the movie's audio.

In slide show projects, you can use the Slideshow Settings pane to apply effects to video clips. You can even create Ken Burns moves to pan and zoom across video. It's also fun to use video clips in the Sliding Panels theme, where multiple clips play at once.

Instant Slide Show Tips

iPhoto remembers. When you adjust instant slide show settings—your own music soundtrack, transition settings, and photo durations, for example— iPhoto saves those settings, tying them to whatever you were viewing when you clicked the Play button. For example, if you were viewing an event, your instant slide show settings are saved along with that event. If you were viewing an album, the settings are saved with the album.

The next time you view an instant slide show of that item (event, album, face, and so on), iPhoto uses the settings it saved and immediately begins playing the slide show. What if you want to change the theme, music, or other settings? Just move your mouse, then use the buttons on the slide show controller to display the themes browser, music panel, or settings panel.

Setting defaults. In a related vein, you can save instant slide show settings as defaults so that iPhoto applies them to subsequent slide shows. After making adjustments with the Slideshow Settings pane, click the check box labeled *Use settings as default.*

Where Exported Slide Shows Live

When you export a slide show, iPhoto creates a movie of its images, transitions, effects, and music. By default, those movies live in a folder named iPhoto Slideshows, which is contained within the Pictures folder of your home directory. However, you can choose where iPhoto saves the slide show movie.

Slide Shows, Facebook, and Flickr

As you'll find out a little farther on (specifically, on pages 94 and 98), you can share your photos online using either Facebook or Flickr—or both. The photo sets you share with these online services appear in the iPhoto sidebar under the Web heading.

You can browse these shared photo sets just as you can any other iPhoto album. But if you want an easy and fun way to review your shared photos, just select a shared photo set and click the Slideshow button on iPhoto's toolbar. The same instant slide show features that you saw earlier (see pages 78 to 83) work with Facebook and Flickr photos as well.

You can update your Facebook and Flickr photos from any Web browser on any computer. Say you're visiting an old friend and want to add some of her old photos of you to one of your shared Flickr sets. Using her computer's Web browser, log in to Facebook or Flickr, then add the photos to the set. When you get home, iPhoto will update the set on your Mac, and you can view the photos as a slide show.

Faces and Slide Shows

iPhoto's ability to recognize faces doesn't stop with the Faces feature. With slide shows, iPhoto tries to position photos containing faces in ways that don't omit part of a face. The automatic Ken Burns move will try to avoid facial damage, for example, as will the Sliding Panels theme. There's no tip here—just a little nod to the Apple engineers who sweated that detail.

Slide Show Strategies

Between iPhoto, iMovie, and iDVD, Apple's iLife apps give you three ways to present your photos. For quick results that look and sound great, it's hard to beat iPhoto. But other members of the iLife family bring their own advantages to the table (or the screen). The adjacent table summarizes them.

There's one more option: GarageBand. By exporting a slide show and then bringing that movie into GarageBand, you can add music, narration, sound effects, and chapter and URL markers, and you can even make the movie part of a video podcast.

Comparing Slide Show Options

Program	Pros and Cons
iPhoto	Provides a nice mix of quick results and broad creative options—plus cool themes, some with Ken Burns options. Limited ability to combine video and stills.
iMovie	Requires more effort, but gives you more editing control and creative options: titles, precise timing to music, fine Ken Burns control. Also provides cool themes, the most versatile features for combining video and stills, direct uploading to YouTube, and features for recording voice narration and creating richer soundtracks.
iDVD	Fewer creative options: all photos have the same duration; no Ken Burns moves; limited mixing of video and stills. But a unique and cool advantage: you can include original images on the DVD-ROM portion of the disc.

More Slide Show Tips

Use iPhoto to Create Titles

To earn some extra style points, sprinkle some titles into a slide show. For example, create a set of titles—one for each destination—for your vacation slide show. Sure, you can use the subtitle feature described on page 85, but you can go further.

You already have a great program for making titles. It comes with pre-designed styles that are ready for your own photos and text. The program is called iPhoto.

This trick has several steps. Here's the big picture: you're going to create a post-card, turn it into a PDF, convert that PDF into a JPEG, and then add the JPEG to iPhoto for use in a slide show.

Here are the details.

Step 1. Select the photo or photos that you want to be part of your title.

Step 2. Click the Create button at the bottom of the iPhoto window, and choose Card from the menu.

Step 3. Choose a flat card style, then choose a theme like Plain Bevel. (For details on creating greeting cards, see page 130.)

Step 4. Want text? Using the Layout button, click the front of the card and choose a layout that provides text. Type your text and perform any other design tweaks, such as modifying the text font or the card's background color.

Step 5. Choose File > Print.

Step 6. In the Print dialog, click the From button and be sure that the page range is *1 to 1*. (There's no need to create a PDF of the "back" of your postcard, unless you want to use it in your slide show, too.)

Step 7. Click the PDF pop-up menu and choose Open PDF in Preview.

Your Mac goes to work, and a few moments later, a PDF version of your postcard opens in Preview.

Step 8. In Preview, choose File > Export. Choose the JPEG option, and save the resulting JPEG someplace convenient, such as on your desktop.

Step 9. Import the JPEG you just saved into iPhoto by dragging it to the iPhoto icon or into the iPhoto window.

Your library now contains a JPEG of your postcard. To see it, click the Last Import item in the Recent list. (Now that you've imported the JPEG, you can delete the version you saved on your desktop.)

NEXT STOP: LONDON

Your JPEG title is ready for its screen debut. If you've already created a slide show, drag the title to the slide show in your Slideshows list. If you haven't created the slide show yet, add the title to the album where you've stashed the slide show's images.

Variations. To animate your title slides, use the Ken Burns effect. Here's a fun trick: follow your title with the same photo that you used in the title. Apply the Ken Burns effect to the title so that it zooms in slowly, ending at a point where the photo almost fills the viewing area. Use a dissolve effect between the title and the following photo. When you play your slide show, the title will zoom in, then its background and text will fade away, leaving just the photo.

You can also save a book or calendar page as a PDF, export it from Preview as a JPEG, and add it to a slide show. Making a slide show of a three-week road trip? Start it with a calendar page whose dates contain photos from the trip. Then, use the Ken Burns effect to pan across the calendar page.

Still using Leopard? If you're still using the older Mac OS X 10.6 Snow Leopard, this trick a bit easier. In iPhoto's Print dialog box, simply click the PDF pop-up menu and choose Save PDF to iPhoto. This lets you skip steps 7 and 8 in the process I just described.

Oh, and if you'd like to add the Save PDF to iPhoto option to Lion, you can. Go to Google and search for the phrase *lion save PDF to iphoto,* and you'll find instructions.

Sharing a Slide Show Using iChat Theater

You have yet another way to share a slide show: iChat Theater. This sublimely cool aspect of Apple's instant-messaging software lets you broadcast a slide show (among other things) to people with whom you're chatting. They'll see Ken Burns moves and transitions, and will even hear your background music.

And your friends don't have to be using the very latest Mac OS X version, either—earlier iChat AV versions can also view iChat Theater broadcasts, as can compatible instant-messaging software for Windows.

Note: iChat Theater can broadcast instant slide shows only; you can't broadcast a slide show project. (Workaround: export the slide show as a movie, then broadcast the movie using iChat Theater.)

Sharing an Instant Slide Show

Step 1. In iChat, choose File > Share iPhoto With iChat Theater.

A media browser appears.

Step 2. In the media browser, select an album, then click Share.

iChat tells you to invite a buddy to a video chat.

Step 3. Establish a video chat: select a name in iChat's Buddy List window, then click the video camera button (■) at the bottom of the window.

As soon as your victim accepts the invitation, the slide show begins.

Your Mac switches to iPhoto, where a window lets you control the slide show.

Notes and Tips

Already connected? The instructions at left assume that you haven't yet begun a video chat with someone. If you're already in a video chat, skip Step 3.

Sound options. Your chat buddy will hear whatever music you've assigned to the instant slide show. If your Mac has a microphone, your chat buddy will also hear you talk. If you'd rather not broadcast a music soundtrack—maybe you'd prefer to narrate—click the speaker button in the floating iPhoto control window. (You'll need to do this before starting the slide show broadcast.)

Conversely, if you don't want your buddy to hear you type or talk during a slide show, click the Mute button (🎤) in the Video Chat window.

Sharing Photos via Email

Email takes the immediacy of digital photography to a global scale. You can take a photo of a birthday cake and email it across the world before the candle wax solidifies. It takes just a few mouse clicks—iPhoto takes care of the often tricky chores behind creating email photo attachments.

What's more, iPhoto provides a gallery of attractive and useful email themes for mailing photos, whether to share snapshots casually, illustrate an announcement, or create a journal.

Some themes attach the photos you select directly into the body of the email; other themes create an image that artistically combines the selected photos and, optionally, allows you to attach the photos themselves separately as well. iPhoto can also make the attached images smaller so they transfer faster. Take advantage of this feature, and you won't bog down your recipients' email sessions with huge image attachments.

iPhoto's email themes are glitzy, but maybe you just want to send photos as attachments to ordinary email messages—perhaps so that your recipients can work with them in other programs. No problem: you can set up iPhoto to work with your email program (see page 92). Plain or fancy: it's up to you.

Setting Email Preferences and Accounts

To make iPhoto your photo emailer, you need to make a quick trip to iPhoto's Preferences. If you prefer to send photos using your existing email program, you can skip straight to page 92 to learn how.

Step 1. Choose iPhoto > Preferences, and then click General.

Step 2. Choose iPhoto from the Email Photos Using pop-up menu, and then close the Preferences window.

iPhoto uses the first email account in your Mac's Mail program to email your photos. If you have more than one account set up in Mail, you can select the account you want to use when you send the email.

If you don't use Mail as your Mac's email program, you can still set up email account information for iPhoto to use.

Step 1. Choose iPhoto > Preferences, and click Accounts.

Step 2. Click + and, in the Add Account dialog that appears, click Email, and then click Add.

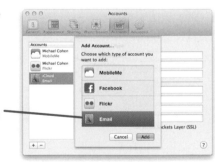

Step 3. In the Choose Service dialog, click your email provider (if your provider isn't shown, click Other), click OK, and then provide your email account information. Some of it may already be filled in.

Tip: Although you can't add CC or BCC addresses to an iPhoto email message manually, you can set an Advanced preference in iPhoto to automatically BCC email messages to yourself.

Creating an iPhoto Email Message

You can use up to 10 photos from any event, Faces collection, Places collection, or album in an iPhoto email.

Step 1. Select the photos you want to email. Remember that you can select multiple photos by Shift-clicking and ⌘-clicking.

Step 2. On the toolbar, click Share, and then choose Email from the Share pop-up.

Step 3. In the right sidebar, choose a theme.

Step 4. Address the message, edit the email's subject line if you like, and optionally choose an email account.

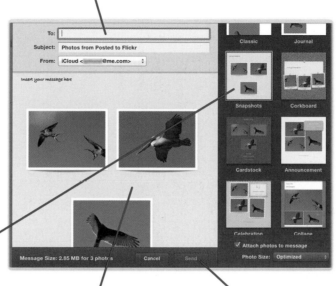

Step 5. Edit the contents of the email.

Step 6. Click Send.

Notes and Tips

Attaching photos, too. With most email themes, you can also have iPhoto include the selected photos as ordinary email attachments—simply check the box labeled *Attach photos to message*. This gives you the best of both worlds: fancy email designs and attachments that your recipients can work with.

When this box is checked, you can use the Photo Size pop-up menu to specify how large your photo attachments should be. The Optimized option provides a nice balance between file size and photo quality. If you anticipate your recipients may want to print the attachments, consider using the Large or Actual Size option.

Customizing the email. You can customize many aspects of an iPhoto email: change

fonts, rearrange photos, and even add additional photos from your library.

To change text formatting, click inside the email's text box, and then use the font panel that appears.

To have a different part of a photo appear, click on the photo and then drag the slider that appears above the photo. This can be a handy way to "crop" a photo without actually editing it.

To rearrange photos—for example, to change their order—drag them from one photo frame to another.

And more. If you Control-click (or right-click) on a photo in an iPhoto email, a shortcut menu appears that lets you edit the photo, mirror it (flip it so that it appears reversed), and more. They're many of the same options that iPhoto provides for print projects, such as books.

Tips for Emailing Photos

As you learned on page 90, iPhoto can create and send very attractive emails. But if you're like me, you might find that iPhoto's themes are overkill, if not downright gimmicky.

If you prefer your emails to be plain, not fancy, you're in luck: you can send your photos using your favorite email software just as easily as you can using iPhoto's built-in theme-rich email capability.

All it takes is a quick trip to iPhoto's Preferences.

Step 1. Choose iPhoto > Preferences, and then click General.

Step 2. Choose your preferred email program from the Email Photos Using pop-up menu, and then close the Preferences window.

Once you've set your email program as the preferred photo emailer, sending photos is a snap.

Step 1. Select the photos.

Remember that you can select multiple photos by Shift-clicking and ⌘-clicking.

Step 2. On the toolbar, click Share, and then choose Email from the Share pop-up.

iPhoto displays the Mail Photo dialog.

Step 3. Specify a size, then click Compose Message.

iPhoto can make the images smaller before emailing. (This doesn't change the dimensions or file sizes of your original images.)

iPhoto estimates the size of the final attachments.

Don't want to share the location information of geotagged photos? Be sure the box is unchecked.

When you click Compose Message, iPhoto adds the photos to a new, blank email, which you can complete and send on its way.

You have the option to include titles and comments along with the images—another good reason to assign this information when organizing your photos.

Tip: Another way to send photos as email attachments is to drag photos from the iPhoto window to the icon of your email program in the Dock. The downsides of this approach are that you can't include titles and comments, nor can you use iPhoto to fine-tune the size of the photo attachments.

Exporting Photos by Hand

When you email a photo using iPhoto's Share button, iPhoto uses the name of the original photo's disk file as the name of the attachment. Problem is, most of your photos probably have incomprehensible filenames, such as *200203241958.jpg*, that were assigned to them by your digital camera.

You might want an attachment to have a friendlier filename, such as *holidays.jpg.* For such cases, export the photo "by hand" and then add it to an email as an attachment. Choose Export from iPhoto's File menu, and be sure the File Export tab is active.

Export the photo as described at right. Save the exported photo in a convenient location, such as on your desktop. (You can delete it after you've emailed it.) Finally, switch to your email program, create a new email message, and add the photo to it as an attachment.

The settings below are good starting points for exporting a photo by hand. Here are a few more details and pointers.

The JPEG format is best for emailing, but you might choose the TIFF format if you're exporting a full-resolution version of a photo for use in a page-layout program.

Higher quality settings mean larger image files. Medium is a good compromise.

When you check this box, iPhoto adds the photo title and any keywords to the image's metadata (see page 140). This is useful if you plan to use the photo with other image-management programs, such as Apple's Aperture or Adobe Lightroom.

For emailing, Medium is a good size. You have additional options, though, including the ability to specify exact pixel dimensions.

As with emailing, you can elect to include or omit any geotags the photos might have.

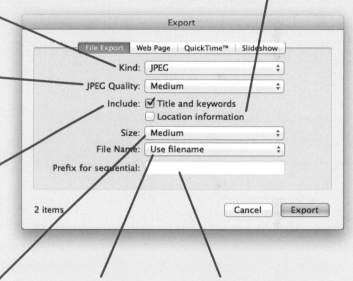

If you titled a photo (page 22), you can have iPhoto use the title as the exported photo's filename. When exporting just one photo, you can choose Filename and then type a name after clicking Export.

Exporting multiple photos? You can choose Sequential from the File Name pop-up menu, and then type a prefix here. iPhoto names the files accordingly. For example, if you type *dog* as the prefix, the files are named *dog1.jpg, dog2.jpg, dog3.jpg*, and so on.

Sharing Photos on Facebook

Facebook is the most popular social networking site on the Internet, a place with nearly a billion members, most of them ex-classmates, ex-girlfriends, or ex-boyfriends of yours.

OK, I'm joking about that last part, but it is true that millions of people use Facebook to connect with old friends in addition to making new friends and staying in touch with colleagues and family.

You can do several different things on Facebook: post links to interesting Web sites you've seen, join groups and discuss topics you care about, play games, give virtual gifts (I prefer real ones, thank you), and peck out short status messages that let your Facebook friends know what's on your mind.

You can also publish photos, and that's what we're here to talk about. iPhoto lets you publish photos from your iPhoto library directly to your Facebook account. You can control who is able to see the photos, from everyone on Facebook to just your friends.

iPhoto also helps put the *face* in Facebook. For example, if you've named the faces in a photo, iPhoto automatically adds those names to the photo's tags on Facebook. (A *tag* in Facebook is like a keyword in iPhoto: an information tidbit that helps categorize a photo.)

As I describe on these pages, the conduit between iPhoto and Facebook is a two-way street. Here's how to get your photos in front of all those ex-classmates.

Facebook Publishing Essentials

To get the most out of the iPhoto-Facebook connection, it helps to understand a couple of essential concepts.

Getting set up. When you publish from iPhoto to Facebook for the first time, you need to enter the email address and password that you use to log in to Facebook.

Faces information. Facebook can notify people via email when you upload photos containing them. This works nicely with the Faces feature in iPhoto—*if* you set it up to begin with.

The process begins at the Faces corkboard. Select the tile of the person, then click the Info button at the bottom of the iPhoto window. Type the person's full name and email address in the fields.

Important: Be sure to type the person's name and email address exactly as they're set up on Facebook. (To verify that information, go to the Info tab on the person's Facebook profile page.) If you type a variation of the name or a different email address, Facebook won't notify the person when you upload a photo of him or her.

Publishing Photos to Facebook

When you publish to Facebook, iPhoto creates a new album on Facebook for the photos. Even if you publish just one photo, iPhoto creates a new album for it.

Step 1. Select the photos you want to publish.

You can select several photos, an entire event or album, a tile on the Faces corkboard, or just one photo.

Step 2. Click the Share button on the bottom tool-bar, and then choose Facebook from the menu.

Step 3. In the Facebook Albums menu, choose whether to create a new album with your photos, add them to an existing album, use them as profile pictures, or post them on your Facebook wall.

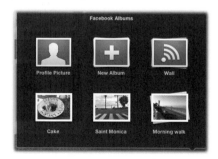

Step 4. Choose publishing options, then click Publish.

iPhoto proposes using the name or event containing the photo as the name of the new album on Facebook. If you select someone's tile on the Faces corkboard, iPhoto proposes that person's name. However, you can rename the album before you publish.

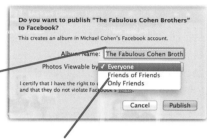

Control who can see the photos (see the table below).

Facebook Privacy Options

With This Option	Photos Can Be Viewed By
Everyone	Your friends and people on your networks, as well as friends of anyone who is tagged in the photos.
Friends of Friends	Your friends and their friends, even if they aren't your friends.
Only Friends	Only your friends. This is the most restrictive option, and the one I often prefer to use.

Click your Facebook account in the iPhoto sidebar under the Web heading to see your Facebook albums.

When you view a Facebook album, you can open it in your Web browser by clicking the ⬁ button above the album in the iPhoto window.

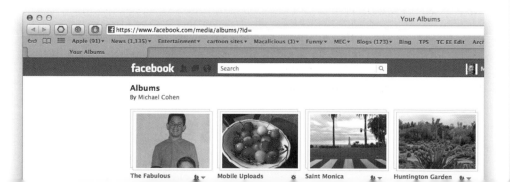

Tips for Facebook Publishing

Editing a Published Album

You can add photos to, and remove them from, a published album. And you can do it using iPhoto or your Web browser.

Editing an album in iPhoto. To add more photos, select the photos in an event, album, or other collection in your iPhoto library. Then, click the Share button on iPhoto's toolbar and choose Facebook. Finally, in the Facebook Albums menu, choose the album to which you want to add the photos.

To rename an album, select the album's name in iPhoto and type your changes.

Similarly, you can edit a photo—crop it or adjust its exposure, for example—that you've published from iPhoto (you can't edit photos that you published to Facebook some other way—such photos have a icon in the lower-left corner). Open the Facebook album that contains the photo, then open the photo in edit view. When you finish, click the Edit button again to leave edit view.

To remove a photo from a Facebook album, open the Facebook album by double-clicking its thumbnail. Next, select the photo and press the Delete key. If you see a confirmation dialog, click its Remove Photo button to confirm the deletion (you can avoid that dialog in the future by selecting its Don't Ask Again check box).

Editing an album in Facebook. You can also use your Web browser to edit an album directly in Facebook—adding, removing, and changing the order of photos. It's easier to use iPhoto, but maybe you want to work on an album using your Windows PC while at the office. (Hey, that's why I call it social not-working.)

When you return to iPhoto and view the album, iPhoto updates the album, downloading photos you added and removing photos you deleted.

Changing an album's settings. Having second thoughts about allowing people who might not be your Facebook friends to see photos in an album? Change the settings. Select the published Facebook album, then click the Info button in the lower-right corner of the iPhoto window. Use the Album Viewable By menu to change the privacy settings as described on page 95.

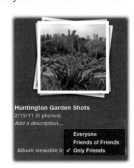

Deleting an album. To delete an album and its photos from Facebook, select the album, then choose Photos > Delete Album. When iPhoto displays "are you sure?" dialog, click Delete. As is always the case in iPhoto, deleting an album doesn't delete the photos it contains—that is, it won't delete those photos that were published to it from your iPhoto library; it just nixes the album. However, you *will* lose any photos in the album that weren't published from your iPhoto library if you haven't previously imported them to your library. So, when in doubt, when it comes to Facebook albums, import first, then delete.

Removing Your Account

If you want iPhoto to forget you even have a Facebook account—maybe because you want to sign in using a different Facebook account—choose iPhoto > Preferences and then click the Accounts button. Find your Facebook account in the list of accounts, click it, and then click the minus (–) button beneath the list. You will be asked to confirm the account deletion.

When you remove a Facebook account from iPhoto, it doesn't change what's posted on Facebook, but iPhoto does put any photos from your Facebook albums that you haven't previously imported into iPhoto's Trash. Luckily, you needn't root through the trash for your discarded treasure: iPhoto offers you the opportunity to import the photos before deleting the account.

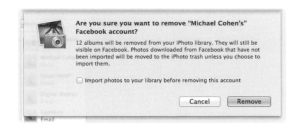

From Facebook to Faces

In Facebook, people who view a photo can use their browsers to add tags that identify the people in the photo.

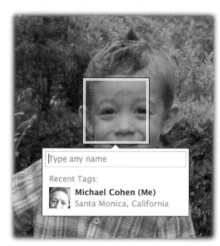

When you sync that photo's album with iPhoto (which you do simply by opening the album in iPhoto), iPhoto reads those tags and passes them on to its Faces feature.

The next time you open that photo in naming view (that is, by selecting the photo and clicking the Name button), you'll see something new: a label for that person's face.

Notice that the label contains the Facebook logo. This is iPhoto's way of saying, "Hey, someone on Facebook added a name tag for this photo. Because the Internet is full of ex-classmates and other crazies, I'm not going to take that at face value. (Get it?) So I'll put the Facebook logo here to let you know this isn't a label that you created. And by the way, until you say this is legit, I'm not going to put a new tile for this person on the corkboard."

What next? To accept the label, click the Facebook logo in the label, fine-tuning the spelling of the name if you like. The Facebook logo disappears, and iPhoto creates a Faces tile for that person on the corkboard. Now (or later) you can go through your library and confirm that person in other photos using the maneuvers on pages 26–29.

There's a second level of protection against faithless Facebook taggers: you'll see the label only if iPhoto's face recognition software recognizes that the tagged item is a face. If someone tags something in a Facebook photo that iPhoto doesn't recognize as a face, you won't see a tag. This helps guard you against Facebook "friends" who might tag a photo of a potted plant (or something less polite) with your name.

Sharing Photos on Flickr

For a serious amateur photographer, there's no better place than Flickr for inspiration and encouragement. Publish your photos, and they become part of your *photostream*—Flickr lingo for your library. Give your photos *tags*—similar to iPhoto keywords—that help you and other Flickr members search. Organize photos into *sets*, which are like albums in iPhoto.

To help people find your shots, submit them to *groups* that deal with subjects relevant to the photos. There are groups for photos of dogs, cats, bridges, food, and, really, anything you can imagine.

Add other Flickr members as *contacts* so you can easily keep an eye on their photos. Comment on each other's images, and add photos you like to your *favorites* so you can go back and enjoy them again. And visit the Explore area to swoon over the most popular of the many thousands of photos that are published on Flickr every single minute.

For a casual photographer, Flickr is a great way to share photos with friends and family. Privacy controls enable you to restrict access to those Flickr contacts whom you've designated as friend or family.

iPhoto lets you publish photos to Flickr with a couple of clicks. A Flickr account is free, but a "Pro" account ($25 per year) gives you much more, including the ability to upload more photos per month. Sign up at flickr.com/upgrade.

Flickr Publishing Essentials

Here are a couple of tidbits you'll want to know before beaming photos from iPhoto to Flickr.

Getting set up. The easiest way to start setting up Flickr is to attempt to share a photo with the service: select a photo, choose Share > Flickr, and you see this dialog.

Click the Set Up button, and iPhoto switches you to your browser, which opens the Yahoo sign-in page. (Flickr is owned by Yahoo.) After you sign in, follow the instructions to authorize the iPhoto uploader. You know you've reached the right place when you see a big, friendly OK, I'll Authorize It button.

Click this button, and another Flickr page notifies you that you successfully authorized "iPhoto Uploader." Now you can return to iPhoto and actually publish something.

Check out my Flickr photos.
www.flickr.com/jimheid

Publishing Photos to Flickr

Step 1. Select the photos you want to publish.

You can select several photos, an entire event or album, a tile on the Faces corkboard, or just one photo.

Step 2. Choose Share > Flickr, or click Share on the iPhoto bottom toolbar and then click Flickr in the menu that appears.

Step 3. Choose whether to add the photos to an existing set, create a new set, or just toss them directly into the photostream.

Step 4. Choose publishing options, then click Publish.

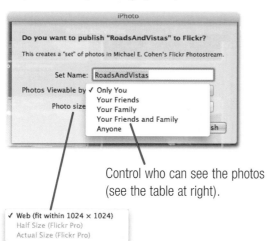

Control who can see the photos (see the table at right).

✓ Web (fit within 1024 × 1024)
Half Size (Flickr Pro)
Actual Size (Flickr Pro)

The Web option is best if you don't anticipate wanting to order large prints. (You've got iPhoto for that anyway.) Another plus: choosing Web lessens the chances that someone will steal your photo and use it for a print project—an occasional problem with photos published for public viewing.

Flickr Privacy Options

With This Option	Photos Can Be Viewed By
Only You	Guess! Consider this option when you want to use Flickr to back up photos you're shooting on the road: upload full-size versions that only you can access.
Your Friends	Flickr contacts whom you've designated as friends. Your other Flickr contacts won't be able to see the photos, nor will anyone else.
Your Family	Flickr contacts whom you've designated as family. Your other Flickr contacts won't be able to see the photos, nor will anyone else.
Your Friends and Family	Contacts whom you've designated as friend, family, or both.
Anyone	Guess! When you want to share your photos with the world, not just a select group, use this option.

To see your uploaded sets, click the Flickr item in the iPhoto sidebar—it's under the Web heading. This item shows you your uploaded Flickr sets but not the photos in your photostream that aren't in any set. But you *can* see them all, and more, on the Flickr site itself: to get there, click the arrow button (◉) at the top of the Flickr pane.

Tips for Flickr Publishing

Notes and Tips

What iPhoto publishes. When you publish a photo, its title becomes the photo's title on Flickr. If you gave the photo a description in iPhoto, the description becomes the photo's caption on Flickr. And, if you use keywords, the iPhoto uploader turns them into Flickr tags.

Editing published photos. When it comes to editing and adding to published albums, the same basic concepts on page 96 also apply to Flickr. If you change a photo in an album you published—edit it to improve its appearance or type a title or description—iPhoto syncs with Flickr and updates the set to which the photo belongs. Note that you can only change photos in iPhoto Flickr albums that you uploaded from iPhoto; photos downloaded to iPhoto from Flickr are read-only in iPhoto.

Similarly, if you add a photo to a published Flickr set in iPhoto, iPhoto uploads it to that album's set. If you delete a photo from a published set, iPhoto removes it from Flickr.

As with Facebook, changes you make using your Web browser are reflected in iPhoto. If you change the title or caption of a photo using your Web browser, iPhoto retrieves the latest text and updates the album. If you add a photo to the set, iPhoto retrieves the photo and adds it to the album (albeit in read-only form unless you choose to import it). It's all pretty cool.

Locations and Maps

Like geotagging and maps? Flickr was hip to them long before iPhoto. Flickr taps into the Yahoo maps that its parent company does so well. And as with iPhoto, you can place photos on a map yourself or have Flickr use the geotagging information in photos that have it.

Since you're already taking the time to geotag some photos in iPhoto (right?), you can have iPhoto pass that information on to Flickr, which will, in turn, place your photos on your Flickr map.

But this process doesn't happen automatically. To protect your privacy, both iPhoto and Flickr have some location-related features turned off. To have geotagged photos appear on the map in Flickr, follow these steps.

Step 1. In iPhoto, choose iPhoto > Preferences, then click the Advanced button and check the box labeled *Include location information for published photos.*

Step 2. In your Web browser, go to flickr.com/account to display your account page.

Step 3. Click the Privacy & Permissions tab, and scroll down to the *Defaults for new uploads* set of options. You'll find two location-related options there.

NEW **Who will be able to see your stuff on a map**	Anyone
Import EXIF location data [?]	No

In this example, Flickr is set to show location information to anyone who views a photo. But you can also restrict map access to only yourself, to only contacts, or to only those contacts who are family or friends.

Step 4. Tweak the location settings by clicking the Edit link to their right (not shown at lower left). Specify the map privacy option you want, and then change the *Import EXIF location data* option to read *yes*.

From now on, when you publish a geotagged photo, iPhoto will send its location information to Flickr, which will add the photo to your Flickr map.

This photo was taken on October 17, 2003 in Camden, Maine, US, using a Nikon E950.

©Yahoo!2010, Data©NAVTEQ2009

Flickr to iPhoto: get lost. iPhoto can ferry location information *to* Flickr, but Flickr doesn't have the ability to send location information *to* iPhoto. That means this: if you use Flickr to geotag a photo that you published using iPhoto, don't expect that photo to suddenly show up in your Places list.

The RSS Angle

If you like to use an RSS newsreader to keep up with the world, you'll love Flickr RSS feeds. Subscribe to someone's photostream, and small thumbnails appear in your newsreader when that person uploads new photos. You can also subscribe to specific tags. Subscribe to the *beach* tag, and your newsreader will show everyone's beach photos as they're uploaded.

Subscribing in iPhoto. You can even subscribe to Flickr RSS feeds in iPhoto

itself. Say you'd like to subscribe to my photo feed. (I'm flattered!) Go to my Flickr page (flickr.com/jimheid), scroll to the bottom of the page, and locate the Subscribe links. Control-click the one that reads *Latest*, then choose Copy Link from the shortcut menu.

Next, switch to iPhoto, and choose File > Subscribe to Photo Feed. Choose Edit > Paste, then press Return.

My photo feed is added to your Subscriptions list, and iPhoto loads thumbnails of my most recent posts.

And remember, Flickr generates feeds for just about everything, including groups. Want to keep an eye on photos added to the Standard Poodle group? Subscribe to its feed. And by the way, you're my kind of person.

Power Publishing with FlickrExport

iPhoto's built-in Flickr support is cool and convenient, but it doesn't do everything serious Flickrites need. For more publishing power, try the FlickrExport plug-in from Connected Flow (www.connectedflow.com).

Unlike iPhoto, FlickrExport supports groups: add your photos to the groups you belong to by simply clicking check boxes when you publish them.

FlickrExport also has great geo-tagging support, and it gives you more control over the size of the images you upload to Flickr.

What do you lose by using FlickrExport? The slick, two-way integration that iPhoto's built-in Flickr support provides. But for serious Flickr addicts like me, that's less important than FlickrExport's great support for groups and its fine-grained control over uploads. iPhoto's

built-in Flickr support is perfect for occasionally publishing an album of photos, but for daily

(if not hourly) Flickr addicts, FlickrExport is the tool of choice.

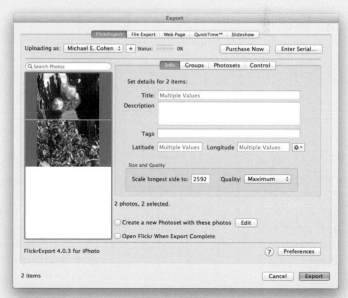

Sharing Photos on a Network

If you have more than one Mac on a network, you can share each Mac's photo libraries and make them accessible to the other Macs on the network, as well as to a second-generation Apple TV.

Network photo sharing leads to all kinds of possibilities. Keep your "master" photo library on one Mac, and then access it from other Macs when you need to—no need to copy the library from one Mac to another and worry about which library is the most current.

Don't like centralization? Embrace anarchy: let everyone in the family have his or her own photo library, and then use sharing to make the libraries available to others.

Have an AirPort-equipped laptop Mac or an Apple TV 2 connected to your HDTV? Sit on the sofa (or at poolside) and show your photos to friends and family. Or take your laptop or Apple TV 2 to their house and browse their libraries. Network sharing, a laptop Mac or Apple TV, and AirPort form the ultimate portable slide projector.

You can choose to share an entire photo library or only some albums, events, and faces. And you can require a password to keep your kids (or your parents) out of your library.

● Activating Sharing

Sharing with other Macs. To share your photo library with other Macs on a network, choose Preferences from the iPhoto menu, click the Sharing button, and then click the Share My Photos check box.

To have iPhoto display the names of shared libraries it finds on the network, check this box.

You can share your entire library or only selected albums. To share a specific album, click its check box.

To turn sharing on, check this box.

To password-protect your shared photos, check this box and specify a password.

The name you specify here appears in other users' copies of iPhoto, as shown at right.

Sharing to Apple TV. To share your photos to your Apple TV, you need to use iTunes. Open or switch to iTunes, then choose Advanced > Choose Photos to Share.

Click the Share Photos From check box, and be sure iPhoto is selected in the pop-up menu.

Specify whether to share all photos, or just selected albums, events, and faces.

You can also share videos that are in your iPhoto library.

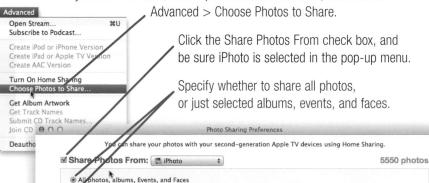

Accessing Shared Photos

To access shared photos, choose Preferences from the iPhoto menu, click the Sharing button, and be sure the Look for Shared Photos box is checked. iPhoto scans your network and, if it finds any shared photo libraries, adds their names to the Shared area of the Library list.

To view a shared library, click its name.

To view albums in a shared library, click the disclosure triangle next to the library's name.

To disconnect from a shared library (perhaps to reduce traffic on your network), click the Eject button.

Working with Shared Photos

No Can Find

You can browse, but you can't search. That is, you can't use iPhoto's searching features to look for specific photos in a shared library. Indeed, when you select a shared library, the Search button isn't visible.

Slide Show Music

You can view an instant slide show of a shared album, but if the shared album has music assigned to it, you won't hear that music. Instead, iPhoto plays the music for whatever theme you choose.

But here's an interesting twist: you can temporarily assign a song or playlist from *your* local

iTunes library to a *shared* album. Just use the techniques described on page 80.

When you assign local music to a shared album, iPhoto doesn't save your assignment. If you disconnect from the shared album and then reconnect, it's back to whatever your chosen theme's song happens to be.

Just Looking

You can view shared photos, and you can email them, order prints, and display a basic slide show. But you can't edit or print shared photos, nor can you send them to iWeb or access them from the photo browsers in the other iLife programs.

To perform these tasks, copy the shared photos you want to your local iPhoto library: select the photos, then drag them to the Library item or to an album.

And what about adding shared photos to slide show projects, calendars, cards, or books? You can do it: if you drag a photo to one of these items in your Library list, iPhoto imports the photo, adds it to your local library, and then adds it to the item.

Note: If you copy shared photos to your library using any of these techniques, iPhoto does not copy the photos' keywords to your local library. If you want to copy some photos to your local library and preserve this information, burn the photos to a CD or DVD (see page 134) and then copy

the photos from the CD or DVD to your library.

Folders and Shared Libraries

If you store albums in folders, as I suggest on page 45, you'll be in for an unpleasant surprise when you connect to your library from a different Mac. iPhoto doesn't display the individual albums within a folder. Instead, it simply displays the name of the folder containing the albums. If you select the folder's name, you'll see the photos in *all* of the albums contained in that folder.

The unfortunate moral: when you want to be able to connect to a specific album from a different Mac, don't store that album in a folder.

Printing Photos

Internet photo sharing is great, but hard copy isn't dead. You might want to share photos with people who don't have computers. Or, you might want to tack a photo to a bulletin board or hang it on your wall. And there's just something special about a printed artifact.

iPhoto makes hard copy easy. If you have a photo-inkjet printer, you can use iPhoto to create beautiful color prints in a variety of sizes. This assumes, of course, that your photos are both beautiful and in color.

When printing your photos, you can choose from several formatting options, called *themes*. You can produce standard prints, but you can also choose themes with elegant borders and mat designs.

Want even more control? A click of the mouse gives it to you. Adjust a photo's appearance, add a text caption, choose different background styles, and more.

So go ahead and beam your photos around the world on the Internet. But when you want something for your wall (or your refrigerator door), think ink.

Printing Standard Prints

A standard print contains just the photo, with no ornamental borders or mats.

Step 1. Select the photo or photos you want to print.

Step 2. Choose File > Print.

Step 3. Choose printing options, then click Print.

For a look at other printing themes, see the opposite page.

Adjust the photo's appearance, add a caption, and more (see page 108).

If you selected multiple photos, you can preview each print by clicking the arrows.

Choose your printer here.

Choose paper and quality settings. For highest quality, choose an option with Fine in its name.

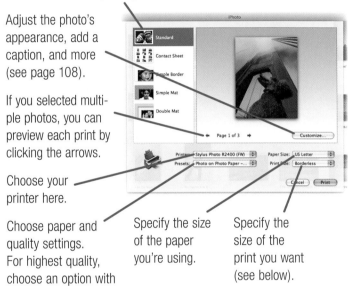

Specify the size of the paper you're using.

Specify the size of the print you want (see below).

Notes and Tips

Choosing a print size. Most of the time, you'll want a photo to fill the page. But you can also choose a print size that is smaller than the paper size you've chosen. A small image floating within a large expanse is a common framing technique.

Another reason to choose a small print size is to get more than one photo on a sheet of paper—to shoehorn a couple of 4- by 6-inch prints onto a letter-sized sheet, for example (see page 108).

Going borderless. To produce borderless prints, your printer must support borderless printing and you must choose a borderless paper option using the Paper Size pop-up menu.

Beyond Standard Prints

With the print themes in iPhoto, you can produce prints with borders, mats, and more. And by clicking the Customize button in the Print dialog, you can personalize the themes to match your photos and tastes. For details on customizing print jobs, see the following pages.

Contact Sheet

Prints numerous photos on a page—a handy quick-reference to the photos in an event, album, face, or place. Select multiple photos (or one of the aforementioned items) before choosing Print.

Customizing: Change the background of the page as well as how many images appear across each row. Print titles, captions, dates, and exposure information beneath thumbnails.

Simple Border

Adds a wide border around the image.

Customizing: Change the border style and choose from several layouts, some with text captions and multiple photos on a page.

Single Mat

Simulates the stiff cardboard mat that a framing shop uses to accent a photo and set it off from its frame. The mat has a bevel-cut opening through which the photo appears.

Customizing: Choose from 26 mat colors and styles. Add a white border inside the mat. Choose from several layouts, some with text captions and multiple photos on a page.

Double Mat

Simulates a framing technique that involves using two mats to provide a richer look. A top mat has a large opening that reveals a bottom mat, whose smaller opening reveals the photo.

Customizing: Choose from 26 mat colors and numerous border styles. Choose from several layouts, some with text captions and multiple photos on a page.

Customizing a Print Job

For creating basic prints, the steps on the previous pages are all you need. But you can go beyond the basics to customize many aspects of a print job.

Change the eye candy. Every print theme lets you add a text caption and choose various design layout options. Even the Standard theme provides customizing opportunities, including the ability to print borders and text captions.

Adjust the photo. Here's one of those "local editing" opportunities I discussed back on page 50. You can crop a photo and adjust its exposure, sharpness, and other settings for just a single print—no need to edit the original (and thus change the photo's appearance elsewhere, such as in a slide show).

Print Settings View at a Glance

To customize a print job, click the Customize button in the Print dialog. This opens iPhoto's *print settings view*.

To print multiple photos at once, select them before choosing Print. Use the buttons to the left of the thumbnails to switch between viewing pages (shown here) and the photos used in them.

Reposition a photo within the print area (see opposite page).

Apply your settings and print the photos.

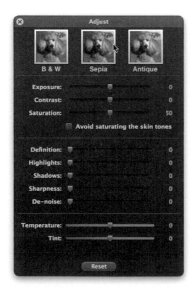

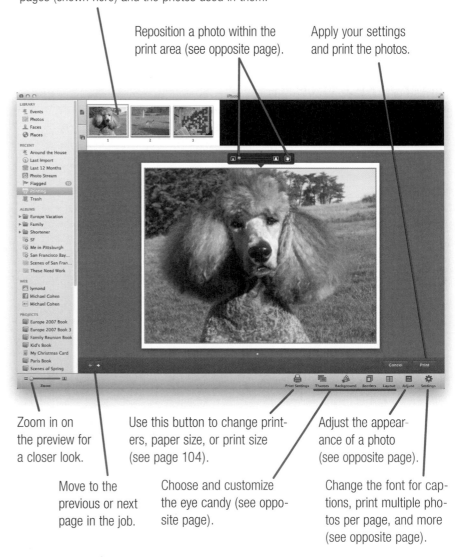

Zoom in on the preview for a closer look.

Use this button to change printers, paper size, or print size (see page 104).

Adjust the appearance of a photo (see opposite page).

Move to the previous or next page in the job.

Choose and customize the eye candy (see opposite page).

Change the font for captions, print multiple photos per page, and more (see opposite page).

Perfecting Your Print

Here are the two most common adjustments you can make—ones from which any print job can benefit.

Adjust "cropping." A photo's proportions rarely match the proportions of the paper size you're using. I don't know of any digital camera whose photos perfectly fit an 8.5- by 11-inch sheet.

With some programs, mismatched proportions yield prints with uneven borders. iPhoto eliminates that problem by enlarging an image until it fits the dimensions of the print size you chose. That gives you nice, even borders (or a

fully borderless print), but at a price: parts of the photo's edges are cut off. In this example, iPhoto cut off part of Sophie's ear (ouch).

By positioning a photo within the print area, you can control how the photo is cropped. Click the photo, then use the controls above it to zoom and reposition the photo. You can see the results on the opposite page: I dragged Sophie (gently!) to fix the unwanted ear surgery.

Adjust appearance. To adjust exposure, contrast, and other image settings, select the photo and click the Adjust button. The Adjust pane, shown on the opposite page, is similar to its counterpart in edit view (pages 58–67), but changes you make here apply only to this print job.

Sharpen up. The single best adjustment you can make is to sharpen. Ink-jet printers introduce some softness, and sharpening can help. Don't be afraid to crank the sharpness way up—even to 100 percent. Make some before-and-after prints and judge for yourself.

Tip: The one downside of making "local" image adjustments is that iPhoto doesn't save your settings. If you want to make another print a week later using the same settings, you'll have to recreate them by hand. If you anticipate wanting to repeat a print job, jot down the Adjust pane settings you've made.

More Ways to Customize

Use the Background, Borders, and Layout pop-up menus to explore each theme's design options. Here are some tips.

Add a caption. To print a text caption at the bottom of a print, use the Layout pop-up menu to choose a layout with text.

Type the text below the photo. To change the font and size of the entire caption, click Settings. To mix and match fonts within the caption, use the Fonts pane. For details and tips, see page 122.

Multi-photo layouts. Most theme layouts provide options that print two or more photos on a page.

But what if you selected only one photo before choosing Print?

No problem—just add more photos to the print job. When you open print settings view, an item named Printing appears in your Recent list. To add photos to the print job, drag their thumbnails to the Printing item.

Then, click the Printing item. iPhoto automatically creates additional pages for the new

photos, but you can rearrange the photos as you see fit. To remove a photo from a page, select it and press Delete. To see all the photos in the print job, click the ▣ button in the thumbnail browser.

Mix and match settings. Normally, when you change a print background or border, iPhoto applies the change to *all* the pages in the print job. But you can also apply changes on a page-by-page basis: just hold down the Option key while choosing a background or border.

Printing Tips and Troubleshooting

Multiple Copies

By tweaking a few print settings, you can print multiple copies of a photo on a single sheet of paper. Have a cute kid photo that you want to send around? Print multiple 4- by 6-inch photos on a letter- or legal-sized sheet, then cut them apart.

Step 1. Select the photo and choose File > Print.

Step 2. Choose the paper size you're using, such as Letter or Legal.

Step 3. From the Print Size pop-up menu, choose a smaller size, such as 3 x 5 or 4 x 6.

Step 4. Click the Customize button.

Step 5. In print settings view, click the Settings button at the bottom right of the iPhoto window (not to be confused with the Print Settings button).

Step 6. In the dialog that appears, from the Photos Per Page pop-up menu, choose Multiple of the Same Photo Per Page, then click OK.

Step 7. Click the Print button.

Tips: iPhoto can print guides to help you cut the photos apart. In the Settings dialog, click the Show Crop Marks box.

You can also use this technique to print multiple photos (but not the same one) on a single sheet of paper. Select several photos, then perform steps 1–5. In Step 6, choose the option labeled Multiple Photos Per Page.

Kill the Cropping

On previous pages, I discussed how iPhoto prevents uneven borders by enlarging a photo until it fills the paper size you've chosen. And I described how you can use print settings view to zoom and pan a photo to crop it as you see fit.

But what if you don't want any cropping at all? Easy. In print settings view, Control-click a photo and, from the shortcut menu, choose Fit Photo to Frame Size.

Your print will almost certainly have some uneven borders, but it will contain every precious pixel of your original image. You can trim the borders by hand after printing.

Save a PDF

Remember that you can save a print job as a PDF file and use it elsewhere, such as in an iPhoto or iDVD slide show, a print project, or an iMovie project. After customizing the print job, click the Print button. In the final print dialog (the one you see when you're actually ready to commit ink to paper), use the options in the PDF pop-up menu to create a PDF.

PDF to photographic print. You can combine this PDF technique with Apple's online print-ordering service (page 110). The result: the ability to design a fancy print and then have it printed by Apple.

Design a print, first making sure to choose a paper size that corresponds to the print size you'll order. (For example, if you plan to order an 8 by 10, choose the 8 x 10 paper size.)

Next, use print settings view to choose mats and borders and adjust the photo as desired. Click the Print button, then use the PDF pop-up menu and choose Open PDF in Preview. In Preview, save the print as a JPEG image and then import that JPEG image back into iPhoto.

When iPhoto has finished importing the image, select it and choose File > Order Prints. Complete your print order as described on page 110.

When Prints Disappoint

When your prints aren't charming, read on.

Verify paper choices. In iPhoto's Print dialog, be sure to choose the preset that matches the type of paper you're using and the quality you're seeking. It's easy to overlook this step and end up specifying plain paper when you're actually using pricey photo paper.

Check ink. Strange colors? Check your printer's ink supply. Many printers include diagnostic software that reports how much ink remains in each cartridge.

Clean up. The nozzles in an inkjet printer can become clogged, especially if you don't print every day. If you're seeing odd colors or a horizontal banding pattern, use your printer's cleaning mode to clean your ink nozzles. Most printers can print a test page designed to show when the nozzles need cleaning. You may have to repeat the cleaning process a few times.

Preserving Your Prints

After all the effort you put into making inkjet prints, it may disappoint you to learn that they may not last long.

Many inkjet prints begin to fade within a year or two—even faster when displayed in direct sunlight. Most printer manufacturers now offer pigment-based inks and archival papers that last for decades, but pigment-based printers are pricier than the more common dye-based printers.

If you have a dye-based printer, consider using a paper rated for longer print life. Epson's ColorLife paper, for example, has a much higher permanence rating than Epson's Premium Glossy Photo Paper.

To prolong the life of any print, don't display it in direct sunlight. Frame it under glass to protect it from humidity and pollutants. (Ozone pollution, common in cities, is poison to an inkjet print.)

Allow prints to dry for at least a few (preferably 24) hours before framing them or stacking them atop each other.

For long-term storage, consider using acid-free sleeves designed for archival photo storage.

Finally, avoid bargain-priced paper or ink from the local office superstore. Print preservation guru Henry Wilhelm (www.wilhelm-research.com) recommends using only premium inks and papers manufactured by the same company that made your printer.

Is all this necessary for a print that will be tacked to a refrigerator for a few months and then thrown away? Of course not. But when you want prints to last, these steps can help.

To learn more about digital printing, read Harald Johnson's *Mastering Digital Printing, Second Edition* (Muska & Lipman, 2005).

Ordering Prints

Inkjet photo printers provide immediate gratification, but not without hassles. Paper and ink are expensive. Getting perfectly even borders is next to impossible, and getting borderless prints can be equally frustrating.

There is another path to hard copy: ordering prints through iPhoto. Choose the Order Prints command, specify the print sizes you want, and iPhoto transmits your photos over the Internet to Apple's print service. The prints look great, and because they're true photographic prints, they can last longer than inkjet prints.

You can also order prints from other online photofinishers, many of whom also offer free online photo albums and other sharing services. Using these services isn't as straightforward as clicking a button in iPhoto, but it isn't difficult, either. Many services, such as Shutterfly (www.shutterfly.com), offer software that simplifies transferring your shots. The Flickr online photo-sharing site also offers print-ordering services.

And some services offer output options that iPhoto doesn't, such as mouse pads, T-shirts, and even photo cookies. For links to some online photofinishers, see www.macilife.com/iphoto.

To Order Prints

Step 1. Select the photos you want prints of, then choose File > Order Prints.

Step 2. Specify the sizes and quantities you want, then click Buy Now.

The yellow triangle of doom (⚠) indicates that the photo doesn't have enough resolution for good quality at that size; see the sidebar at right for details.

Want to order a quantity of a certain size? Choose the size here, then click the arrows to specify the quantity.

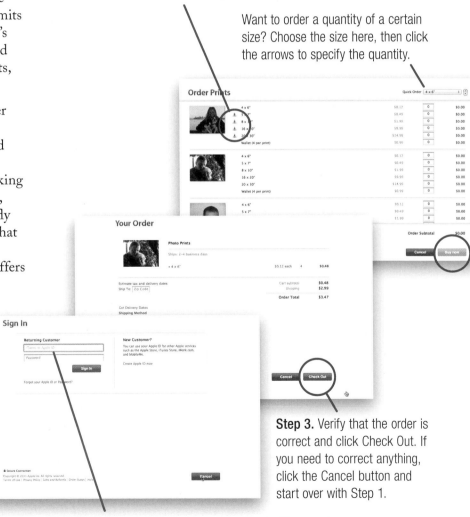

Step 3. Verify that the order is correct and click Check Out. If you need to correct anything, click the Cancel button and start over with Step 1.

To order prints, you must have an Apple ID account.

Notes and Tips

Create a Temporary Album

If you're ordering prints from many different events, create an album and use it to hold the photos you want to print. Give the album an obvious name, such as *Pix to Print.* This makes it easier to keep track of which photos you're printing. After you've placed your order, you can delete the album.

As an alternative to creating an album, you can flag photos you want to print. After you've done so, click the Flagged item, then choose Order Prints.

Cropping Concerns

The proportions of most standard print sizes don't match the proportions of a typical digital camera image. As a result, Apple's print service automatically crops a photo to fill the print size you've ordered.

The problem is, automatic cropping may lop off part of the image that's important to you. If you don't want your photos cropped by a machine, do the cropping yourself, using iPhoto's edit view, before ordering. Use the Constrain pop-up menu to specify the proportions you want.

If you plan to order prints in several sizes, you may have even more work to do. A 5 by 7 print has a different *aspect ratio* than a 4 by 6 or an 8 by 10. If you want to order a 5 by 7 *and* one of these other sizes, you need to create a separate version of each picture—for example, one version cropped for a 5 by 7 and another cropped for an 8 by 10.

To create separate versions of a picture, make a duplicate of the original photo for each size you want (select the photo and press ⌘-D), and then crop each version appropriately.

If you crop a photo to oddball proportions—for example, a narrow rectangle—Apple's automatic cropping will yield a weird-looking print. If you have an image-editing program, such as Adobe Photoshop Elements, here's a workaround. In the imaging program, create a blank image at the size you plan to print (for example, 5 by 7 inches). Then open your cropped photo in the imaging program and paste it into this blank image. Save the resulting image as a JPEG file (use the Maximum quality setting), add it to iPhoto, and then order your print.

Resolution's Relationship to Print Quality

If you're working with low-resolution images—ones that you've cropped heavily or shot at a low resolution, for example—you may see iPhoto's dreaded low-resolution warning icon (⚠) when ordering prints or a book.

This is iPhoto's way of telling you that an image doesn't have enough pixels—enough digital information—to yield a good-quality print at the size that you've chosen.

Don't feel obligated to cancel a print job or an order if you see this warning. But do note that you may see some fuzziness in your prints.

The table here lists the minimum resolution an image should have to yield a good print at various sizes. Remember, this is a minimum and with resolution, as with many things in life, more is better.

Print Sizes and Resolution

For This Print Size (Inches)	Image Resolution Should Be at Least (Pixels)
Wallet	640 by 480
4 by 6	768 by 512
5 by 7	1075 by 768
8 by 10	1280 by 1024
16 by 20	2272 by 1704

Creating Photo Books

Something special happens to photos when they're pasted into the pages of a book. Arranged in a specific order and accompanied by captions, photos form a narrative: they tell a story.

Put away your paste. With iPhoto's book mode, you can create beautiful, full-color books in several sizes and styles. Arrange your photos in the order you want, adding captions and descriptive text if you like. Choose from a gallery of design *themes* to spice up your pages with layouts that complement your subject. Even add gorgeous travel maps that tap into your Places list to show where your photos were taken.

When you're done, iPhoto connects to the Internet and transfers your book to Apple's printing service, where the book is printed on a four-color digital printing press (a Hewlett-Packard Indigo, if you're curious) and then bound and shipped to you.

iPhoto books are great for commemorating a vacation, wedding, or other special event. They're also open for business: architects, artists, photographers, and designers use iPhoto to create spectacular portfolios, proposals, and brochures.

So don't just print those extra-special shots. Publish them.

Book Publishing at a Glance

The most efficient way to create a book is to first add photos to an album, and then tell iPhoto to create a book based on that album. Here's an overview of the process.

Step 1. Create a new album containing the photos you want to publish (page 42). Arrange the photos in approximately the same order that you want them to appear in the book. (You can always change their order later.)

Step 2. Select the album in the Albums list, choose Book from the Create pop-up menu. (You can also choose File > New Book.)

Step 3. Choose a book type and a theme, then click Create. For a summary of the types of books you can order, see the sidebar at right.

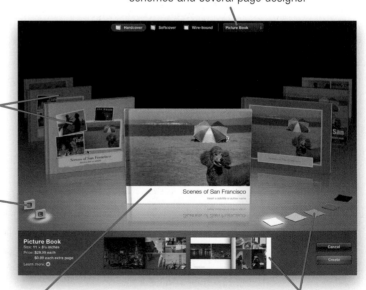

Most book types provide numerous themes. All themes provide coordinated color schemes and several page designs.

You can browse themes by clicking through the carousel display.

Choose a page size for your book. When you choose an option, the page dimensions appear in the lower-left corner.

Hardcover books have a dust jacket with a cover and inside flaps that you can customize.

Click a color swatch to choose background colors for your book's cover and pages. A preview appears at the bottom of the window.

Step 4. Lay out the book.

You can have iPhoto place the photos for you (the autoflow mode), or you can manually place each photo yourself (see the following pages).

Switch between viewing thumbnails for all photos in the project (shown here), photos that have been placed in the book, or photos that you haven't yet placed in the book (page 116).

To jump to a page, double-click its thumbnail. To rearrange pages, drag them left or right (page 118).

When you're editing an individual page, you can reposition a photo within its frame (page 123).

Switch themes and page designs and perform other layout and design tasks (pages 116–123).

Many page designs allow for text, whose type style you can customize (page 123).

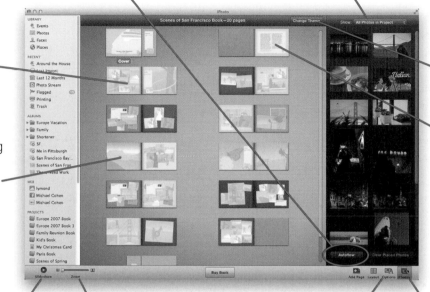

Display your book's pages as a slide show (page 124).

Zoom in on a page for proofreading and fine tuning.

For more layout options, click a photo in Page view (page 125) and click the Options button.

Displays the Photo pane, from which you drag photos to your book's pages (page 116).

Step 5. Click ⌗ Buy Book ⌗ and pay up using your Apple ID.

Book Types and Sizes

You can create several kinds of books with iPhoto. To preview the books, explore the options in the pop-up menu shown in Step 3 on the opposite page. The cost of a book depends on the type of book you order and on its number of pages; see apple.com/iphoto.

Hardcover. The classiest book option, and the priciest. Also called a *keepsake* book. You can select either XL (13 inches wide by 10 inches tall) or L (11 inches wide by 8.5 inches tall). The book's title is foil-stamped on a suede-like hardcover, and a customizable dust jacket protects the entire affair.

Softcover. Available in three sizes: 11 by 8.5 inches, 8 by 6 inches, and 2.6 by 3.5 inches. The tiniest size is sold in packs of three.

Wire-bound softcover. Available in 11 by 8.5 inch and 8 by 6 inch sizes, this softcover variation has a wire binding that lets the book lie flat.

Planning for Publishing

A book project doesn't begin in a page-layout program. It begins with an author who has something to say, and with photo editors and designers who have ideas about the best ways to say it.

When you create a photo book, you wear all of those hats. iPhoto works hard to make you look as fetching as possible in each of them, but you can help by putting some thought into your book before you click the Book button.

What do you want your book to say? Is it commemorating an event? Or is it celebrating a person, place, or thing? Does the book need a story arc—a beginning, a middle, and an ending? Would the book benefit from distinct sections—one for each place you visited, for example, or one for each member of the family?

And no publishing project occurs without a discussion of production expenses. Is money no object? Or are you pinching pennies?

Your answers to these questions will influence the photos you choose, the book designs you use, and the way you organize and present your photos and any accompanying text. The very best time to address these questions isn't before you start your book—it's before you start shooting. If you have a certain kind of book in mind, you can make sure you get the shots you need.

Here's more food for thought.

Questions to Ask

Here's a look at some of the factors that may influence your choice of book sizes and themes.

What Size Book?

The book size you choose will be dictated by your budget and design goals. On a budget? Use the medium-sized or large softcover formats. Want the largest selection of design options? Go large or extra-large hardcover. Larger book sizes are also best when you want to get as many photos as possible on a page.

Your photos may also influence your choice: for example, if you have low-resolution shots and want to present one photo per page, you may need to choose a medium-sized (or small) book to get acceptable quality.

How Much Text?

Most photography books contain more than just photos. Will you want text in your book? If so, how much? Some themes provide for more copy than others.

How Many Photos?

Some themes provide for more photos per page than others. The Travel theme provides up to seven; Picture Book, 16; Folio, only two.

Twilight Walk

What Design Options?

Each book size and type provides its own set of themes. Each theme has its own design options, including different color schemes; different ways to arrange photos on each page; and special photo effects and design elements, such as collages and travel maps.

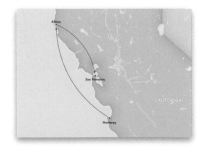

Options to Consider

Think about ways to have the left- and right-hand pages complement each other.

In this spread, which uses the Travel theme, the left-hand page shows works from the Museé d'Orsay, shown on the right-hand page.

Don't have high-resolution photos? Consider a medium or small softcover book, or choose page designs with small photo zones or multiple photos per page.

The Family Album theme has a warm, sentimental look—perfect for vintage photos.

Many themes (including Crayon, shown here) have page designs that allow for text headings and lengthy captions whose formatting you can customize.

Wire-bound books, available in large and medium softcover sizes, lie flat when opened.

In the elegant Folio design, photo titles become headings.

Dust Jacket Decisions

Extra-large and large hardcover books include a paper dust jacket that can hold text and photos. Besides having front and back covers that you can customize, dust jackets also have inside flaps that tuck behind the front and back covers.

You can customize these flaps, too. In publishing, it's common for the front flap to describe the book, and for the back flap to describe the author. If there's a lot to say about the book or its subject, the text on the front flap may continue on the back flap.

Each book theme has several flap layouts: just a photo, text and a photo, just text, and blank. When creating a hardcover book, decide how much you want to talk about your book—and yourself—and choose the appropriate layout.

Book Layout Techniques

Manual or Autoflow?

When you create a book, iPhoto automatically lays out the book, choosing a page layout for each page and adding photos. Along the way, iPhoto adds variety by mixing various page layouts throughout the book.

iPhoto always creates a book with at least 20 pages—the minimum a book can contain. But iPhoto will create as many pages as needed to place the photos that you selected before creating the book.

This entire process is called *Autoflow,* and it's a great way to get quick results.

How Autoflow works. iPhoto doesn't just randomly spew photos onto pages; rather, iPhoto follows a few rules as it flows your photos.

For example, iPhoto tries to avoid putting photos taken on different days on the same page. And if you're creating a book from an event, iPhoto uses the key photo—the one that represents the event's thumbnail when you're viewing your library—as the cover photo for the book.

iPhoto also takes into account any star ratings you've assigned. If a particular photo has a five-star rating, for example, it's more likely to appear in a full-page layout than a photo with a three-star rating. (There's another good reasons to rate those special shots.)

As for faces, Autoflow treats them gently, applying facial-recognition smarts to avoid cutting off part of a face when positioning a photo on a page.

The manual advantage. The one thing Autoflow doesn't give you is control. Yes, you can customize the book that iPhoto flows for you, but I prefer to start out with a vacant lot instead of a fixer upper—I'd rather have blank pages that I can build and add photos to myself.

I often want to change the designs that iPhoto has chosen, and if I'm going to do that, I might as well start fresh—why have iPhoto position photos that I'm going to be rearranging anyway?

Removing all placed photos. To get back to a vacant lot, click the Photos button to display the Photo pane, then click the Clear Placed Photos button. iPhoto warns you that you can't undo this. Consider the enormity of your actions, then click Remove.

iPhoto removes all the photos from your book's pages, but keeps them in your library. The photos still appear in the Photos pane, where you can place them where you want them.

Combining auto and manual. If you'd rather get immediate results and then fine-tune the results, by all means let Autoflow do its thing and then customize the resulting book. Or mix both approaches. If you want to do something fancy at the beginning of your book— maybe have a full-page photo opposite

an introduction text page—lay out those first couple of pages. Then click the Autoflow button to have iPhoto do the rest.

Cost concerns. Note that the Autoflow feature adds additional pages to your book if necessary to accommodate the rest of your unplaced photos. Those extra pages will cost you, so if you're watching your production budget, keep an eye on your total page count.

Working in Two Views

Creating a book means working in, and often switching between, two views. Each view has its own tools and options.

In All Pages view, iPhoto shows little thumbnail versions of each page in your book, as shown on page 113. This is the view to use when you want to rearrange the order of pages or just get the big picture of your book so you can quickly jump around within it.

When you want to work on a specific page, double-click its thumbnail in All Pages view. This is *page spread view,* where you can place and rearrange photos, change page layouts, and much more.

To switch from page spread view back to All Pages view, click the All Pages button at the top of the page view.

Layout Basics

Each book theme includes numerous *layouts*, each with a different arrangement of text and photos. Some layouts contain just text, some hold just photos, and some hold both.

Choosing a layout. First, navigate to the page you want to change: click the left- or right-arrow buttons or double-click the page in the All Pages browser.

Next, click the Layout button. The Layout pane appears, where you can browse and choose layouts for the book theme you're using.

To change a page's background, click one of the color swatches.

To have space for text captions on a page, click this box.

Step 1. Choose the type of page you want—the number of photos or a special page, such as a map or text page.

Step 2. Each page type offers several designs. Click the one you like.

Tip: You can also use the little pop-up menu that appears above a page to change layouts and background colors.

Adding photos. Add photos to the empty frames on a page by dragging them from the Photo pane. (If you don't see the Photo pane, click the Photos button.)

Working with Photos

Adding to a full page. If you drag a photo from the Photo pane to a page that already contains photos in each photo frame, iPhoto changes the page type, adding an additional photo frame to accommodate the photo.

With some themes and page designs, iPhoto may add more than one photo frame. For example, in the Picture Book theme, the available page types jump from four photos per page to six. If you add a photo to a fully populated four-photo page,

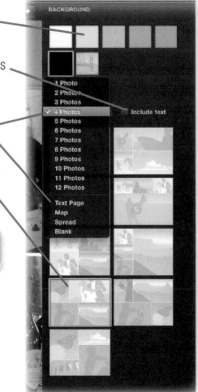

iPhoto switches to the six-photo page type. You can either add a sixth photo or ignore the empty frame. iPhoto will omit it when you order your book.

Moving and swapping. To move a photo to a different frame, drag it there. If that frame already contains a photo, iPhoto swaps the two photos.

Removing a photo. To remove a photo, select the photo and press the Delete key. The photo vanishes from the page, but remains in the Photo pane so you can add it to a different page or restore it if you change your mind later.

To remove the photo's frame, switch to a page type that provides fewer photos, or simply ignore the empty frame—that's what iPhoto will do when you order your book.

Editing a photo. Need to edit a photo that you've placed on a page? Select the photo in page view and click Edit Photo in the Options pane. Or simply right-click on the photo and choose Edit Photo from the shortcut menu.

Adding photos from your library. To add additional photos to a book, drag them from your library to the book's name in the Projects list.

Another way to add photos to the book is to select them, and then click the Add To button in the iPhoto toolbar. From the pop-up menu that appears, choose Book, then click the name of the book where you want to use the added photos.

More Book Layout Techniques

Adding and Removing Pages

To add a page, click the Add Page button. To insert 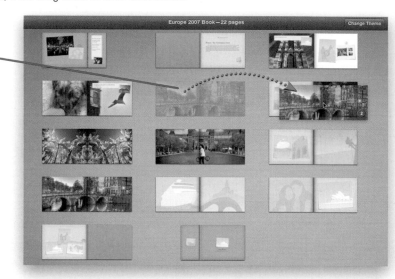 a page between two existing pages, use the All Pages browser to select the page that you want to precede the new page. For example, to add a new page between pages 4 and 5, select page 4, then click Add Page in the iPhoto toolbar.

When you add a page, iPhoto gives the page or pages a layout from the book's current theme, filled with empty photo frames. Customize the layout as desired.

One page or two? An iPhoto book must always have an even number of pages. If adding a page results in an odd number of pages, iPhoto adds a blank page to your book to maintain an even-numbered page count. If your book happens to have a blank page in it, iPhoto deletes the page instead of adding one.

Removing a page. To remove a page, select it in the All Pages browser and press the Delete key. Or, Control-click a blank area of the doomed page and choose Remove Page from the shortcut menu. **Note:** If you delete a page in this manner, iPhoto presents a confirmation dialog. If you find this constant reminder annoying, click the *Don't ask me again* check box and you'll never be asked again.

Rearranging Pages

To reorganize your pages, drag their thumbnails left and right in the All Pages browser.

Moving two or more pages. To move a two-page spread, select both pages: click on one page, and then Shift-click on the other, or draw a selection marquee around the two pages to highlight them.

You can also move more than two pages by using this same technique: select all the pages, then drag them to their destination.

In this example, pages 6 and 7 are being moved so they follow pages 8 and 9.

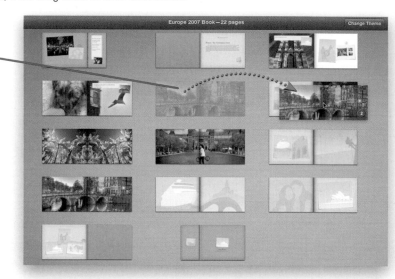

Moving a single page. To move a single page, select the page and move it before the page where you want it to appear. Below, page 6 is being moved so it follows page 4.

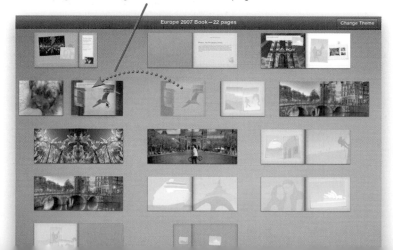

Tips for Book Layout

To customize, explore your Options. The Options button is your gateway to many of iPhoto's book-customizing options. Click the button, and the Options pane appears.

Exactly which options appear depends on what you're doing. If you select a photo and click Options, the Options pane contains settings for borders and effects (described below). If you select a text element, you get font formatting options (page 123).

Adding borders and effects. You can have borders around any photo, and in several styles. Some borders allow for text captions, while others simulate shadows and even crinkled paper. To add or customize a border, select a photo, click the Options button, and choose a style.

You can also use the Options pane to apply a black-and-white, sepia, or antique effect to a selected photo. These are the same effects described on page 57, but if you apply them here instead of actually editing the photo, you won't change your original—which is good if you're also using that photo elsewhere, such as in a slide show or calendar.

Page numbers? Optional. Most book themes allow for automatic page numbers. (Themes that do not are Picture Book, Photo Essay, Contemporary, and Folio.)

But do you need page numbers? If your book is relatively short and you aren't creating a table of contents or index, maybe not.

To turn page numbering on or off, display the Options pane and click the Book Settings button. In the Book Settings dialog box, check (or uncheck) the Show Page Numbers box. When you've turned page numbers on, you can also specify font formatting here. And if you don't see the page-number options, you've chosen a theme that doesn't provide page numbers.

Apple logo? Very optional. Normally, iPhoto places an Apple logo at the end of your book. I always nix the free advertising. In the Book Settings dialog box, uncheck the Include Apple logo at end of book box.

Tips for the Photo Pane

The photo pane is your book's photo inventory, the place where the iPhoto displays those photos that you selected before you started the book project. As I've described, when you want to add a photo to a page, display the Photos pane and the destination page, then drag the photo to its frame.

Here are some tips for working with the Photo pane.

Changing thumbnail size. To display larger thumbnails in the Photos pane, Control-click (or right-click) in the border between thumbnails, then choose Large Photos from the shortcut menu. I do

this when I'm trying to tell the difference between very similar photos.

Where did I use that photo? When you use a photo in a book, iPhoto puts a check mark (☑) on the photo's thumbnail. Here's the cool part: point to the check mark, and it turns into an arrow and the number of the page where you used the photo (☑ 27, 29 ➡). Click the arrow, and iPhoto beams you to that page. If you used the photo on several pages, you can hop from one to the next by clicking the arrow again.

Controlling what photos appear. The Photo pane's Show pop-up menu lets you control which photos appear. For example, its Unplaced Photos command shows only those photos you haven't yet used in the book.

As this screen shows, other Show options let you quickly access your last year's worth of photos, your most recent import, your flagged photos, and the last event you viewed. Each of these options is a convenient way to get to other places in your library—for those times when you need another photo or two in your book.

Creating Travel Maps

Many book projects can benefit from a sense of place: the travel book filled with vacation photos, the family reunion book depicting your old stomping grounds, the wedding book with photos from the ski-slope ceremony and the tropical honeymoon. When creating books like these, consider giving your readers some context by adding *travel maps.*

Travel maps take advantage of the Places feature. But even if you haven't taken the time to geotag your photos, you can still create travel maps; a handy pane lets you add places to a map even as you create your book.

Every theme in iPhoto provides for a travel map, but the largest variety of map designs is in the Travel themes. (Imagine that!) You'll find options ranging from simple, full-page maps to small maps that accompany a full-page photo and some text.

In any theme, you can add gracefully curving arrows or straight lines between destinations: perfect for when your travels took you to more than one place. You can change the font of text on maps, choose between two arrow styles, show and hide the names of countries and other regions, and much more.

Creating a Map

Step 1. Navigate to the page where you want the map.

Step 2. From the Layout pop-up menu or the Layout pane, choose Map, then choose a map style.

Step 3. Create your map: add places, zoom and pan to highlight locations, and more.

To show more or less of the world in the map, drag the zoom slider.

Each check-marked place appears on the map (opposite page).

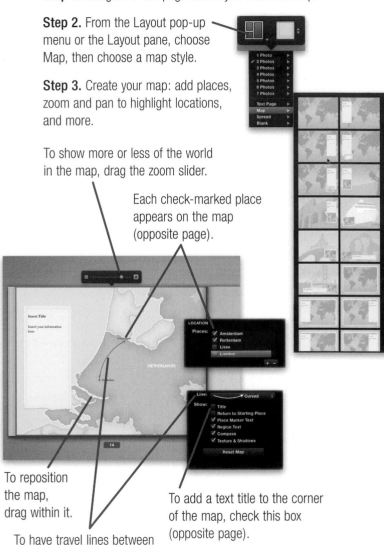

To reposition the map, drag within it.

To have travel lines between places, use this pop-up menu (opposite page).

To add a text title to the corner of the map, check this box (opposite page).

In the Travel Book theme, many map layouts allow for text and photos. Add them using the techniques described on previous pages.

Managing Places on a Map

You can add places to a map and remove them. You can also change the order in which they appear—important if you're adding travel lines.

Adding a place. To add a place, click the ⊞ button below the Location list, then type the name of the place. If iPhoto knows about that place, it offers suggestions to complete the name for you.

If iPhoto doesn't know about the place, you can add it using the Manage My Places window. The process is similar to adding a place in the Places feature; for details, see page 32.

Removing a place. To remove a place from the map, select it in the Location list and click the ⊟ button. Or just uncheck the box next to the place name—that way, you can restore the place if you change your mind.

Rearranging places. iPhoto uses the top-to-bottom order of places to add the arrowheads in travel lines. Thus, your first stop (or your point of origin) should appear first in the list, followed by your second stop, and so on. To rearrange places, drag them up and down.

Notes and Tips

Which style? Using the Travel Book theme? Which of the 22 map styles should you use? That depends in part on your book's topic. For a book about a journey, a full-page map is probably in order. For a book about a family reunion or party that happened in one location, a small map that sits within a full-page photo—maybe also with a column of descriptive text—might be ideal.

More than one. Consider using multiple maps in your book. Start your vacation book with a full-page map that shows all your destinations, complete with arrow lines. Then, for each section that you devote to a particular destination, have a small map showing just that destination.

Font fun. To change the font of map text, click the text, then use the formatting pop-up menus to change the text font, size, and alignment.

Zooming and centering. When you zoom way in on a map, you can lose your place and find yourself staring at the middle of an ocean rather than one of the places in the map. To find yourself, Control-click on the map and choose Center Map on Places from the shortcut menu.

More customizing. Don't want a title? In the Options pane, uncheck the Title box. Want to indicate a round trip with an arrow that points to your starting place? Click the Return to Starting Place box. For further customizing, the Options pane provides check boxes that let you remove the compass, omit the shading and textures (creating a flatter-looking map), omit the names of regions (such as countries), and more.

Using maps elsewhere. You can save a map as a PDF to use elsewhere.

Choose File > Print. In the Pages pop-up menu, choose Single and type the page number containing the map. From the PDF pop-up menu, choose Open PDF in Preview. You can then save the PDF as a TIFF, PNG, or JPEG and import that into iPhoto for use in other projects, just like any other photo.

(For more tips on turning book pages into PDFs, see page 125.)

Tips for Creating Books

Formatting Text

Each book theme provides its own text elements—captions, titles, descriptions, map labels, and so on. And in each theme, each element is factory-formatted to work with the others to create a unified design.

But you can also leave the factory to format text to your own tastes.

Making a change in one spot. Want a certain caption to appear bigger or in a different font? Click within the caption to activate its text box, then select the text and use the font options that appear above the text box.

You can also use the Options pane, described below. Select the text, display the Options pane, and do your formatting there. The Options pane provides more formatting controls than do the formatting options above a text box.

Changing an element everywhere. For a photo book that contains only a few text elements, some typographic variety can be fun. But for a longer book—or one with a lot of text—consistency is important.

It's easy to customize the formatting in one element and then to tell iPhoto to apply that formatting to every other element of that same type in your book.

Need a specific font size in order to make some text fit? Type it here.

Choose a color for selected text.

A text element can have up to three columns (see "Column Decisions," below).

Increase or decrease space between lines and characters (see "Spacing Control," at right).

For example, to customize all your photo titles, click any photo title in your book to activate its text box. Next, click the Options button and use its formatting controls. Finally, click the Change Everywhere button, and then confirm the "are you sure?" message. Now all the photo titles in your book will have the formatting you just specified.

Back to the factory. Unhappy with the custom formatting you've done? To revert to Apple's factory formatting for a certain element, select it, and then click the Revert to Default button in the Options pane.

The triangle of doom. You've typed some text or changed text formatting, and suddenly the yellow triangle of doom appears in the text box. iPhoto is telling you that the text won't fit with its current type specs. Either change formatting or delete some text.

Column Decisions

Many books, including this one, use page layouts that have multiple columns of text. Your iPhoto books can, too. To change a text page from one column to two or three, select the main text element on the page, then use the Options pane to choose the number of columns you want.

Spacing Control

To control spacing between lines in a text element, select the text element and then drag the line spacing slider. For example, if you have a text page containing just a few sentences that run the full width of the page, consider opening up the line spacing to improve readability.

Similarly, you can use the character spacing slider to decrease or increase the space between characters. Large headlines can often benefit from a little bit of tightening. Conversely, with some fonts, adding a bit of space between characters can create an elegant look to a headline, especially one containing all capital letters. Again, a little goes a long way.

More Tips for Text

Kerning letter pairs. Some combinations of letters get along better than others. The capital T and capital Y can be particularly standoffish: their shape makes it look like they're avoiding the character next to them.

Typesetters and designers address this by *kerning:* decreasing the space between two characters to snug one closer to the other. It's particularly common in headlines that use large type.

To kern in iPhoto, position the blinking insertion point between the two characters that need some relationship help. Next, choose Edit > Font > Kern > Tighten. Better yet, use the keyboard shortcut: ⌘-Option-left bracket ([). Use

the command (or its shortcut) as many times as you need.

In this example, I didn't kern in the top headline, but did in the bottom one, snugging the *o* beneath the *T* and the comma closer to the *y.*

> **Yesterday, I couldn't kern.**
> **Today, I can.**

By using the Tighten and Loosen commands (or better yet, their keyboard shortcuts), you can finely control the spacing between characters.

Auto kerning. Another way to improve letter spacing is to rely on the kerning information that's built into most fonts. Select a text element, then choose Edit > Font > Kern > Use Default.

Smart quotes and other details. Another way to make your book look professionally typeset is to use true typographer's quotes—the curly kind—and em dashes instead of double hyphens. iPhoto can automate this beautifully. To "curlify" the quote marks in a text element, select the text and then Control-click or right-click on it. From the shortcut menu, choose Substitutions > Replace Quotes. To change any double hyphens to an em dash, choose Substitutions > Replace Dashes.

Photo as Background

To use a photo as a page background, choose the Photo Background option in the Layout panel.

Next, choose a layout and add photos and/or text to the page, as appropriate.

Tip: A busy background photo will overwhelm text or other photos, impairing legibility. Solution: increase the transparency of the background photo. Click the photo, and drag the lower slider to the right until the photo appears faint.

Full-Spread Photo

With some themes, iPhoto can fill an entire two-page spread with a single photo—it's a dramatic way to highlight a scenic vista or a panorama. In the Layout pane, choose the Spread option. Many themes have several variations.

Tip: Keep in mind that part of the photo will get lost in the gutter between the left and right pages. By zooming in a bit and repositioning the photo, you can often make sure nothing important gets lost.

More Tips for Creating Books

Before You Buy

Before you click the Buy Book button to place your order, do one last proofreading pass of any text in your book. And remember, your Mac can help: select the text in a text box and choose Edit > Spelling > Check Spelling.

Placeholder text. Also check to see that you haven't left placeholder text on any pages. (This is the stuff iPhoto inserts for you when you choose a page design that supports text. It usually reads *Insert a description of your book*.) But don't sweat it: if your book contains placeholder text and you click Buy Book, iPhoto reassures you that the placeholder text won't be printed.

Unused photo frames. Don't worry if any pages have unused (gray) photo frames. iPhoto simply ignores them.

Tip: The fact that iPhoto ignores empty photo frames opens up additional design options. For example, say you're creating a book in the Picture Book theme and you want a page with five photos on it—a page type Picture Book doesn't provide. Solution: choose the six-photo page type, but put only five photos on it.

Preview. To preview your book, choose File > Print and, with the Pages pop-up menu set to All, click the PDF button, then choose Open PDF in Preview. iPhoto assembles the book and displays its pages in Mac OS X's Preview program.

From Book to Slide Show

In both of iPhoto's book views, you'll notice a Slideshow button near the lower-left corner. It lets you display the pages of your book as a slide show. This opens up some interesting creative possibilities: you can take advantage of iPhoto's book themes and page designs to create "slides" containing multiple images and text. (In the interest of readability, think twice about using a lot of small text.)

You can also send a "book slide show" to iDVD: while in book-edit view, choose Share > iDVD.

Print It Yourself

iPhoto's Print command is alive and well when you're in book view: you can print some or all of your book for proofreading or to bind it yourself.

Printing the entire book. Choose File > Print and set the Pages pop-up menu to All.

Printing a specific page. Want to print just one page of a book? Choose File > Print and then choose Single from the Pages pop-up menu and enter the page number in the text box. (A preview appears below the text box.)

To print a range of pages, set the Pages pop-up menu to Range and type the beginning and ending page number in the text boxes that appear.

Mirroring a Photo

Want to flip a photo so that it appears "backwards"? Select the photo in its book frame, then Control-click it and choose Mirror Image from the shortcut menu.

Here's an easy design trick: Add the same photo to the left and right pages of a two-page spread. Then, mirror one of the photos so that the two photos appear to reflect one another.

Changing Stacking Order

When you have multiple items on a page, you can change the way they overlap. For example, some themes position photos so they overlap. To change the way two photos overlap, Control-click a photo and choose Move to Front or Send to Back.

Pane keyboard shortcuts. To open the Layout pane, press Option-L; the Options pane, Option-D; and the Photos pane, Option-P.

Fun with PDFs

Combining book designs. You love one of the page designs from the Family Album theme, but you really want to use the Line Border theme for the bulk of your book. No problem, thanks to Mac OS X's ability to create a PDF file of anything you can print.

Start by creating the page that you'll want to add to a *different* book. For example, if you want to use the Line Border theme for most of your book but the Family Album theme on one page, create the Family Album page.

Next, choose File > Print and navigate to the preview of the page you created by clicking the left and right arrows in the Print dialog. Choose Single from the Pages pop-up menu in the Print dialog. Then, from the PDF pop-up menu, choose Open PDF in Preview.

In Preview, save the PDF as a TIFF, PNG, or JPEG and import that image to your book. For the page containing the image, choose a layout that provides one photo per page. The result: two different themes within one book.

The spread below presents some old photos using the Family Album theme

opposite some new photos and the Line Border theme.

Other ways to use book-page PDFs. You can also order a print of a book-page-turned-PDF. When you use the Open PDF in Preview option in the Print dialog, the resulting image has enough resolution to produce a 16- by 20-inch print. So create a fancy page, complete with a travel map if you like, and turn it into a poster.

And because iPhoto considers that book page to be just an ordinary image, you can also use the page image in a slide show or an iMovie project or add it to a calendar. Want to create a greeting card containing a travel map? Create the page as a PDF, save it as a TIFF, then add it to a greeting card.

A PDF of the entire book. To create a PDF of your entire book, Control-click the area outside the book's pages in the All Pages view, then choose Save Book as PDF from the shortcut menu. Then what? You decide. Post the PDF on your Web site. Include it in the DVD-ROM portion of an iDVD project. Email it to friends who use Microsoft Windows— just to mess with them.

Creating a Photo Calendar

Store-bought calendars can be gorgeous, but they lack a certain something: *your* photos. Why build your year around someone else's photos when you can build it around your own?

With the calendar-publishing features in iPhoto, you can create calendars containing as few as 12 months and as many as 24. Choose from numerous design themes, each of which formats your photos and the dates of the month in a different way. Then drag photos into your calendar, fine-tuning their cropping and appearance along the way, if you like.

Commercial calendars usually have national holidays printed on them. Yours can, too—and then some. You can add your own milestones to your calendar: birthdays, anniversaries, dentist-appointment reminders. If you use Apple's iCal software, you can even import events from iCal and have them appear in your calendar.

When you're finished, click the Buy Calendar button. iPhoto transfers your photos and design to Apple's printing service, which prints your calendar and ships it to you. A 12-month calendar costs $19.99. Each additional month is $1.49.

And you don't have to postpone your foray into calendar publishing until next year. You can have your calendar begin with any month you like.

The Big Picture

Step 1. The most efficient way to create a calendar is to first add the photos you want to publish to an album.

Tip: To further streamline your layout work, sequence the photos in the album in the same general order in which you want them to appear in the calendar.

Step 2. Click the Create button and choose Calendar from the pop-up menu. The carousel of calendar themes appears.

Step 3. Choose a theme from the pop-up menu, or browse the carousel by clicking the calendars or pressing your keyboard's left and right arrow keys. Then click Create or press Return when you find the theme you want.

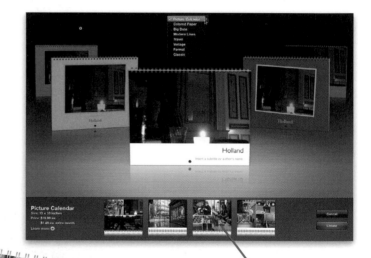

Preview page thumbnails appear at the bottom of the pane.

Have a big year. Calendars measure 13 inches wide by 10.4 inches high—perfect for hanging on a wall.

A Year in Europe

Visual Feasts From Across the Continent

Step 4. Specify calendar details, then click OK. Here's your first big opportunity to customize the calendar so it contains dates that are important to you.

How many months? Type a number between 12 and 24 or click the arrow buttons.

When? Choose a starting month and a year.

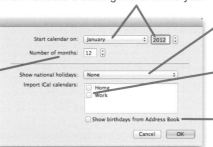

Veterans Day? Deepavali? Queen's Day? Specify your preferred national holiday list, or choose None.

Use iCal? To include iCal dates in your calendar, check the box next to the calendar.

Store birthdays in Mac OS X's Address Book program? You can automatically include them in your calendar.

Step 5. Customize your calendar. iPhoto fills your calendar with photos using the Autoflow scheme described on page 128. You can customize any page using many of the same techniques used for book layout.

View the next or previous month.

To replace this placeholder text with your own, select the text and type.

Do it yourselfer? To start with blank calendar pages, click Clear Placed Photos.

Step 6. Step through each month of the calendar, fine-tuning designs and adding custom date items as desired (see the following pages for details and tips).

Each calendar design offers a variety of photo layouts, some providing space for captions.

You can adjust a photo's position within its frame.

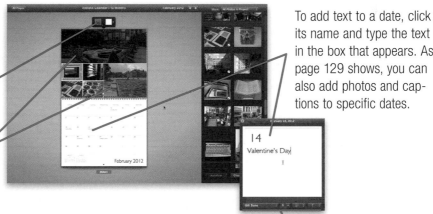

To add text to a date, click its name and type the text in the box that appears. As page 129 shows, you can also add photos and captions to specific dates.

Step 7. Click [Buy Calendar] and pay using your Apple ID.

You can adjust the formatting and position of the text.

Tips for Creating Calendars

Choosing Photos

When creating a calendar, try to choose photos that relate to a given month. Use photos of a family member for the month of his or her birthday. If you have some particularly fine holiday shots, use them for the month of December. This sounds obvious, I know, but you'd be surprised how many times I see iPhoto calendars with photos that bear no relationship to the months in which they appear.

Think vivid. I've ordered several calendars, and in my experience, photos with soft, muted colors often print poorly. You're likely to see faint vertical stripes, sometimes called *banding*, in the photos. I get the best results when I use photos that have bright, vivid colors. Black-and-white photos work beautifully, too, provided they have strong contrast.

Layout Techniques

Laying out a calendar involves many of the same techniques behind book creation (pages 112–125). You can add photos by hand, dragging them from the Photos pane into specific months, or you can click the Autoflow button and have iPhoto sling the photos into your year as it sees fit. As with books, I prefer the manual layout technique for calendars.

How many photos in a month? iPhoto's calendar themes, like its book themes, provide multiple page designs. Some designs provide for just one photo for a given month, while others allow for a half dozen or more.

I like to minimize the number of photos I use each month. Bigger photos have a more dramatic look, and they're easier to see and appreciate when the calendar is hanging on a wall at the opposite end of a room. For most of my calendars, I put just one photo on each month.

That's a rule that begs to be broken, and I do break it now and then. If I have relatively low-resolution photos and iPhoto displays its yellow warning triangle, I'll switch to a page design that has smaller photo frames. Or if I have a series of photos that tells a story about a particular month, I'll choose a page design that lets me use all of those photos. Or, if I have particularly compelling portrait orientation photos, I might choose a two-photo side-by-side layout.

Top, bottom, or both? Normally, iPhoto's calendar view displays both halves of a given month—that is, the upper portion, where your photos appear, and the lower portion, where the days and weeks are displayed. Between those two halves is the spiral binding that holds the calendar together.

But when you're fine-tuning a calendar's design, you may find it useful to display only the upper or lower portions. The answer? Tear out the spiral binding. Move the Zoom slider all the way to the right.

To switch between viewing the upper or lower portion of a month, drag the rectangle in the Navigator to frame the page you want to see.

Adding Photos to Dates

When creating a calendar, your photo options aren't limited to just the page above each month. You can also add photos to individual dates. To commemorate a birthday, add a photo to the birthday girl's date. To never forget your anniversary, put a wedding photo on the date. (Another good way to never forget an anniversary is to forget it just once, but this method is not recommended.)

To add a photo to a date, drag it from the Photos pane to the calendar date.

To remove a photo from a date, select the date and press the Delete key.

Don't Forget iCal

When creating a new calendar, you can choose to have iPhoto include event information from iCal. You can also add iCal data to an existing calendar by clicking the Settings button and checking the appropriate Import iCal Calendars box.

Don't use iCal to manage your life? You can download thousands of calendars from iCalShare (www.icalshare.com). Because I like my calendars to include the phases of the moon, I subscribed to a lunar calendar at iCalShare. When I'm creating a new calendar, I simply check the moon-phases calendar and iPhoto does the rest.

Improving Your Calendar Typography

Many of the typographic tips that apply to books (pages 122–123) also apply to calendars.

Global formatting. You can change the fonts that iPhoto uses for various elements of the calendar. For example, to

change the font used for date captions, click on any date caption, then display the Options pane. Work your formatting magic, then click the Change Everywhere button.

Local formatting. As with books, you can also override iPhoto's font settings and apply formatting to individual text

items, but within limits: you can't apply local formatting to a specific date. (For example, you can't have February 14 appear in a bold red font.) You can apply local formatting only to comments and photo captions. To do so, display the item's text box (click the date, and the text box zooms into view), then select the text and use the font controls at the bottom of the text box.

Nix the logo. While you're improving your calendar, remove the Apple logo that would otherwise be printed on it. In the Options pane, click the Calendar Settings button, then uncheck the *Include Apple logo* box.

Customizing Photos on Dates

You can customize the way a photo appears on a date.

iPhoto displays the date to which the photo belongs.

To display a text caption adjacent to the photo, check the Caption box. iPhoto uses the photo's title as the caption text, but you can replace that text by selecting it and typing your own. (For details on assigning titles to photos, see page 22.)

As with slide shows and books, you can fine-tune a photo's composition without having to use the Crop tool. Drag the size slider to zoom in, then drag the photo within its frame until it's positioned as desired.

Photo captions appear on an adjacent date, with an arrow pointing to the photo. To choose where the caption appears, choose from the "Photo caption" pop-up menu. In this example, I've selected Right, telling iPhoto to display the caption on the date to the right of the photo.

Creating Greeting Cards and Postcards

Let us hereby resolve to never buy a greeting card from a store rack again. OK, maybe that's a bit strong. But with the greeting card and postcard features in iPhoto, you can definitely curtail your contributions to Hallmark's balance sheet.

An iPhoto greeting card measures 5 by 7 inches and is of the "tent" variety—folded on its top or at the left, per your option. Landscape photos work best for top-folds, and portrait photos are best for left-folds. Letterpress cards cost $2.99 each and regular folded cards $1.49 each. The letterpress cards have beautiful embossed borders and other elements. (Alas, custom text you add is not embossed.)

As for postcards (called "Flat" when you create your project), they measure 4 by 6 inches and cost $.99 each. The back of a flat card can contain a full block of text, and in some themes, you can use a standard postcard-mailing format, complete with a "place postage here" box.

Greeting cards and postcards are printed on a heavy card stock and include matching envelopes. Even if you order a postcard with a "place postage here" box, you still get an envelope—complete with an embossed Apple logo on its flap.

So forget this era of email and instant messaging, and use iPhoto to create some old-fashioned correspondence. Your recipients will thank you.

Creating a Greeting Card

Step 1. Select the photo that you want on the greeting card.

Step 2. Click the Create button, then choose Card from the pop-up menu.

Step 3. Choose a style (Letterpress or Folded), then choose a theme.

I'm partial to the Picture Card theme, which prints a border-less photo.

Step 4. Choose a horizontal or vertical card.

Step 5. Optional: Click the swatches to choose a background.

Step 6. Click Create or press Return.

Step 7. Replace the card's placeholder text with your own, and then fine-tune the design, if desired (opposite page).

Tip: To have the inside of the card appear blank, just leave the placeholder text as is—or, if you're nervous about getting a card that contains the heartwarming message *Insert Title*, delete the placeholder text.

Step 8. Proofread any text you added, then proofread it again. Then, click Buy Card and pay using your Apple ID.

Creating a Flat Card

Step 1. Select the photo you want to include on the postcard.

Step 2. Click the Create button.

Step 3. Choose Card from the pop-up menu.

Step 4. Click Flat, choose a theme, then click Create or press Return.

The themes are similar to their greeting-card counterparts.

Step 5. Replace the card's placeholder text and then fine-tune the design, if desired.

Step 6. Do that proofreading thing you do so well, then click Buy Card and pay using your Apple ID.

Tip: Want to use a book layout as a card? Follow the instructions on page 125, then add the resulting "page image" to a card that uses the Picture Card theme.

Card Design Tips

Switching postcard styles.
To switch between a self-mailing postcard and one that tucks into an envelope, select the back of the postcard, then use the Layout pane.

Switching designs and backgrounds. All card themes provide more than one design option for the front of the card. Many themes, for example, provide an option that lets you type some text on the front of the card. To access different layouts, select the front of the card, then click the Layout button. While you're in the Layout pane, uncheck the *Apple logo* box.

Many theme designs also offer a selection of background colors or textures. You can access them by using the Layout pane, too.

Why is this kid smiling?

Fine-tuning photos. As with books, slide shows, and calendars, you can adjust the appearance and positioning of a photo without having to edit the original. Simply click the photo, then use the slider to zoom in as desired. To position the photo within its frame, drag it.

Fun with fonts. As with books and calendars, you can customize the font formatting of your card. The easiest way is to select some text, then use the font panel overlay that appears above the text box.

For more formatting control, including the line- and character-spacing adjustments discussed on pages 122–125, use the Options pane.

Print it yourself. As with books, you can print greeting cards and postcards on your own color inkjet printer (or laser printer). Just choose the Print command while the card editor is visible. Note that if you plan to use both sides of the card, you'll need to use inkjet paper designed for double-sided printing. And if you're using a laser printer, use its duplex option (if it has one).

More Ways to Share Photos

Now it's time to talk about some of the more obscure sharing options in iPhoto. Most people who use iPhoto share photos using the avenues I've already described: email for zapping some shots to a few friends; Flickr and Facebook for putting photos on the Web; slide shows and iDVD for presenting photos with glitz and glamour; and print products for creating keepsakes.

But there's more. You can also export photos in a kind of bare-bones slide show format: a simple cross dissolve between each shot, some background music, but no glitzy themes, no title slide, and no Ken Burns. Why would you want to? You can have a background color or image appear behind photos, and you can type specific pixel dimensions for the resulting movie.

Big deal, right? The fact is, slide show projects and the Export button give you far more control. But when you want to create a simple QuickTime slide show, iPhoto can accommodate.

In a similar vein, you can export photos as a set of plain-looking Web pages. And although you can find online services that may offer better options, provide a flashier presentation, and have more controls, iPhoto's exported Web pages can have a few advantages, as I describe at right.

Looking for still more ways to share? Redecorate your Macintosh desktop with your favorite photo. Or, use a set of photos as a screen saver.

It's obvious: if your digital photos aren't getting seen, it isn't iPhoto's fault.

Exporting Web Pages

You can export photos and albums as Web pages. iPhoto creates small thumbnail versions of your images, as well as the HTML pages that display them. (HTML stands for *HyperText Markup Language*—it's the set of codes used to design Web pages.)

To export a Web page, select some photos or an album, choose File > Export, then click the Web Page tab. Specify the page appearance and dimensions of the thumbnails and the images. You can also have additional information appear with each photo, such as its title, caption, location, and metadata (page 141).

After clicking the Export button, click the New Folder button to create a new folder. (The export process will create several folders, so it's a good idea to stash everything in one folder.)

Notes and Tips

Viewing the site. To view the Web pages, open the folder you created to house them, then double-click the file named *index.html*. You'll see a set of thumbnails on a page that resembles the bland Web sites of the mid 1990s. Spartan instead of stylish—but the page will load quickly.

Using the site. What next? If you have a Web server, you can stash these files there. If you use a Web editor, such as Adobe Dreamweaver, you can customize the pages and clean up their 1990s-vintage code.

Burning the site. You can also burn the Web pages on a CD and mail them to others. They can use a Web browser to view the pages on their Macs or PCs.

No renaming. Don't rename the index.html file or any other files or folders that you exported. If you do, the links won't work.

Exporting a Basic QuickTime Movie

Step 1. Select some images or select an event, an album, a Faces tile, or a place in Places, then choose File > Export.

Step 2. To access movie-export options, click QuickTime.

Specify the duration for each image to display.

You can specify that iPhoto add a background color or background image to the movie. The color or image appears whenever the dimensions of the currently displayed photo don't match that of the movie itself. (For example, in a 640 by 480 movie, the background will be visible in photos shot in vertical orientation.) The background will also be visible at the beginning and end of the movie—before the first image fades in and after the last image fades out.

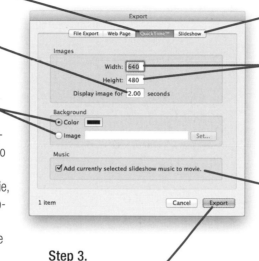

Step 3.
To create the movie, click Export and type a name for the movie.

This tab summons the standard Export dialog shown on page 85.

Specify the desired dimensions for the movie, in pixels. The preset values shown here work well, but if you specify smaller dimensions, such as 320 by 240, you'll get a smaller movie file—useful if you plan to distribute the movie over the Internet.

If you've assigned music to the album or slide show, iPhoto adds it to the movie. To create a silent movie, uncheck this box. **Note:** If you plan to distribute your slide-show movie, don't use songs from the iTunes Store; see page 140.

Using Photos as Desktop Images and Screen Savers

iPhoto lets you share photos with yourself. Select a photo and choose Share > Set Desktop, and iPhoto replaces the Mac's desktop with the photo you selected.

If you select multiple photos or an event or album, your desktop image will change as you work,

complete with a cross-dissolve effect between images. It's an iPhoto slide show applied to your desktop.

Another way to turn an iPhoto album or event into a desktop screen saver is to use the Desktop & Screen Saver system preference—choose the album

in the Screen Savers list (right).

Warning: Using vacation photos as desktop images has been proven to cause wanderlust.

Burning Photos to CDs and DVDs

The phrase "burning photos" can strike terror into any photographer's heart, but fear not: I'm not talking about open flames here. Fire up your Mac's burner (if it has one—they don't come standard on minis or MacBook Airs), and you can save, or burn, photos onto CDs or DVDs. You can burn your entire photo library, an album or two, some favorite events, a slide show, or even just one photo.

iPhoto's burning features make possible all manner of photo-transportation tasks. Back up some photos: burn some particularly important events and then stash the disc in a safe place. Move photos and albums from one Mac to another: burn a selection, then insert the disc in another Mac to work with them there.

iPhoto doesn't just copy photos to a disc. It creates a full-fledged iPhoto library on the disc. That library contains the images' titles and keywords, any albums that you burned, and even original versions of images you've retouched or cropped. Think of an iPhoto-burned disc as a portable iPhoto library.

That's all grand, but your burning desires may be different. Maybe you want to burn photos for a friend who uses Windows, or for printing by a photofinisher. That's easy, too.

So back away from that fire extinguisher—we've got some burning to do.

Burning Basics

Burning photos involves selecting what you want to burn, then telling iPhoto to light a match.

Step 1. Select items to burn.

Remember that you can also select multiple items by Shift-clicking or ⌘-clicking each one (page 43).

You can't burn projects, such as books, calendars, or greeting cards, to disc.

Step 2. Choose Burn from the Share menu.

iPhoto asks you to insert a blank disc.

Step 3. Insert a blank disc and click OK.

iPhoto displays information about the pending burn. You can add photos to or remove them from the selection, and iPhoto will update its information area accordingly.

Tip: Give your disc a descriptive name by typing in the Name box.

Step 4. Click the Burn button.

iPhoto displays another dialog. To set burning options, such as a different burn speed, click the Expand button.

To cancel the burn, click Cancel. To proceed, click Burn.

iPhoto prepares the images, then burns and verifies the contents of the disc.

Working with Burned Discs

When you insert a disc burned in iPhoto, the disc appears in the Shared list. To see its photos, select the disc's name. Note that the disc's photos aren't in the iPhoto library on your hard drive—they're in the iPhoto library on the disc.

A small triangle appears next to the disc's name. To view the disc's items, click the triangle.

You can display photos on a disc using the same techniques that you use to display photos stored in your iPhoto library. You can also display instant slide shows, email photos, and order prints.

However, you can't edit photos stored on a burned disc, nor can you create a slide show project, a book, a calendar, or a greeting card. To perform these tasks, add the photos to your photo library as described at right.

Copying Items from a Burned Disc

To modify an item that's stored on a burned disc, you must copy it to your iPhoto library.

To copy an item, select it and drag it to the Events or Photos item in the Library area.

Burning for Windows or Photofinishers

Here's how to burn photos for a friend who uses Windows, or for printing by a photofinisher. You can also use these steps to burn a disc for a fellow Mac user who doesn't use iPhoto.

Step 1. Prepare a disc.
Insert a blank CD or DVD in your Mac's optical drive. The dialog below appears.

Type a name for the CD and click OK. The blank disc's icon appears on your desktop.

Step 2. Copy the photos.
Position the iPhoto window so that you can see it and the blank disc's icon. Drag the photos that you want to burn to the icon of the blank disc.

As an alternative to dragging photos, you can also select them and use the File menu's Export command to export copies to the blank disc. This approach gives you the option of resizing the photos and changing their file names.

Another alternative is to create a burn folder on your hard disk and drag the items to that burn folder.

Step 3. Burn. To burn the disc, drag its icon to the Burn Disc icon in your dock, or click the Burn icon in the Burn Folder. (The Burn Disc icon replaces the Trash icon when you've selected a blank disc.) In the dialog that appears next, click the Burn button.

Creating and Managing Photo Libraries

iPhoto is designed to manage thousands of photos without bogging down. And its photo-management features are aimed at helping you find that photo of a needle in your photo of a haystack.

I mention this as a way of saying that you may be completely happy having just one master iPhoto library, even if it becomes huge. Just remember to back it up often (see the opposite page).

Still, a lot of people like to keep multiple libraries and switch among them. Some people do it for backup convenience: it's easier to sling a smaller library over to a DVD-R or an external hard drive.

For some people, multiple libraries are a way of further categorizing photos. Vintage scanned photos in one library, newer digital shots in another. Or a separate library for each year. Or each vacation.

But what about when you want to make a slide show or some other project? Because all the photos for a project must be in the same library, you might have to do a lot of work to gather the photos you need into one library.

Also, having multiple libraries defeats some of iPhoto's filing features. You can't tell iPhoto, "Show me all my photos of Toby" if some of those photos are in other libraries.

For these reasons, I keep all my photos in one library. It weighs in at well over 200 GB (I just checked), and iPhoto still purrs.

But if you prefer to maintain separate libraries, here's what you need to know.

Creating a New Library

Before creating a new library, you may want to back up your existing library by dragging your iPhoto Library to another hard drive or, if it will fit, by burning it to a DVD. For some backup strategies, see the sidebar on the opposite page.

Step 1. Quit iPhoto.

Step 2. Locate your iPhoto Library and rename it.

To quickly locate the library, choose Home from the Finder's Go menu, then double-click the Pictures folder, where you'll find the iPhoto Library. Another way to get there is to click the Pictures folder in the sidebar on the left side of any Finder window. (No sidebars? Choose View > Show Sidebar.)

July iPhoto Library

Step 3. Start iPhoto.

iPhoto asks if you want to locate an existing library or create a new one.

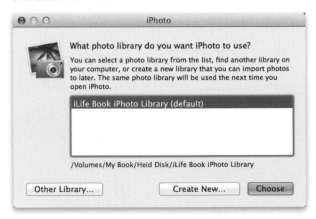

Step 4. Click Create New.

iPhoto proposes the name iPhoto Library, but you can type a different name if you like.

You don't need to store your library in the Pictures folder; see the sidebar below.

Step 5. Click Save, and iPhoto creates the new, empty library.

Switching Between Libraries

There may be times when you want to switch to a different iPhoto library—for example, to access the photos in an older library. It's easy: Start iPhoto and press the Option key immediately, even as iPhoto is still starting up. iPhoto will ask which library you want to use (of the ones it knows about). Either pick one from the list (opposite page) or click Other Library and navigate to the one you want.

Managing and Backing Up Your Library

Storing Photos Elsewhere

Normally, iPhoto stores your photo library in the Pictures folder. You might prefer to store your library elsewhere, such as on an external hard drive.

To store your photo library elsewhere, quit iPhoto, then simply move the iPhoto Library wherever you like. If you're copying the library to a different disk, delete the original library after the copy is complete. To open the library after you've copied it, just double-click its icon.

Backing Up

In the film days, you had to fall victim to a fire or other disaster in order to lose all your photos. In the digital age, it's much easier to lose photos; all it takes is a hardware failure or software glitch.

Please don't let photo loss happen to you.

Back up your photos. An easy way to back up is to buy an external hard drive and drag your iPhoto Library over to it now and then.

For a more sophisticated approach, use the Time Machine feature in Mac OS X Snow Leopard or Lion. It backs up your entire hard drive every day and lets you, as Apple says, "revisit your Mac as it appeared in the past." (In iPhoto, you can browse your Time Machine

backups by choosing File > Browse Backups.)

You can also burn your most important photos to DVDs, although these optical discs aren't as permanent as you might think. They can develop problems after just a few years, especially if stored in a warm environment.

As you can see, you have backup options aplenty. For the sake of your photos, use at least one of them.

Getting Old Photos into iPhoto

You love your digital camera and the convenience of iPhoto, and it would take an act of Congress to force you to use film again.

And yet the past haunts you. You have boxes of negatives and slides that you haven't seen in years. If you could get them into iPhoto, you could organize them into albums and share them through Web albums, slide shows, prints and books, and even movies and DVDs.

Many services will scan slides, negatives, and prints for you, with retouching and color restoration available as options. One of the most popular is ScanCafe (www.scancafe.com), which charges as little as $.22 per scan.

If you'd rather do the job yourself, you need a scanner. Here's an overview of what to look for, and some strategies for getting those old photos into iPhoto.

Scanning the Options

Before you buy a scanner, take stock of what types of media you'll need to digitize. Do you have negatives, prints, slides, or all three? Not all scanners are ideal for every task.

Flatbed scanners. If you'll be scanning printed photos, a *flatbed scanner* is your best bet. Place a photo face down on the scanner's glass, and a sensor glides beneath it and captures the image.

Repeating this process for hundreds of photos can be tedious. If you have a closet full of photos, you may want to look for a scanner that supports an automatic document feeder so you can scan a stack of photos without having to hand-feed the scanner. Some flatbeds include photo feeders that can handle up to 24 prints in sizes up to 4 by 6 inches. Other scanners accept optional document feeders. Just be sure to verify that the document feeder can handle photos—many can't.

Film scanners. A print is one generation away from the original image, and may have faded with time or been poorly printed to begin with. Worse, many photos are printed on linen-finish paper, whose rough texture blurs image detail when scanned. Bottom line: you'll get better results by scanning the original film.

Many flatbed scanners include a film adapter for scanning negatives or slides. A flatbed scanner with a film adapter is a versatile scanning system, but a *film scanner* provides much sharper scans of negatives and slides. Unfortunately, this quality will cost you: film scanners cost more than flatbeds.

Clean-up features. Many film and flatbed scanners provide dust and scratch removal options, such as Digital ICE (short for *image correction/enhancement*). Developed by Kodak and licensed to numerous scanner manufacturers, Digital ICE does an astonishingly good job of cleaning up color film. However, it doesn't work with black-and-white negatives.

Scanning Right

Whether you use a flatbed or film scanner, you'll encounter enough jargon to intimidate an astronaut: histograms, tone curves, black points, white points. Don't fret: all scanners include software that provides presets for common scanning scenarios, such as scanning for color inkjet output. Start with these presets. As you learn about scanning, you can customize settings to optimize your exposures.

The right resolution. A critical scanning setting deals with how many dots per inch (dpi) the scanner uses to represent an image. Volumes have been written about scanning resolution, but it boils down to a simple rule of thumb: if you're using a flatbed scanner and you plan to print your scans on a photo inkjet printer, you can get fine results with a resolution of 180 to 240 dpi. If you plan to order photographic prints from your scans, scan at 300 dpi. Scanning at more than 300 dpi will usually not improve quality—but it will definitely use more disk space.

Film scanners are different. A film scanner scans a much smaller original— for example, a 35mm negative instead of a 4 by 6 inch print. To produce enough data for high-quality prints, a film scanner must scan at a much higher resolution than a flatbed. The film scanner I use, Minolta's Scan Elite 5400, scans at up to 5400 dpi.

This difference in approach can make for even more head scratching when it comes time to decide what resolution to use. Just do what I do: use the presets in the scanning software. I typically choose my film scanner's "PhotoCD 2048 by 3072" option, which yields a file roughly equivalent to a 6-megapixel image.

Special circumstances. If you plan to apply iPhoto's or iMovie's Ken Burns effect to an image, you'll want a high-resolution scan so you can zoom in without encountering jagged pixels. Experiment to find the best resolution for a specific image and zoom setting.

In a related vein, if you plan to crop out unwanted portions of an image, scan at a higher resolution than you might normally use. Cropping discards pixels, so the more data you have to begin with, the more cropping flexibility you have.

Format strategies. Which file format should you use for saving images? As I've mentioned before, the JPEG format is *lossy:* it sacrifices quality slightly in order to save disk space. If this is the last time you plan to scan those old photos, you may not want to save them in a lossy format. When scanning my old slides and negatives, I save the images as TIFF files.

Photos, Meet iPhoto

Once you've scanned and saved your photos, you can import them into iPhoto.

Filing photos. To take advantage of iPhoto's filing features, you may want to have a separate iPhoto event for each set of related photos. In the Finder, move each set of related photos into its own folder, giving each folder a descriptive name, such as *Vacation 1972*. Next,

drag each folder into the iPhoto window. iPhoto gives each event the same name as its corresponding folder.

You can delete the folders after you've imported their shots, since iPhoto will

have created duplicates in iPhoto Library. (If you prefer to retain your existing filing system, you can set up iPhoto to not copy the photos to the iPhoto Library; see page 17.)

Turn back the clock. To make your iPhoto library chronologically accurate, change the date of the photos and events to reflect when the photos were taken, not when they were imported (see page 23).

While you're sweating the details, consider geotagging photos whose locations are particularly significant. And jump over to the Faces item to see if iPhoto recognizes someone from Back Then.

Time for retouching. You can use iPhoto's Retouch tool to fix scratches and dust specks, and its Enhance button and Adjust pane to fix color and exposure problems. For serious retouching, though, use Photoshop Elements or Photoshop. To learn more about digital retouching, I recommend Katrin Eismann and Wayne Palmer's *Adobe Photoshop Restoration and Retouching, Third Edition* (New Riders, 2005).

iPhoto Tips

Purchased Songs and Slide Shows

You can use songs from the iTunes Store for slide show soundtracks. But if you plan to export the slide shows as QuickTime movies, using the technique described on page 133, note that the songs will play only on computers authorized for your iTunes account. The workaround: burn the songs to an audio CD, then re-rip them into iTunes, and use those unprotected versions for your soundtracks.

Note that this limitation applies only to old iTunes purchases that are shackled by digital rights management (DRM) copy protection. These days, virtually all iTunes songs are not DRM-protected, so you can use them in your slide shows without worrying about whether they'll play on other computers.

But if you have tunes purchased back in the day, you'll need to resort to this workaround to get them to play. (To determine whether a song is copy-protected, go to iTunes, select the song, and choose File > Get Info. In the information dialog, click the Summary tab, and look for the Kind item. If the file is protected, its kind reads *Protected AAC Audio File.*)

Note that all this nonsense applies only to a slide show that you export as a bare-bones QuickTime movie. If you use the Export button to save a slide show as a movie, even shackled songs will play back fine on other computers.

Controlling the Camera Connection

Normally, when you connect a camera (or an iOS device with a camera), your Mac plops you into iPhoto. You might prefer that it didn't—it can be annoying when you're simply syncing your iPhone, for example.

To control what happens when you connect a camera to your Mac, choose iPhoto > Preferences. Click the General button, and in the Connecting Camera Opens pop-up menu, choose No Application.

Keywords for Movies and Raw Photos

Usually, assigning keywords to photos is your job (page 38). But iPhoto automatically assigns keywords to two types of items that you import: movie clips and raw-format images.

Movies get the keyword *Movie*, and raw images get the keyword *Raw*. Remember, you can use smart albums to quickly display items with one or more keywords. For example, to see all the movies in your iPhoto library, create a smart album whose criterion is Keyword is *Movie*.

Entering Custom Crop Proportions

With the Constrain pop-up menu in edit view, you can tell iPhoto to restrict cropping rectangles to standard proportions (page 53). If you want non-standard proportions, choose Custom from the Constrain pop-up menu and enter the proportions in the boxes that appear. Note that you can't enter fractional values: 8.5, for example, is rounded up to 9.

Hiding Event Titles

If you're browsing your photo library in Photos view, you can have iPhoto hide event titles and show your entire library as one massive set of thumbnails. In Photos view, choose View > Event Titles to deselect it. It's a cumbersome way to view your library, but you might find it useful when assigning keywords or renaming photos.

To restore some sanity to Photos view, choose View > Event Titles to select it again.

Rebuilding Your iPhoto Library

If iPhoto is acting up—for example, taking forever to launch, running unusually slowly, or not displaying photo thumbnails—try rebuilding your iPhoto Library. Quit iPhoto, then hold down the ⌘ and Option keys while starting iPhoto. A dialog appears asking if you're sure you want to rebuild your library and giving you several options for doing so.

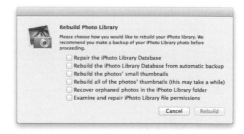

If your image thumbnails appear gray or blank, try selecting the rebuild thumbnail options. If iPhoto crashes or refuses to load photos when you first launch it, try the rebuild database options. If some of your photos seem to have disappeared, try the "recover orphaned photos" option. And if iPhoto is misbehaving in several ways, check all of the options.

Important: To avoid the risk of making a bad situation worse, consider backing up your iPhoto Library before trying to rebuild your library.

Non-Destructive Editing and Older Libraries

On page 50, I discussed how iPhoto has non-destructive editing that maximizes quality by always applying your edits to the original version of an image.

There's an exception to this rule, and it concerns iPhoto libraries created in iPhoto '06 or earlier versions. Specifically, if you edit a photo that you previously edited using an older iPhoto version, iPhoto '11 applies your latest changes to the *edited* photo, not to the original. Thus, you don't have the full advantage of non-destructive editing.

The solution? If you want to edit a photo that you've already edited using iPhoto '06 or an earlier version, revert to the original version of the photo. Choose Photos > Revert to Original (or, for raw images, Reprocess Raw). This discards edits you made in the past, and new edits will be applied to the original version of the photo.

Inside the iPhoto Library

The iPhoto Library item is a *package*—a special kind of Mac OS X folder. If you double-click the iPhoto Library item, your Mac simply starts or switches to iPhoto.

But there *is* a way to get inside if you must. Control-click the iPhoto Library item and choose Show Package Contents from the shortcut menu. Inside, you'll find a bevy of folders and files that constitute your library.

Warning: Leave them be. Always use iPhoto to add photos to or remove photos from your library: drag photos into and out of the iPhoto window.

EXIF Exposed: Getting Information About Photos

Digital cameras store information along with each photo—the date and time when the photo was taken, its exposure, the kind of camera used, and more. This is called the *EXIF* data. It's also often called *metadata*.

iPhoto saves this EXIF data when you import photos. This data is what you see in

the yellow-white box at the top of the Information pane.

Not all of this information will be useful to you, but some of it might. If you have more than one digital camera, for example, you can use it to see which camera you used for a given shot. And as I mentioned on page 46, you can use smart

albums to search for various metadata items. At the very least, you can see what kind of exposure settings your camera is using.

More iPhoto Tips

Including Photos in Documents

You may want to include photos in documents that you're creating in Microsoft Word or other programs. It's easy: just drag the image from iPhoto into your document.

If you use Apple's iWork software—Keynote, Pages, and Numbers—your job is even easier. All three programs provide media browsers much like those in the iLife programs: access your photo library directly, search for a photo, and then add it to a document by dragging it from the media browser.

If you drag an image to the Finder desktop or to a folder window, iPhoto makes a duplicate copy of the image file. Use this technique when you want to copy a photo out of your library.

Caution: Merging Faces

You can move corkboard tiles around to rearrange faces in whatever order you like: just click and drag them. But take care: if you drag one tile *atop* another, iPhoto merges those two faces: the face you dragged takes on the name of the face you dragged it to. (And there's a sentence I never thought I'd type.) Fortunately, iPhoto can warn you about this. (As a safety measure, don't check the Don't Ask Again in that warning.)

If you do accidentally drag one face tile atop another, sprint right up to the Edit menu and choose Undo Merge Faces.

Writing a Book? Use a Word Processor

Working on a book that contains a lot of text? Consider using your favorite word processor to write and format the text. Then, move the text into iPhoto as needed: select the text you need for a given page, and copy it to the Clipboard. Next, switch to iPhoto, click in the destination text box, and paste. iPhoto even retains your formatting.

This approach lets you take advantage of a word processor's superior editing features, not to mention its Save command—something iPhoto lacks.

Emailing Movies

iPhoto can store movie clips that your digital camera takes, but it can't email them. When you select a movie and choose Email from the Share pop-up, iPhoto gently chides you.

The workaround is easy. Start a new, blank email message, then position the iPhoto window so you can see the movie thumbnail and your message. Finally, drag the movie thumbnail from the iPhoto window into the blank email message. Or, if you use Apple's Mail program and have it in your Dock, just drag the movie to the Mail dock icon to create a new message with the movie attached.

Fun with Mosaics

What's better than a great photo? Dozens or hundreds or even thousands of great photos combined into a photo mosaic.

Here are a few ways to make mosaic magic.

Use the Mac's screen saver. The screen saver in Mac OS X has a dazzlingly cool mosaic option. A full-screen version of a photo appears, then grows gradually smaller as other photos appear around it. As the photos get ever tinier,

you see what's going on: they're forming a mosaic of yet another photo. The process then repeats with a different photo—it's mesmerizing.

Open the Desktop & Screen Saver system preference, click the Screen Saver button, select an album or event in the scrolling column on the left, then choose the Mosaic display style.

Make a life poster. With Zykloid Software's Posterino, you can turn a

collection of photos into a full-page poster. Choose from a variety of layout options and templates, then add the poster to iPhoto and order a print or make your own.

Make a photo mosaic. With a free program called MacOSaiX, you can create a stunning photo mosaic—a single photo made up of thousands of separate photos, each chosen by the software to match the color and tonal qualities of part of the original photo.

This mosaic, created by the free MacOSaiX software, is made up of over 1200 photos. To see and download the original, visit my Flickr photos (www.flickr.com/photos/jimheid) and search for *mosaic*.

Mastering Your Digital Camera

Resolution Matters

Always shoot at your camera's highest resolution. This gives you maximum flexibility for cropping, for making big prints, and for the Ken Burns effect in iPhoto and iMovie. You can always use iPhoto to make photos smaller (for example, for emailing or Web publishing).

Shutter Lag

Some older digital cameras and iPhones suffer from a curse called *shutter lag*— a delay between the time you press the shutter button and the moment when the shutter actually fires.

Shutter lag occurs because the camera's built-in computer must calculate exposure and focus. If you're shooting fast-moving subjects, it's easy to miss the shot you wanted.

The solution: give your camera a head start. Press and hold the shutter button partway, and the camera calculates focus

and exposure. Now wait until the right moment arrives, then press the button the rest of the way.

ISO Speeds

In the film world, if you want to take low-light shots, you can buy high-speed film—ISO 400 or 800, for example. Fast film allows you to take nighttime or indoor shots without the harsh glare of electronic flash.

Digital cameras allow you to adjust light sensitivity on a shot-by-shot basis. Switch the camera into one of its manual-exposure modes (a common mode is labeled *P*, for *program*), and then use the camera's menus to adjust its ISO speed.

Note that shots photographed at higher ISO speeds—settings over 1000, especially on less-expensive cameras—are likely to have digital *noise*, a slightly grainy appearance. For me, it's a happy trade-off: I'd rather have a sharp, naturally lit photo with some noise than a noise-free but blurry (or flash-lit) photo.

Higher ISO speeds can also help you capture fast-moving action by day. The higher speed forces the camera to use a faster shutter speed, thereby minimizing blur. That shot on this page of Mimi leaping into the air? Shot at a high ISO.

White Balance

Few light sources are pure white; they have a color cast of some kind. Incandescent lamps (lightbulbs) cast a yellowish light, while fluorescent light is greenish. Even outdoors, there can be light-source variations—bluish in the morning, reddish in the evening. Each of these light sources has a different *color temperature*.

Our eyes and brains compensate for these variances. Digital cameras try to do so with a feature called *automatic white balance*, but they aren't always as good at it. That's why many cameras have manual white balance adjustments that essentially let you tell the camera, "Hey, I'm shooting under incandescent (or fluorescent) lights now, so make some adjustments in how you record color."

White balance adjustments are usually labeled WB, often with icons representing cloudy skies ☁️, incandescent lamps ☀️, and fluorescent lighting. You'll probably have to switch to your camera's manual-exposure mode to access its white balance settings.

Sharpness and Color Settings

Digital cameras do more than simply capture a scene. They also manipulate the image they capture by applying sharpening and color correction (including white balance adjustments).

Some photographers don't like the idea of their cameras making manipulations like these. If you're in this group, consider exploring your camera's menus and tweaking any color and sharpness settings you find.

For example, many cameras have two color modes: "standard" and "real." The "standard" mode punches up the color saturation—something you can do yourself with iPhoto. I'd prefer to capture accurate colors and make adjustments later. A "real" mode—or its equivalent on your camera—gives you more-natural color. You can always punch it up in iPhoto if you must.

The same applies to sharpness. Most cameras offer a variety of sharpening settings, and when I'm shooting JPEG images, I like to reduce the camera's built-in sharpening. If I feel an image needs some sharpening later, I'll do the job in iPhoto or Photoshop.

And of course, remember that for maximum control, you should shoot in raw mode, in which the camera doesn't apply any color or sharpness adjustments.

Custom White Balance

Most cameras also let you create a custom white-balance setting. Generally, the process works like this: put a white sheet of paper in the scene, get up close so the paper fills the viewfinder, and then press a button sequence on the camera. The camera measures the light reflected from the paper, compares it to the camera's built-in definition of *white*, and then adjusts to compensate for the lighting.

If you're a stickler for color and you're shooting under strange lighting conditions, creating a custom white balance setting is a good idea.

Better still, shoot in raw mode if your camera allows it. Then you'll have complete control over color balance.

Stay Sharp

A camera's built-in LCD screen is great for reviewing a shot you just took. But the screen is so tiny that it's often hard to tell whether the photo is in sharp focus.

Most cameras allow you to zoom in on a photo while displaying it. I like to zoom in and verify that my photo isn't blurred—especially if the subject is still in front of me and I have another chance.

If your camera has an electronic viewfinder, it can be a superior alternative to the LCD screen for reviewing your shots, especially in bright light.

Your Camera's Histogram

If you read through pages 60 and 61, you've seen the value that a histogram display can offer for making exposure adjustments.

Many mid-range and all high-end cameras can display a histogram, too, which you can use to adjust exposure settings *before* you take a photo.

With your camera in one of its manual-exposure modes, activate the histogram display. Then adjust your exposure settings—shutter speed, ISO speed, and aperture—so that the histogram's data is as far to the right-hand side of the graph as possible without introducing white clipping. (Remember, white clipping means lost highlight detail.)

Photography gurus call this technique *exposing to the right*, and it ensures that you're getting as much image data as your camera is capable of capturing.

Photographer Michael Reichmann, publisher of the magnificent Luminous Landscape site, has written an excellent tutorial on using histograms when shooting. I've linked to it on www.macilife.com/iphoto.

Tips for Better Digital Photography

Get Up Close

Too many photographers shy away from their subjects. Get close to show detail. If you can't get physically closer, use your camera's zoom feature, if it has one. If your camera has a macro feature, use it to take extreme close-ups of flowers, rocks, seashells, tattoos—you name it. Don't limit yourself to wide shots.

Vary Your Angle

Don't just shoot from a standing position. Get down into a crouch and shoot low— or get up on a chair and shoot down. Vary your angles. The LCD screen on a digital camera makes it easy—you don't press your eye to the camera to compose a shot.

Changing your angle can be a great way to remove a cluttered background. When photographing flowers, for example, I like to position the camera low and aim it upwards, so that the flowers are shot against the sky.

Avoid Digital Zooming

Many digital cameras supplement their optical zoom lenses with digital zoom functions that bring your subject even closer. Think twice about using digital zoom—it usually adds undesirable artifacts to an image.

Position the Horizon

In landscape shots, the position of the horizon influences the mood of the photo. To imply a vast, wide open space, put the horizon along the lower third of the frame and show lots of sky. (This obviously works best when the sky is cooperating.) To imply a sense of closeness—or if the sky is a bland shade of gray—put the horizon along the upper third, showing little sky.

This rule, like others, is meant to be broken. For example, if you're shooting a forlorn-looking desert landscape, you might want to have the horizon bisect the image to imply a sense of bleak monotony.

Crop Carefully

You can often use iPhoto's Crop tool to fix composition problems. But note that cropping results in lost pixels, and that can affect your ability to produce high-quality prints. Try to do your cropping in the camera's viewfinder, not iPhoto.

Kill Your Flash

I turn off my camera's built-in flash and rarely turn it on. Existing light provides a much more flattering, natural-looking image, with none of the harshness of electronic flash.

Dimly lit indoor shots may have a slight blur to them, but I'll take blur over the radioactive look of flash any day.

Beware of the Background

More accurately, *be aware* of the background. Is a tree growing out of Mary's head? If so, move yourself or Mary. Are there distracting details in the background? Find a simpler setting or get up close. Is your shadow visible in the shot? Change your position. When looking at a scene, our brains tend to ignore irrelevant things. But the camera sees all. As you compose, look at the entire frame, not just your subject.

Embrace Blur

A blurred photo is a ruined photo, right? Not necessarily. Blur conveys motion, something still images don't usually do. A photo with a sharp background but a car that is blurred tells you the car was in motion. To take this kind of shot, keep the camera steady and snap the shutter at the moment the car crosses the frame.

You can also convey motion by turning this formula around: if you pan along with the moving car as you snap, the car will be sharp but the background will be blurred. A canine-oriented example is above.

Compose Carefully

Following a couple of rules of thumb can help you compose photos that are more visually pleasing.

First, there's the age-old *rule of thirds*, in which you divide the image rectangle into thirds and place your photo's subject at or near one of the intersections of the resulting grid.

Place your photo's subject at or near these intersections.

This composition technique yields images that are more visually dynamic. The Crop tool in iPhoto's edit view makes it easy to crop according to the rule of thirds (page 53).

A second technique is to draw the viewer's eyes to your subject and add a sense of dynamism by using diagonal lines, such as a receding fence.

No Tripod?

If you want to take sharp photos in low light, mount your camera on a tripod. If you don't have a tripod handy, here's a workaround: turn on your camera's self-timer mode—the mode you'd usually use when you want to get yourself in the picture—then set the camera on a rigid surface and press the shutter button. Because you won't be holding the camera when the shutter goes off, you won't risk getting a blurred shot.

Index

Index

Index

Index